Carleton Watkins THE ART OF PERCEPTION

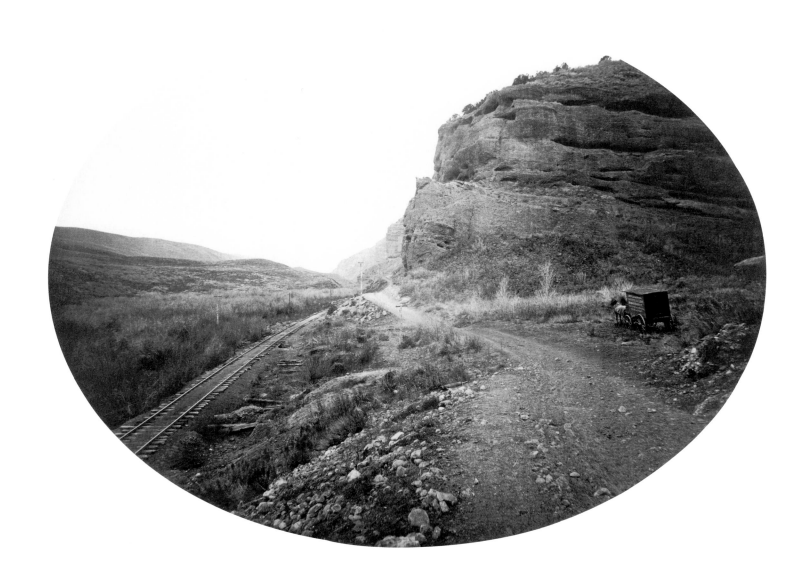

Carleton Watkins THE ART OF PERCEPTION

Douglas R. Nickel
with an introduction by Maria Morris Hambourg

SAN FRANCISCO MUSEUM OF MODERN ART

Carleton Watkins: The Art of Perception is organized by the San Francisco Museum of Modern Art, in association with the Metropolitan Museum of Art, New York, and with special cooperation from the Huntington Library and Art Gallery, San Marino, California.

The exhibition is made possible by Wells Fargo and The Henry Luce Foundation, Inc. Additional major support has been provided by Judy and John Webb; Chevron Corporation; and by the National Endowment for the Humanities, dedicated to expanding American understanding of history and culture.

Exhibition Schedule:

San Francisco Museum of Modern Art
May 28 to September 7, 1999

Metropolitan Museum of Art, New York
October 11, 1999, to January 9, 2000

National Gallery of Art, Washington, D.C.
February 6 to April 30, 2000

Clothbound edition published by
Harry N. Abrams, Inc.
100 Fifth Avenue
New York, N.Y. 10011
www.abramsbooks.com

Library of Congress Cataloging-in-Publication Data:

Nickel, Douglas R. (Douglas Robert), 1961–
 Carleton Watkins : the art of perception /Douglas R. Nickel and
 Maria Morris Hambourg.
 p. cm.
Published on the occasion of an exhibition at the San Francisco Museum
of Modern Art, May 28–Sept. 7, 1999.
 Includes bibliographical references.
 ISBN 0-8109-4102-3 (hardcover)
 ISBN 0-918471-51-6 (softcover)
 1. Photography, Artistic—Exhibitions.
 2. Outdoor photography—Exhibitions.
 3. Watkins, Carleton E., 1829–1916—Exhibitions.
 4. West (U.S.)—Pictorial works—Exhibitions.
 I. Watkins, Carleton E. 1829–1916.
 II. Hambourg, Maria Morris.
 III. San Francisco Museum of Modern Art.
 IV. Title.
TR647.W368 1999
779'.092 — dc21 98-53012
 CIP

Publications Director: Kara Kirk
Publications Coordinator: Alexandra Chappell
Editor: Janet Wilson
Designer: Jody Hanson
Tritone and Duotone Separations: Robert Hennessey

Front Cover: Detail of plate 61: *Eagle Creek, Columbia River*, 1867.

Back Cover: Carleton Watkins. *Primitive Mining. The Old Rocker* (self-portrait as a miner), ca. 1876 (stereo half). Collection of the Society of California Pioneers.

Frontispiece: Carleton Watkins. *Red Rock in Echo Canyon, Utah*, 1873–74. 4¹⁵⁄₁₆ x 6⁵⁄₁₆ in. (12.5 x 16.1 cm). Collection of James Crain.

Page 18: *Watkins's Traveling Wagon*, ca. 1871 (stereo half). Collection of The Bancroft Library, University of California, Berkeley.

Printed and bound in the United States.

CONTENTS

LENDERS TO THE EXHIBITION

Addison Gallery of American Art,
Phillips Academy, Andover, Massachusetts

American Antiquarian Society

Amon Carter Museum, Fort Worth, Texas

The Art Institute of Chicago

The Bancroft Library,
University of California, Berkeley

Gordon L. Bennett

California State Library

Centre Canadien d'Architecture/
Canadian Centre for Architecture,
Montréal

The Cleveland Museum of Art

James Crain

Fraenkel Gallery, San Francisco

The J. Paul Getty Museum

Gilman Paper Company Collection

The Huntington Library, Art Collections,
and Botanical Gardens

Mark Leno

The Metropolitan Museum of Art

Catherine Mills

The Museum of Modern Art, New York

National Gallery of Art, Washington

Oregon Historical Society

Merrily and Tony Page: Page Imageworks

Peter E. Palmquist

Kathy and Ron Perisho

Jane Levy Reed

San Francisco Museum of Modern Art

The Society of California Pioneers

Stanford University Libraries,
Cecil H. Green Library,
Department of Special Collections

Howard Stein

Marjorie and Leonard Vernon

Leonard A. Walle

Weston Gallery, Inc., Carmel, California

Michael and Jane Wilson

Daniel Wolf

Yosemite Museum, National Park Service

Private collections

DIRECTOR'S FOREWORD

One of the genuine pleasures for museum directors comes when we are given the opportunity to introduce to our audience the work of some great but still largely unknown artist. Another occurs when we get to honor those visionary forebears in the community who helped conceive our institutions and therefore made our jobs possible. In presenting the work of Carleton Watkins, I have occasion to do both, for Watkins was not only the most gifted and precocious landscape photographer America produced in the nineteenth century but he was also, interestingly, one of this museum's founders. In 1871 Watkins signed on as a charter fellow of an organization called the San Francisco Art Association, established by civic-minded local artists and their patrons to promote their calling and "the diffusion of a cultivated taste for art in the community at large," in what was still, culturally speaking, a frontier town. The association established its own art school in due course and later split into two entities, one of which became the San Francisco Art Institute, the other an organization that came to be called the San Francisco Museum of Modern Art. Watkins's signal participation, in the company of the West Coast's leading painters and most well-heeled patrons, speaks to the high esteem in which he was held personally and to the stature his work as a photographic artist had achieved.

Carleton Watkins: The Art of Perception is the first large-scale exhibition to look at this Victorian photographer's work from a critical, art-historical perspective. During his long career, Watkins made literally thousands of landscape images: famous, influential photographs of Yosemite and the scenery of the Columbia River, photographs of the rugged Pacific Coast, of the mining activity in the Sierra foothills that followed the first Gold Rush, and of developing towns in the West that sprang forth along the routes of the newly built Central and Southern Pacific railroads. A nineteenth-century pioneer in a new technologically based medium, he often secured these images under the most difficult conditions, hauling heavy equipment and supplies through bad weather to spots far from even the semblance of a road, working at dawn to avoid wind, at times losing priceless glass-plate negatives when his mule tripped. Such hard-earned pictures provided an international audience with visual access to the sublimity and abundant resources of California and the West, at a time when actual travel to the region was arduous, and did so with an aesthetic sophistication almost unrivaled in the history of photography. As Douglas R. Nickel so eloquently articulates in his essay in this publication, Watkins created images that strike us as preternaturally modern in appearance: this remarkable nineteenth-century artist made tangible an art of perception, one that spoke to the emerging conditions of visuality that, in their maturity, came to define our own century and the art that characterizes it.

This project was orchestrated by Douglas Nickel, SFMOMA associate curator of photography. His unflagging energy and high standards are manifest in every aspect of the exhibition and the volume that accompanies it. Maria Morris Hambourg, curator in charge of the Department of Photographs at the Metropolitan Museum of Art, worked with Dr. Nickel throughout the development of the project and contributed a thoughtful and elegant essay to this publication. Of course, the exhibition could never have been realized without the support of the many individuals and institutions who lent works and other forms of material assistance, to all of whom we are deeply indebted.

Finally, I would like to express our very great appreciation to Wells Fargo; the Henry Luce Foundation, Inc.; Judy and John Webb; Chevron Corporation; and the National Endowment for the Humanities. Their generous support has made this exhibition, publication, and the accompanying programs possible.

David A. Ross

Carleton Watkins: An Introduction

MARIA MORRIS HAMBOURG

In 1842 in the Susquehanna River Valley village of Oneonta, New York, the favorite amusement of thirteen-year-old Carleton Watkins and his friends was to improvise fireworks for their own pleasure. Soaking balls of cotton batting in turpentine, the boys would climb the tower of the Presbyterian church, light the balls, and toss them "blazing into the dark void below, illuminating the immediate surroundings with spectacular effect."[1] Beyond recalling the spontaneous creativity and homemade diversions of the last century and the perennial joys of fireworks for adolescent boys, the story points past the visual excitement and its public reception to an earlier, related event in the boy's life.

On 13 November 1833, two days after Carleton's fourth birthday,

a most extraordinary spectacle was furnished by an aurora borealis, accompanied by a very great number of meteors and shooting stars; the streams of light in different colors extending far up toward the zenith; not alone in the vicinity of the northern horizon but seemingly emanating from other quarters of the sky as well. This marvelous celestial display created profound interest and not a little nervous excitement in Oneonta, as well as elsewhere; most of the awed population of the little hamlet being congregated in the dead of night at the junction of Main and Chestnut streets, for the purpose of comparing observations upon the startling event. . . . They listened to an impromptu address by Squire Ira Emmons, who. . . being a man of scientific attainments, was enabled to make an exceedingly entertaining discourse to his fellow townspeople upon the subject of the phenomenal manifestation.

Interviewing Watkins in 1905 for his history of Oneonta, Willard Huntington found that the photographer remembered the event vividly despite the more than seventy intervening years. Huntington continued:

Carleton E. Watkins informs me that he remembers the occasion just described, although he was but a small boy at the time. Also, that he recalls seeing Mr. Emmons, who was then looked upon as being one of the best informed men in town, making his address to the villagers; moreover, that in those days, the portion of Chestnut Street situated between the two Main Street hotels was a favorite gathering place for the people upon eventful occasions; that he recollects seeing Squire Emmons standing up in his chaise (the body of which, each winter, he usually transferred from wheels to runners), and that he wore, during his remarks at the time, his then well-known long cloak with its cape attachment.[2]

Watkins's memory was remarkable; crystallized by the extraordinary event, it pinpointed the relevant issues against the underlying shape of life in his small town. From the public houses on either side of the main intersection, he plotted the way that crossing became the natural town center and mapped the line of sight between the villagers assembled on foot and the local squire, standing in an elevated position in his carriage; he further noted the fine figure cut by the wealthy, learned landowner. While Watkins's description was surely inflected by his years of photographic practice, it was grounded in the memories of a most acute spatial intelligence. Even the child's mind grasped the world in coherent scenes, aligning perspectives and focusing cleanly on telling details. It is hardly surprising that a youth endowed with such vision should find a way to recreate the views he composed so effortlessly with his mind's eye. Unable to draw, Carleton was fortunate that photography, invented in 1839, reached maturity about the same time he did.

In the mid-1850s when Watkins began to work as a photographer in the San Francisco area, rumor announced another spectacular natural wonder. Hidden in the mountains southeast of the city by cliffs that touched the sky lay a vast valley of untrammeled beauty studded with dramatic geological formations and thundering waterfalls. The sketchy reports exalted the imagination and stirred several parties to trek on muleback into the isolated valley, then still exceedingly difficult of access. James Hutchings, a local publisher, took photographer C. L. Weed to the valley in the summer of 1859. Weed's photographs were seen at Vance's San Francisco gallery later that year, and the woodcuts made from them, which lavishly illustrated four articles on the valley in *Hutchings' Illustrated California Magazine* in 1859–60, generated further interest.[3] Yosemite seemed a miracle of nature, a veritable Garden of Eden left by God at America's backdoor. The news was as exciting to San Franciscans as the northern lights had been to the villagers of Oneonta, but in this case the local squire was named Frémont, and the man who rose to speak was Thomas Starr King.

Colonel John C. Frémont was the dashing explorer who mapped the Far West as "the Pathfinder" with his friend Kit Carson—his very name spelled adventure, California, and expansionist enthusiasm to the American imagination of the 1840s. Elected one of California's first senators in 1850, Frémont was immensely popular and well connected; he ran for president of the United States in 1856 and considered running again in 1864. His huge Mariposa estate, which bordered Yosemite and sat astride the gold-rich mother lode of the Sierra Nevada Mountains, was acquired as a "floating" land grant before California became a state. His right to this land and to other mining operations was contested, as were many tracts, claims, and counterclaims during the volatile period of gold fever and new government regulations. To help establish boundaries, prove ownership, and entice investors to defray the costs of the extraction operations, Frémont hired Watkins to photograph his land and mines. By 1860, when Watkins had spent many weeks working at Las Mariposas, he had become closely associated with the colorful Frémonts, their rapacious business partner Trenor Park, and Mrs. Frémont's favorite, the young Unitarian preacher from Boston, Thomas Starr King.

King was a leading figure in the intellectual community in San Francisco and a fixture at Jessie Benton Frémont's home in 1860–61. Having visited Yosemite in 1858, the Frémonts were instrumental in promoting interest in the nation's new scenic wonder, whose principal gateway lay through their estate. In 1859 they invited Horace Greeley, editor of the *New York Tribune*, to visit the area, and in 1860, Starr King. A great orator especially stirred by mountain landscape, King delivered inspiring sermons on his experience and wrote eight long, rapturous letters detailing and exaggerating the glories of the valley for publication in the *Boston Evening Transcript*.

No portraiture by pen or pencil has done justice to the "infinite variety" in the forms of the rocks, and their inspiring livingness of aspect,—if such an expression means anything. What the valley is worth to a geologist I do not know; but an artist who loves rocks might revel in it for a dozen life-times.... And the walls support all sorts of crowning figures and ornaments. Cones are set on them; domes swell from them; turrets and towers overhang them; aiguilles and spires shoot above them; pyramids are based on them; and the raggedest splinters, a thousand feet in height, start up from them and drop a few hundred tons of granite, every winter, to adorn the base of the rampart with picturesque ruin.[4]

Watkins might not have undertaken the complex proposition to photograph Yosemite had it not been for King's awestruck enthusiasm and the support of the Frémonts. Recognizing that the scale of the valley required exceptional preparations, Watkins had a cabinetmaker fashion a huge camera capable of accepting negatives eighteen by twenty-two inches in the spring of 1861; he also purchased a stereo camera and assembled a staggering amount of materiel to be carried on pack mules into the valley. Whether the job was commissioned by Trenor Park, who was in the valley that summer, or was a self-assigned quest to see the wondrous spectacle is unclear. In either case, the motivation to create a spectacle to convey the excitement of the phenomenon was a feat not unlike devising fireworks to dazzle one's friends.

Watkins managed to capture the physical magnitude and visual textures of Yosemite with a grace and intelligence unsurpassed today. He composed the large scale of the rock formations and the amplitude of the spaces in comfortable, mutually accommodating ways. If, beneath the dome-tops of the prints, rivers, trees, and rocks seem to bend toward each other, this was the implication of Watkins's lens, and also of the prevailing pictorial conventions, which preferred the softened contours of the vignetted view to a clean slice from the visual field.[5] In the presence of the marvelous it is easy to wax rhapsodic, but Watkins shied away from the rhetorical and the effusive, preferring to convey the stupendous by containment and the inspirational by quietude (pl. 20).

The 1861 suite of mammoth photographs and accompanying stereographs of Yosemite made Watkins's name. Reading Starr King's articles, Bostonians wrote to ask him for photographs. Through King, Watkins gave stereographs to Ralph Waldo Emerson and Oliver Wendell Holmes. Emerson wrote that the photographs of the Grizzly Giant reversed his doubt and "make the tree possible," while Holmes wrote a long article praising the pictures as "a perfection of art which compares with the finest European work."[6] William Brewer, a young Yale-trained scientist from Ithaca who had moved to San Francisco to work for the California State Geological Survey under Professor Josiah Whitney, also from Yale, saw the "magnificent photographs" and sought out their maker in January 1862. Two months later Brewer took Whitney to meet Watkins and bought photographs to send to their professor, Asa Gray, as well as to Frederick Law Olmsted, the noted landscape architect.

By December 1862 the views were the talk of New York, where they were shown at Goupil's Gallery, having been forwarded by the gallery's San Francisco partners, Roos and Wunderlich. The *New York Times* reported that "as specimens of the photographic art they are unequalled and reflect great credit upon the producer, Mr. Watkins. The views…are indescribably unique and beautiful. Nothing in the way of landscapes can be more impressive or picturesque."[7] Frémont's lawyer Frederick Billings sent them to Professor Louis Agassiz, the famous naturalist at Harvard, who wrote, "I have never seen photographs equal to these. . . . [They] are the best illustrations I know of the physical character of any country."[8]

The further efforts of Jessie Benton Frémont, daughter of Senator Thomas Hart Benton, and I. W. Raymond, a steamship magnate who sent a set of Watkins's photographs to Senator John Conness of California, proposed that the U.S. Congress pass a bill protecting Yosemite and the Mariposa Grove from commercial exploitation, otherwise a likely fate given the practices of men like Frémont and Park. On 29 June 1864 President Lincoln signed a law of inviolation for the tract—a tacit recognition of the necessity of natural conservancy in a climate of rampant development and an important precedent in establishing the present system of national parks.

Watkins must have been gratified by the results of his labors: his art was acclaimed on both coasts by the sensitive and knowledgeable and had helped set a national policy of scenic conservation. In such an enviable position many would have capitalized on the fame, but Watkins hardly maintained a business, much less an agent to advertise and protect his pictures. He did not even stamp his mounts with address and copyright, puzzling one East Coast admirer who inquired, "Do you know where the Mr. Watkins who took the [photographs of Yosemite] is to be found?"[9] Not only did the artist delight in giving away his prints, he seemed downright loath to engage in commerce. Olmsted, who became chairman of the Yosemite Commission, took his family to the valley in 1865. An Englishwoman who accompanied his family wrote: "[Watkins] is here now taking

new and beautiful views and seems so lukewarm about pushing their sale that I am afraid it will be long before they become known where it seems to me, they would be so thoroughly appreciated both for intrinsic excellence and the interest in the subject."[10]

At this point in his career, Watkins apparently regarded photography as an opportunity to make pleasing spectacles and business as a chance to offer his pictures to people of taste and learning. Turning these personal satisfactions to financial advantage would become necessary, but making a living was as yet a decidedly minor concern of this "confoundly [sic] generous" man.[11] However, with the Frémonts' departure from San Francisco and King's death, both in 1864, Watkins lost important supporters. During the next few years his staunchest allies were the natural scientists from back east: Brewer and Whitney and, to a lesser extent, William Ashburner and Clarence King, who also worked on the California State Geological Survey in the Sierra Nevada.

Whitney hired Watkins to make additional photographs of Yosemite for his Survey in 1865 and 1866. For this Watkins bought a new wide-angled landscape lens that allowed distant objects to be approached more closely, broadened the pictorial scope, and entirely covered the negative with high-definition information. He no longer needed to trim the tops of his pictures to an arch and could realize the finest detail while retaining the grand sense of scale the lens allowed. There is consequently much more space in the 1865–66 Yosemite pictures. Compared with the concisely composed 1861 views, these photographs stretch out horizontally; objects in them tilt away from one another as the space between them distends, making everything more legible—a feature desirable to a team of surveyors. To apprehend the broadest views, such as that seen from the top of the Sentinel Dome (pls. 30–32), he made correlated negatives to capture a panoramic sweep of space. As Douglas Nickel discusses elsewhere in this volume, Watkins executed feats of astonishing virtuosity to encompass his sense of the vastness of the place.

Working with one or more assistants and three cameras, often in exceptionally difficult locales where water had to be hauled over long distances, with the help of twelve recalcitrant mules loaned by Olmsted, and literally a ton of equipment, the photographer necessarily became a logistical and technical expert. The results of his "big take" are astonishing pictures that are also extraordinary geological reports (pls. 29, 38). The project was a real challenge for the meticulous, tireless photographer, who met it by establishing the highest standards of picture making under adverse conditions; the resulting optical tours de force manifest a robust muscularity and a spectacular degree of resolution. Existing as if in the thin air of higher altitudes, these pictures suggest a highly controlled exaltation.

If Watkins's cool, keen views of Yosemite from 1865–66 seem more factual and less obviously poetic than those he made in 1861, how much more disengaged were most of the photographs he took in the valley in the 1870s. No longer offering either surprise or logistical hardship, the once-secret paradise was now fully mapped, its points of view clichéd. In a tourist park laced with easy roads and hotel accommodations, the photographer's challenge was to find a truly stimulating subject; this he sought by climbing to now more accessible heights, but even so there are few great photographs of Yosemite from the later period. When returning to a familiar site in the 1870s, Watkins generally created either a sure, if rather pat, rendering of what he had already captured or a dramatic version, more baroque than his reined-in pictures of the 1860s. When he sought something altogether new, the dynamic camera angles and felicitous vignettes he devised often betray the strain of producing novelties to appeal to tourists.

The differences between the three periods of Yosemite photographs demonstrate clearly how permeable was Watkins's art to the prevailing atmosphere of his feelings. As sensitive to every invisible aspect of his projects as he was to weather and light, he registered all the moods and expectations of his perceived audience, the shifting reception of his work, the novelty, wonder, and challenges of his job, as well as the strictly commercial demands that came increasingly into play, and which he answered with competent illustrations or stylish pictures as appropriate. The marked disparities within the oeuvre, which is broad and rather uneven, like the man's poor business acumen, were alike rooted in this special sensitivity, at once the source of his personal difficulties and his absolute artistry.

Although Watkins would always be identified with Yosemite, many of the most satisfying photographs he took after 1861 are not of that grand locale but of less famous sites on the West Coast. He made the majority of these exceptional photographs in the 1860s when he was in his thirties and no longer a novice but the energetic master of his medium. He had accomplished his apprenticeship making portraits and legal land-claim documents with daguerreotypy and other early photographic techniques in smaller towns such as Marysville and San Jose beginning in 1854. By 1860 he was sharing a studio on San Francisco's Montgomery Street, a commercial artery comparable to New York's Broadway, where many photographers congregated. In 1866 his colleagues united in an association, ostensibly for mutual benefit but actually to fix prices and discourage "that ruinous spirit of competition."[12] Watkins, characteristically, would have nothing to do with the group; not only was he not a joiner, but when he sold his photographs he did not shrink from asking top dollar—namely, one hundred fifty dollars for a set of thirty mammoth prints of Yosemite. Although fees from commissions and occasional sales did not cover the lean winter months, Watkins endured being "poor as poverty" as the price for pursuing his calling as he wished, without constraints of a gallery, partner, publisher, or association.[13] Could he have grasped financial security without compromising his personal freedom and integrity he would have, but he likely recognized no alternative to his impeccable standards and intensive, firsthand production—until forced to.

Watkins made most of his great pictures when he enjoyed the challenge of devising a shape for the previously undepicted. The novelty was important: it necessitated learning, and it was when dealing creatively with the unknown that Watkins was most alive. He especially thrived when he had a commission from an intelligent client who provided information and collegial support, who would effectively become his appreciative audience but meanwhile left him free to work according to his own dictates. The photographs of New Almaden and Mendocino are cases in point.

Sherman Day, superintendent of the New Almaden quicksilver mine south of San Francisco, hired Watkins in 1863 to photograph the operation, the rights to which had been long and vehemently disputed and just recently settled. Another bright young colleague of William Brewer's, Day probably hired the photographer on Brewer's recommendation.[14] The photographs show that Watkins enjoyed working with Day; in addition to taking some straightforward views of the operations, he had several dozen miners pose in front of a metal shed, shot the charming tree-lined main street, and in *The Town on the Hill, New Almaden* (pl. 16) produced a masterpiece of quite a different order from those he had made in Yosemite. Altogether more subtle, shimmering with raking light softened by mountain haze, the photograph is not about grandeur or geology so much as with the way humans settled on the face of the empty land, their little geometric shelters gleaming sharply against the exquisitely graded tones of the undulating hills beyond.

Similarly, Watkins's view of *Albion River, Mendocino Co., Cal.* (pl. 45) was part of a series documenting the lumber industry north of San Francisco, likely undertaken at the instigation of Jerome Ford of the Mendocino Lumber Company, purchaser of some fifty of Watkins's mammoth views of this region.[15] Sheltered from the Pacific in the bay formed by the mouth of the river, the Albion mill tidily fits its cove, as if nature had scooped out just the right amount of headland to cozily nestle this operation. Not only does the enterprise feel unobtrusive here, it is also laid out in its entirety, allowing us to explore its details. We could surmise that Watkins chose his vantage because it displayed the mill optimally and located it relative to sea and shore, handily indicating the shipping route and providing a pointer—a planked barn—which aligns the picture like the carat on a compass. But as surely as he considered these elements, Watkins also responded to an invitation, which he reissued for us, to know the world in miniature—a proposition as delightful as it is difficult to ignore.

The vision of industry comfortably enveloped in nature was an important aspect of Watkins's original relation to the world. Growing up in Oneonta, he lived amid the rolling hills of a beautiful river valley in a village just beginning to welcome modern communications and industry. His father, John Watkins, was a carpenter who helped construct many of the town's residences as well

as the Oneonta House, the hotel he inherited from William Angell and ran from 1842 on. Oneonta might have stayed a sleepy hamlet if Angell had not also built new turnpikes that made the town a transportation hub. Eight coaches arrived daily, bringing news from New York and filling the two hotels at Main and Chestnut; even at night their taverns were blazing with lights and crowded with travelers from the 2 and 4 A.M. stages. In addition to the two hostelries, the town had a church, tannery, carriage shop, woolen factory, and distillery, and, after Solon Huntington settled in Oneonta around 1840, also a first-rate hardware store. Carleton could climb to the rock ledges that jut out from the mountain behind the town and see the whole community laid out below, a toy village built by his father and his friends' fathers, related not just historically but organically to his daily life and set within the gentle geographics of the river and neighboring valleys that encompassed his existence.

That Watkins perceived the small outposts of industry and civilization on the West Coast as positive is not surprising, given the emptiness of the new territories and the needs of its settlers, but that he saw the relationship of the natural to the manmade as so smoothly harmonious probably owes to his childhood in Oneonta, where nature and town ran together seamlessly. When he and his friends had dragged a big wood sled to the top of the mountain on a moonlit night and coasted downhill for a mile, they finally came to a stop in the middle of the village; when he swam or fished for trout with his friend Collis Huntington, it was in the river that ran under the town bridge; and to go hunting, he simply crossed the pike and walked into the woods.[16]

Watkins's vision and career were deeply affected by his early formation and first impressions. The first child of eight, Carleton was much influenced by his father, a kind, genial man who ran the Oneonta House with remarkable energy and a persevering sense of duty. He and his wife, Julia, were of Scottish heritage and raised their children as Presbyterians. Scrubbed clean of theatrical ritual, the religion was clear in its liturgy and logical in its predication; it taught discipline, the importance of the life of the mind, and moral purpose, and, as a form of frontier civilization, it fostered educa-

tion, westward expansion, and strict civic order and decency. Therefore, although John Watkins ran a tavern, he never drank alcohol and was so generous and solicitous that he could scarcely make a profit from his business. Something of his craftsman's pride, abstemious self-denial, drive, generosity and poor head for business passed directly to Carleton, together with a marked penchant for clarity and order and a belief in the civilizing power of mankind.

Oneonta provided more than a model for understanding and interacting with the environment, it also launched young Carleton with friendly relations into the wider world. Around 1840 his father had traveled to Ohio to investigate the possibility of moving west, where it was commonly thought opportunity might have a freer hand. He evidently decided to remain in New York and made ends meet by selling off land he had inherited from Angell to Solon Huntington, and by lodging Solon's brother Collis for two years beginning in 1842, when Carleton was thirteen. On his own since age fourteen, nineteen-year-old Collis had already spent five years on the road as a wide-ranging itinerant hardware salesman—surely he seemed an experienced man of the world to the teenager he befriended. By 1848 John Watkins was indebted to the ambitious Huntington brothers, and it may have been to resolve that debt that his first son became attached to Collis, who had caught the gold fever.

"The California gold mania has broken out among us," the *Oneonta Weekly Journal* noted in January 1849. "Now many of our young men, ay and older men, too, have their heads full of [the mines], eager to be off. A company for emigration is forming in the county, and the notices are posted up on the village trees in every direction."[17] Collis Huntington, George Murray, and a handful of other young men departed Oneonta for California in March 1849. It is not clear whether Watkins went with them or accompanied Collis back to California in 1851 with Mrs. Huntington.[18] In either case, by 1851 Watkins was working for Huntington at his store in Sacramento, California, delivering hardware and mining supplies to a branch store nearer the mines, in Marysville.

Like San Francisco, the wide-open, rapidly growing frontier city downriver and across the bay, Sacramento was a rough town,

which made the liquor-free dormitory and library the Huntingtons provided for their clerks all the more welcome. When much of Sacramento was destroyed by fire in 1852, including the Huntingtons' new brick store, Watkins worked as a carpenter and bunked with George Murray, formerly the bookkeeper in the Oneonta store. As they rebuilt Sacramento, Murray asked Watkins to help him set up a book and stationery store, which Watkins did. However, by late 1853 Murray had given up on the reading public of Sacramento and moved the enterprise to the grand new Montgomery Block in San Francisco, taking Watkins with him. Nor did this venture last; by 1855 Murray was back in Sacramento working for Huntington. As for Watkins, a neighbor on Montgomery Street, Robert Vance, asked him to fill in for an absentee operator in his daguerreotype studio up in Marysville.[19]

Huntington, meanwhile, was becoming involved in local politics and establishing relationships with the Crocker brothers, Mark Hopkins, and Leland Stanford, which led to the creation of the Central Pacific Railroad. His bond with Watkins would survive his eventual prosperity. Upon learning that the railroad had fitted up a photography darkroom, Huntington closed it and funneled the business to Watkins, who copied maps and undertook commissions for views.[20] Until the end of his working days the photographer also received free transport of his horse and van on the railroad, as well as the transport and use of a specially outfitted railroad car. Eventually Huntington deeded his aging friend and protégé a ranch near the railroad's right-of-way for his retirement.[21]

Huntington was just one of the more prominent of the photographer's associates in the 1860s; well buttressed by hometown friends, Watkins was also abetted in his enterprise by close connections with the scientific establishment. It was not chance that the four-year-old Carleton had such clear recall of Squire Emmons; he was the first of the long line of learned personages who fed Watkins's hunger for knowledge about the world. In this lineage were Whitney and Brewer, whose correspondence reveals the web of support they wove around the photographer, their accommodation of his exigencies, encouragement of his art, and concern for his well-being. Treating Watkins with respect, generosity, and good humor, the eminent scientists were his untiring and devoted advocates.

In December 1866 Whitney wrote to Brewer, who had returned to Connecticut to teach at Yale, that the photographer was still "poor as a church mouse." Two months later he was concerned that matters had grown worse; "Watkins is as poor as Job's turkey of late. He told me that he had only received $2.50 in twenty days." In late February 1867 Ashburner told Whitney he thought Watkins was a completely "played out man." Brewer, moreover, had discovered "a scoundrel" in Philadelphia who was blithely copying and selling Watkins's early Yosemite views as his own.[22] Confronting economic necessity and affronted by the pirating of his personal accomplishments, Watkins finally listened to his friends' advice and made a concerted effort to establish a viable business.

Fitting up a gallery space in the Austin Building on Montgomery Street in the spring of 1867, he established a permanent address in the heart of the commercial district.[23] He also began to copyright his photographs and entered a suite of splendidly framed mammoth plates in the Paris International Exposition, eventually winning the coveted prize for his division. By hiring an assistant to take orders and run the business, he could get back into the field and now eagerly prepared to photograph the Columbia River in Oregon, a fabled region of spectacular scenery deemed second only to Yosemite on the West Coast.[24] Dead broke, Watkins could scarcely have shouldered the cost of his new operation alone; he must have had a silent partner. Whatever that angel's identity, it was Whitney who loaned Watkins the money for steamship passage to Portland, where he was met by his old friend George Murray.

Murray had been with the Oregon Steam Navigation Company, perhaps at Huntington's bidding, for five years.[25] Acting as secretary for the outfit, he made it possible for Watkins to photograph up and down the Columbia, smoothing his passage along the river, providing transportation and connections with helpful locals like John Stevenson, the first settler at Cape Horn, who served as Watkins's guide (pl. 69).[26] From Murray's point of view, photographs of the company's crucial rail portages would be crit-

ical; so, too, were documents of the river's rapids, which were the cause of the portages; and views of the river's scenic beauties would recommend the area to tourists. Altogether, a suite of these diverse sorts of pictures would offer concrete and alluring evidence of the company's key selling points.[27]

None of these subjects lay outside the scope of Watkins's interests. The resulting set of views—of Portland and Oregon City, of river industry, rail portages, shallow rapids, and breathtaking scenery threaded with rails—was a meaningful, organic package perfectly comprehensible in its parts and its unity to the photographer and his clients. It is evident from the pictures that Watkins enjoyed the three-month trip in a new terrain quite different from Yosemite, where he had worked the previous two summers. In later years he recalled that he was the first to photograph this territory, a telling and characteristically modest flicker of pride in creating so many exquisite, wholly unprecedented images (pls. 50, 72).

Cape Horn near Celilo (pl. 71) expresses the faith of not just Watkins, Huntington, and Murray but of a whole generation of Americans in the continuing westward advance of civilization. Yet it is more than an illustration of Manifest Destiny or of the local railroad's route. The artful balance Watkins achieved between the valley etched by the river and the railroad laid down alongside it recognizes the providential harmony of nature and man in this place. Celilo was the farthest reach of Watkins's river excursion. His last picture before turning back, this poised collocation of sky, river, and land suggests the artist's intuition that the distance covered balanced the distance still to go, and suggested how arrival merges with departure and achievement runs to horizons of further challenge.

We do not know what Watkins thought of such triumphs or, for that matter, what he thought of his more routine pictures, for he did not discuss his work in any form that has survived. From his letters, it is evident that he was not as comfortable expressing himself verbally as he was behind the camera or in the darkroom. His taste in literature leaned to the popular and the sentimental: favorites were Bret Harte's humorous sketches of local western color and Romantic poetry by the likes of Thomas Moore and Henry Wadsworth Longfellow. These were not authors to help him articulate what he was doing.

The closest Watkins came to accounting for his exceptional talent was to discount everything personal he brought to his art. He understood, and explained in the most disarming way, that the only things that could be taught were simple skills. In 1873 when John Hillers, a photographer hired by the U.S. Geological Surveys, came to him for advice on photographing in the field under difficult conditions, Watkins received him "very kindly." He looked over his photographs and said, "I have little advice to offer. You are a clean worker in which lies the great secret of photography."[28]

Certainly Watkins had learned from experience that the unforeseen impediment to achieving a successful image in the field was the grit that dusted the lens and pitted the tacky surface of his plates. Working with the daguerreotype had refined his sensitivity to delicate tonal and textural contrasts and to the signal importance of the angle and quality of light in the construction of spatial clarity. Transferring this vision to wet plates, he had become adept at recording and virtually triangulating landscapes for judicial review. Extending his scale to the mammoth plate, which required even more dexterous handling, Watkins proceeded with the scrupulous and deliberate manner of a master artisan. Employing several plates or several cameras, he challenged himself still further. He had created a graduated ladder of difficulty for himself, and, like many autodidacts, he could not see the difficulties he had overcome, just as he took for granted his broad shoulders, large hands, and resilient constitution.

Beyond these advantages, Watkins brought to his art great patience. He knew that nature's pace could not be forced, and that he might encourage greater success if he woke early and stayed long. He also brought measure, a balance of inbred reserve and generosity. Faced with minimal interest, he dispensed serious consideration, and before the grandiose he detected simpler truths. Treating nothing with disrespect and exaggerating nothing, Watkins created an art of modulation, the first in American photography.

Many precepts of Presbyterianism and Manifest Destiny that Watkins had absorbed in youth undergirded his mature art.

Like these religions, he himself was a force of civilization, carving clarity and rational order out of the chaos of the world: his photographs show that he loved the steamer tethered at the river's edge, the mill, the mine, and the rails cutting into the wilderness. This carpenter's son relished a universe with mitered edges and snug, dovetailed corners; he found deep satisfaction in running fences and in simple, wooden buildings in good light. When he could collect some of these things and compose them into a coherent and orderly picture, he had effectively become the carpenter-creator of his own perfect universe (pl. 61). As he became more experienced in this abstract, geometric art, he could apply his reductive, constructive vision to more inchoate subjects.[29] On his best days he could distill quicksilver from falling water and hew diamonds from the rough (pls. 66 and 68).

In the service of this demanding vision, Watkins instinctively avoided wind, mist, and fog, which dissolved the clarity he needed to describe things with acuity and in the specific terms of their local color. To help isolate distinctions and heighten singularity, he also avoided flat light, preferring raking angles or dappled effects that picked out edges, drew planes taut, and emphasized certain details while neatly swallowing others. Equipped with such expressive aids, he created his remarkable orders of things.

In landscape, as in human life, meaning lies less in objects than in relations, the links that tie specific incidents and entities together as an event or a place. In grasping myriad related connections and recording them photographically, Watkins created an intelligible world that maps and illustrates mental activity, mimicking the skeins of meaning our perceptions generate. His photographs awaken us to the exquisite pleasure of active seeing, inducing that conscious visual alertness we experience when viewing landscapes by Cézanne, for example. Only here the artist's mental calculations are not laid down in painted strokes, they merge diaphanously with the trees and dissolve on the surface of the objective world. Looking at the photograph, we think we see the true structure of nature, its orderly scaffolding and superb textures merely disclosed; it takes real, imaginative effort to recognize that no things in the picture nor the relations between them were self-evident. Everything—the slant of a shadow on fresh clapboards, the depth of the darkness in cracks in pine bark, the silkiness of the slightly shimmering water—is the delicate trace of the artist's considered attention. Surely it was not modesty that made Watkins avoid the portraitist's lens, but a natural artist's tacit understanding that his true identity was everywhere imprinted in his greatest pictures.

NOTES

1. Willard V. Huntington, nephew of Collis P. Huntington, intended to write a five-volume history of his hometown, Oneonta. The twelve volumes of his typescript notes, titled "In Old Oneonta," now reside in the Huntington Memorial Library in Oneonta, New York; this information was kindly provided by Fran Green. The citation is from p. 2188. Courtesy Peter Palmquist, Arcata, California.

2. Ibid., p. 2002.

3. The photographs were praised in "Ho! For the Yo-Semite Valley," *San Francisco Daily Times*, 15 September 1859. Hutchings's extended four-part article, "The Great Yo-Semite Valley," appeared serially in *Hutchings' Illustrated California Magazine* in October, November, and December 1859 and March 1860.

4. Thomas Starr King, "A Vacation among the Sierras, No. 8" (January 1861), as reprinted in *A Vacation among the Sierras; Yosemite in 1860*, ed. John A. Hussey (San Francisco: The Book Club of California, 1962), pp. 60–61.

5. In the early 1860s Watkins used a lens, perhaps the Grubb-C, that did not sufficiently cover his mammoth plates and bent the objects at the edges of the pictures toward the center. Probably to minimize the defects at the top of the images and to accommodate the pictorial conventions of the day, he trimmed the tops of the prints to an arch shape, called in photographic circles a "dome-top."

6. Oliver Wendell Holmes, "The Doings of the Sunbeam," *Atlantic Monthly* 12 (July 1863), pp. 7–8. See also Nanette Sexton, "Carleton E. Watkins: Pioneer California Photographer (1829–1916): A Study in the Evolution of Photographic Style during the First Decade of Wet Plate Photography," Ph. D. diss., Harvard University, 1982, pp. 182–83.

7. As reported in the *North Pacific Review*, vol. 1, no. 5 (February 1863), p. 208. Courtesy Peter Palmquist.

8. An exchange of letters between T. G. Camp and Frederick Billings in the summer of 1864, including Agassiz's letter to Billings of 1 August 1864, is in the Billings Mansion Archives, Woodstock, Vermont. Courtesy Peter Palmquist.

9. Camp to Billings, 1 August 1864.

10. Harriet Errington to her sister Charlotte Field, 10 August 1865, in the Olmsted Papers, Washington D.C., as cited in Sexton, p. 216.

11. Whitney to Brewer, 15 December 1865, as cited in Sexton, p. 258.

12. *Constitution of the San Francisco Photographic Artists' Association*, as reported in Peter E. Palmquist, *Carleton E. Watkins: Photographer of the American West* (Albuquerque: University of New Mexico Press, 1983), p. 31.

13. "Watkins has been poor as poverty all winter. In the first three months after he returned from the Yosemite he did not get two hundred dollars in orders." Whitney to Brewer, 19 March 1866, as cited in Sexton, p. 265.

14. Day was the son of the president of Yale University. The connection was recounted by Brewer in *Up and Down California in 1860–1864: The Journal of William H. Brewer* (Berkeley: University of California Press, 1966), p. 159. See Sexton, p. 200.

15. On Ford, see Sexton, pp. 206–7.

16. The incidents are recounted in "In Old Oneonta," pp. 2203, 2221, 2278.

17. "In Old Oneonta," evidently citing the newspaper for 10 January 1849. Ibid., p. 2278. Also cited on a different page in Parts 1 and 2 of Peter E. Palmquist's serialized biography of Watkins in *The Photographic Historian*, vol. 8, no. 4 (winter 1987–88), n. 44.

18. After considerable research consulting the lists of all passengers arriving by boat in San Francisco in 1849–51 and a review of all the Huntington family's correspondence, which mentions the men from Oneonta with some frequency, Sexton could not pin down the date of Watkins's migration to California. She gives no evidence for her claim that Watkins was in New York with the Huntingtons in 1851, and without further discussion concludes that Watkins went to California in 1851. See Sexton, pp. 39–41. Palmquist has accepted the 1851 date while noting that it is not supported. Earlier accounts gave the date as 1849.

19. Although Watkins's first biographer, Charles Turrill, recounted the story that Watkins filled in for an operator in Vance's establishment in San Jose, Palmquist has shown that the more likely site was Marysville, and that Watkins worked in San Jose later. An admirable accounting of the details of Watkins's life through 1858, based on much original research, is available in Palmquist's biography of Watkins, published in parts in *The Photographic Historian*, pp. 7–26 (see n. 17 above), and in *The Daguerrian Annual* (1990), pp. 167–86, and (1991), pp. 225–46.

20. Huntington was evidently elegant in his manner of helping Watkins. Of the shutting of the railroad's darkroom, Turrill reported, "Even his friend Watkins did not know of the circumstance until some years later." Charles B. Turrill, "An Early California Photographer: C. E. Watkins," *News Notes of California Libraries*, vol. 13, no. 1 (1918), p. 34.

21. Characteristically Watkins did not retire, despite failing eyesight, but kept working until the 1906 earthquake destroyed his negatives and forced him to leave San Francisco.

22. Whitney to Brewer, 18 December 1866; Whitney to Brewer, 8 and 26 February 1867, all as cited in Sexton, pp. 307–9.

23. Watkins moved to several different addresses in later years, as is detailed in the chronology, but from this point on he at least could be found by the public.

24. Sexton recounts that Samuel Bowles, editor of the *Springfield Republican*, who met Watkins in 1865 in Yosemite and used his photographs to illustrate his book *Across the Continent* (1866), ranked the Columbia River scenery second to Yosemite. See Sexton, pp. 315–16.

25. Sexton, p. 317. For undisclosed reasons, Sexton believed that Huntington may have been behind Murray's move to the Oregon Steam Navigation Company, possibly because he wanted to include this line in his growing conglomerate, the Central Pacific Railroad.

26. See David Featherstone, "Carleton E. Watkins: The Columbia River and Oregon Expedition," in James Alinder, ed., *Carleton E. Watkins: Photographer of the Columbia River and Oregon* (Carmel, Calif.: The Friends of Photography in association with the Weston Gallery, 1979), p. 16.

27. In fact, when the company was sold in 1872, Jay Cooke, representing the interests of the purchaser, the Northern Pacific Railroad, was given a set of Watkins's Columbia River views. See Featherstone, ibid., p. 20.

28. John K. Hillers to J. W. Powell, December 1873, National Archives. Courtesy Joni Kinsey, Kate Nearpass, and Peter Palmquist.

29. As Douglas Nickel makes clear in his essay, Watkins addressed the chaos of nature with his stereo camera from 1861 on as one gambit in his play with that format's spatial demands. It may have been in part through the stereo experience that he later addressed greater chaos with the mammoth plates.

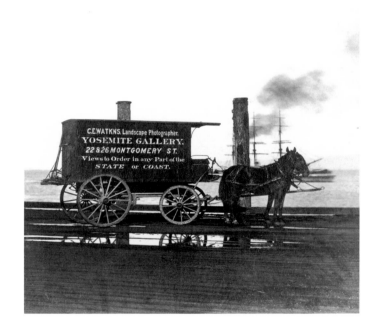

An Art of Perception

DOUGLAS R. NICKEL

At 5:12 A.M. on the morning of 18 April 1906, Carleton Watkins was jolted out of his sleep by the most violent earthquake ever to strike the city of San Francisco. Around him on the floor of his downtown studio lodgings, the near-blind photographer discovered his life's work in ruins: mounted prints, albums, equipment, business records, thousands of glass-plate negatives—the products of a half-century's labor afield—lay strewn in dark and broken confusion at his feet, as the bell on City Hall announced the first of those fires that would burn the metropolis for days and take with them any lingering vestiges of Watkins's achievement. Ironically, just the weekend before, a curator from Stanford University had visited the old man and made arrangements to cart away the most valuable part of the collection for safekeeping.[1] Now there was nothing left to remove. As he was led away from the wreckage, limping and dazed, Watkins perhaps marveled at this crowning tragedy of his career. Once the owner of the most prestigious photographic gallery on the West Coast, whose public had included American presidents and European royalty, Watkins combined poor business sense with a talent for bad luck that together compelled him to forfeit the negatives that had made his fame, resulting in a chronic, grinding poverty that,

by 1895, left his family living in a railroad boxcar. If three days earlier the photographer had felt any consolation that some legacy of his might be preserved, surely now he had the uncanny sensation of being, in a matter of moments, erased from history.

Watkins's loss is ours as well. Except for one pocket notebook, a handful of family letters, and a few stray artifacts, the only records the artist left of his intentions and outlook are his pictures—the finest landscape photographs produced by an American in the nineteenth century, and some of the most sophisticated and arresting images ever produced with a camera. But images are mute, at best a slippery kind of evidence. In the absence of period criticism, manifestos, correspondence with peers and patrons, or interviews—in other words, deprived of an art-historical armature upon which his work might have been hung—Watkins's pictures have garnered respect but eluded analysis, languishing until recently on the sidelines of photographic history. The standard English-language histories of the medium neglected mention of the photographer altogether.[2] When scholarly interest in the artist did first arise in the 1960s and 1970s, Watkins was conflated with western exploration photographers such as Timothy O'Sullivan and William Henry Jackson, or was seen as the photo-

grapher of Yosemite, to the exclusion of any other subject.[3] More recent appraisals of Watkins have restored the broader range of his activities and the professional aspect of his photographic enterprise,[4] but a fundamental question persists: how did this obscure individual, trained only as a store clerk and operating on the outermost edge of the country, come to devise such profoundly original and advanced images? How, as John Coplans once put it, did this "strange genius flame out of nowhere"?[5]

For here is the essence of the problem: Carleton Watkins made photographs that are more modern in appearance than our understanding of art history ought to allow. Their alternation between, at times, an elaborate manipulation of abstracted space, compositional torque, and acute detail and, at others, an almost naive and totemic directness suggests the kind of formal gamesmanship we might expect of a perceptive artist working after the advent of Cubism, but not of a struggling tradesman in San Francisco in the 1860s. In Watkins's photographs we find skies hanging as featureless voids behind cutout cliffs, or peaches crated into abstract grids; whole landscapes may be rendered inverted on the surface of a stream. Nothing in the photographer's life would seem to have qualified him to make such pictures, so that, no matter how insightful and well informed, explanations relying on biography at some point encounter a kind of categorical limit, beyond which lies only speculation. A more indirect approach is evidently needed, one that can deal with the prescient visual qualities of Watkins's photographs while still maintaining their embeddedness in history.

To do this, it may first be useful to specify the kinds of claims that will not be made on behalf of the subject. Watkins—it must be insisted, axiomatically even—was not "ahead of his time." In historical writing this concept usually signals a deficient understanding of "the time" rather than the discovery of a true avatar; indeed, such a formulation only displaces the problem. Watkins worked for over fifty years anticipating the needs of clients; he sold tens of thousands of photographic prints and albums to scientists, tycoons, mining engineers, lawyers, investors, visiting dignitaries, local boosters, claim jumpers, the government, irrigation farmers, home owners, and tourists, and by all accounts secured universal high praise for his results in this enterprise. Over time his photographs were increasingly destined for the open market, to which their maker looked for his livelihood. So while in theory it might be possible to imagine a visionary naïf materializing sui generis in the western provinces during the second half of the nineteenth century, conducting daring protomodern experiments with a wet-plate camera, we would still have to account for how these works appealed to the practical sensibilities of the geographers, congressmen, loggers, and dairy farmers who were most likely to commission or purchase them. In other words, it is not just the prodigy Watkins who needs explaining, but also a historical record that nowhere registers anything particularly eccentric about his work, and a broadly mainstream audience that either failed to notice his formal extravagance entirely, or could accept radical photographic departures from pictorial tradition more readily than we have heretofore had reason to imagine.

Nor will we make much progress hypothesizing about what kinds of coincident intellectual or artistic movements came to inform Watkins's vision. Although he knew and sometimes worked side by side with many of the great landscape painters of the West—Albert Bierstadt, William Keith, and Thomas Hill, for example—it is also fairly obvious that the inspiration flowed the other way, with the painters subsuming parts of Watkins's unorthodox visual schemes into their own more picturesque formulas (fig. 1).[6] There is little reason to suspect that the photographer had any meaningful contact with the second-generation Hudson River School masters or other East Coast artists. To characterize Watkins as some kind of Luminist-once-removed reveals little about the photographs nor does it provide an adequate model of how a sensibility arises in two disparate places at the same moment.[7] Equally inexpedient is the notion that the photographer's muse was Nature herself, that the pantheistic discovery of God's divine order in Nature motivated their conception.[8] As recent historians have noted, Watkins's subject as a whole was never really "nature" so much as it was "natural resources and their development."[9] Even in the Edenic Yosemite photographs, he made little effort over the years to avoid increasing signs of human presence in the valley.

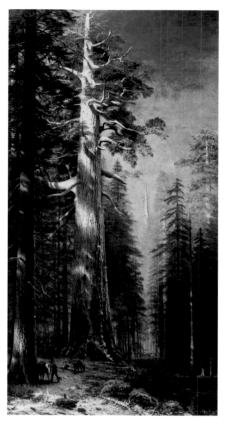

Figure 1. Albert Bierstadt (after Carleton Watkins). *The Great Trees, Mariposa Grove, California,* 1864. Private collection

Competition with other California photographers, indeed with his own earlier work, certainly provided an impetus to innovate, but this factor scarcely compelled the specific innovations that he authored. It might further be noted that Watkins was under the thrall of no one geological theory, no established iconographic tradition, no particular philosophy or aesthetic program, and no identifiable photographic precedents from abroad.

It is clear, however, that Watkins had a propensity for making pictures that were immediate, lush in detail, visually coherent, and psychologically compelling. These photographs function like mobile windows onto the world, where the viewer's presence in the scene is purchased with the photographer's corresponding absence. Victorian observers usually reacted to Watkins's images as if confronted with the actual landscape: "Each pebble on the shore of the little lake. . .may be as easily counted as on the shore in nature itself. . . .We get a nearer view of the mountains, only to make their perpendicular sides look more fearful and impossible of ascent."[10] Pictorial transparency—the impression of *being* there at that very moment—is a trope often encountered in nineteenth-century photographic criticism, but Watkins elevated the sensation of visual contingency to a new level; he cultivated an art of perception that presented photography's mechanical reproductions of reality as analogous to direct visual encounter. Looking at a Watkins photograph was thus meant to be not so much an intel-lectual as an experiential affair. This fascination with appearances only nominally involves illusionism however. It would be more accurate to say that the photographs, in their various forms, amplify and manipulate the picture experience in order to more effectively naturalize a selective, abstract investigation of the visible world.

Watkins's laconically stated creative program—to find "the spot which would give the best view"[11]—became a lifelong project, carried out in different ways and modulated across various formats over his career, reformulated as conditions and subject demanded, and ultimately expressing a visual ideology shared with his sponsors and clientele. For, it goes without saying, this ocular enterprise implies a beholder, one culturally equipped to appreciate (and pay for) the perceptual pleasures on offer, whose habits of viewing needed to have resonated conspicuously with Watkins's own habits of photographic seeing. Both the photographer and his audience were products of, and responding to, new modes of visuality emerging in the nineteenth century, brought about in part through modern innovations in the realms of entertainment, communications, and travel. Therefore, we must revise not only our view of Watkins but also of the modernism his work so prophetically, and so problematically, intersects.

The story of modernism in the visual arts goes something like this. In the early Renaissance and for several centuries after, the making of art was more or less keyed to a set of referential, naturalistic codes whose cornerstone was linear perspective, a mathematical system for plotting three-dimensional space onto a two-dimensional surface. But starting with Manet and the Impressionists in the 1870s and 1880s, a new, more analytic kind of art appeared, as painters grew more and more intrigued with the phenomenological nature of their craft and began to grasp the expressive potential of color and perspective for nonmimetic ends. With Cézanne and finally the Cubists of the early twentieth century, a radical break with the Renaissance model was effected; perspectival space was overthrown, the aesthetic autonomy of the art object was announced, and the path cleared for painting's apotheosis as the self-critical, nonrepresentational arena for formal

experimentation. Shadowing this trajectory, meanwhile, was the development of "realist" vehicles such as photography and the cinema, which through their optical circumstances were found, interestingly enough, to confirm and maintain Renaissance perspectivalism. These lens-based media increasingly took on the popular, figurative duties previously arrogated to painting, setting the latter free of its realist strictures to innovate within the pure and exclusive realm we now identify as the avant-garde.

This linear narrative, Jonathan Crary argues in his book *Techniques of the Observer: On Vision and Modernity in the Nineteenth Century*, frames modernist art as a constitutive progression of nineteenth-century names and movements marching ineluctably toward the artistic watershed of Cubism. But when compared with the modes of visuality that actually have become most pervasive in twentieth-century culture—photographic reproduction, film, and television—the vaunted modernist "revolution" seems a bit overplayed, and its Cubist climax a somewhat marginal event. Crary proposes another way of conceptualizing the history of modernism; he insists that we understand both avant-garde art and nineteenth-century photography as "overlapping components of a single social surface on which the modernization of vision" was everywhere taking place.[12] That is to say, the development of both modernist painting and photography can be seen as parallel symptoms of a larger, more fundamental transformation occurring within Western culture, one already well under way by the middle of the nineteenth century. In this view, the parade of canvases with which modern art has traditionally been represented can more properly be taken as a refined, albeit belated manifestation of something else mutating beneath it throughout the modern period. That something else is the evolving subjective experience of a new kind of spectator, brought about by a complex of social and technological conditions organized around new ways of thinking and discussing the visual. Watkins's more challenging photographs might be regarded as symptomatic of this same fascination with perception and addressing the same new kind of viewer.[13]

When he arrived in California around 1851, Watkins, like most easterners, was overwhelmed by the extraordinary immensity

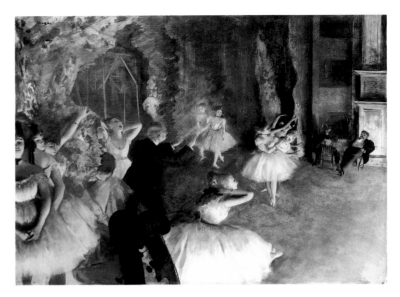

Figure 2. Hilaire-Germain-Edgar Degas. *The Rehearsal of the Ballet Onstage*, 1876. Collection of The Metropolitan Museum of Art, H. O. Havemeyer Collection, Gift of Horace Havemeyer, 1929

of the landscape that confronted him. When he began his photographic career a few years later, he took as his basic artistic challenge the rendering of western spaces, and the scale of western things, for an audience predominantly located back east and in Europe. Self-trained but keenly aware of his public, the photographer went about forging what later modernist criticism might describe as "photographic" solutions to this problem—what Watkins more likely would have understood as the judicious selection of the best spot and instrument to convey the "feel" of his subject. If, in pursuit of viable solutions to the problem, he arrived at compositional means familiar to us from modernist painting—if, for instance, the tree stumps jutting insistently into the lower edges of Watkins's Columbia River pictures remind us of the cello heads that interrupt Degas's ballet scenes of the 1870s (figs. 2 and 3)—it is not a question of Watkins's innate modernism or Degas's love of the photographic, but rather that each of them was responding to an independent need for formal devices that engendered an effect of apparent visual immediacy.[14]

By the same token, and out of the same need, Watkins invented solutions that were at the time unparalleled in the traditional plastic arts; his quest for cogent vehicles of perception led him to contrive means that, while they may bear an indirect family

Figure 3. Carleton Watkins. *Mt. Hood from near Government Island*, 1867. Collection of Stanford University Libraries (cat. no. 73)

relationship to Impressionism's *effets* and *coups d'oeil*, Cubism's spatial deformations, Constructivism's new vision, and so on, are, in fact (and like them), the products of a historical genealogy that goes much deeper than superficial similarities in appearance indicate.[15] Indeed, what remains particularly intriguing about Watkins's project—in contradistinction to the accepted modernist lineage—is that it was not partisan, not conducted on behalf of the avant-garde's minority of an audience, not subversive or even what we would call personal, but instead was demotic, altogether professional, and, in the broadest sense, market-driven. His activity as an artist is inseparable from the conditions of reception that governed it. These determining factors were not simply of the business sort (which he was capable enough of disregarding on occasion), but more broadly include a background awareness of an increasingly modern public whose tastes and predilections could sanction the existence of this new kind of photography.

To even call Watkins an artist requires some qualification. Photography's discovery occurred less than twenty years prior to his taking it up—an interval marked by no small confusion over how to define the medium's essential nature and its relationship to established traditions of picture-making. If, in the 1840s, the gentlemen-amateurs who dominated the conversation about photo-

graphic aesthetics looked chiefly to extant European pictorial conventions for guidance, by the late 1850s a substantively different consensus had taken form. Photography was now held to be unique in its mechanical genesis, distinctive in its precision and truthfulness, and eminently technological, and thus available for industrialization.[16] Professional photographic practice quickly became organized around these terms; by 1860 the average topographic "view" had a glossy, machined finish, was produced in great numbers, and was "published," meaning it was issued as an illustration in a book, as part of a portfolio or album, or as a stereo card, to be filed in a drawer or the parlor basket. The typical photographic "view" is quite unlike a painted landscape, Rosalind Krauss has argued, because the internal structure of the landscape painting presupposes its eventual disposition on a wall, in a "space of exhibition."[17] The "view," conversely, presupposes the more private experience of page-turning or card-sorting: its anonymity and its dependence on other similarly unauthored views within the logic of the larger topographical system of the printed report, album, or archive file militate against the notion that its maker be considered a self-expressive "artist" in our modern sense of the word.

Here the career of Watkins looms as something of a challenge. On the one hand, he was certainly of his generation in embracing the deliberately photographic vocabulary of factuality, sublimated authorship, and high finish characteristic of the period, and he clearly produced many images for practical, illustrative applications. Undeniably his milieu would become that of commercial production: by the late 1860s Watkins was a publisher, issuing and copyrighting countless works over his long career, including those from negatives purchased from other photographers, and after his studio's bankruptcy in the mid-1870s, he beheld most of his own forfeited negatives published under the name of a rival.[18] His organization of photographic stock—the numbering of his 6500-odd stereo photographs, for instance—follows a standard geographical coding employed by any number of photographic publishers.[19] In many respects, then, it would be accurate to locate the preponderance of Watkins's output within the general taxonomy of the photographic "view," whose proper

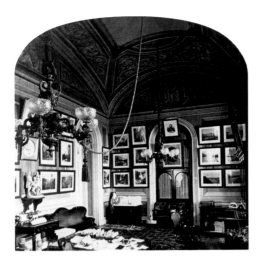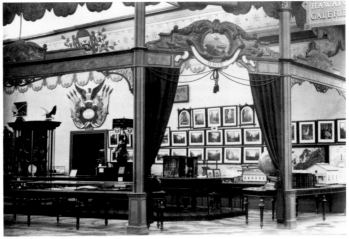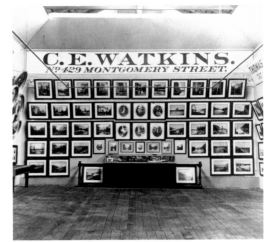

Figure 4. E. & H. T. Anthony & Co. *General French's Room—Senate*, ca. 1867. Courtesy Amon Carter Museum, Fort Worth, Texas.
Figure 5. Gallery View of Watkins's Photographs Display, Paris Universal Exposition, 1867. Collection of The J. Paul Getty Museum, Los Angeles.
Figure 6. Watkins's booth at the San Francisco Mechanics' Institute Industrial Exhibition, ca. 1868–69. Collection of The Bancroft Library, University of California, Berkeley

setting is the library or drawing room, and whose origins in the commodity culture of Victorian publishing align it with any number of similar mechanically repeated, mass-circulated consumer items.

On the other hand, there is abundant evidence that Watkins did not regard his activity in any such exclusive terms, but, in fact, also envisioned himself functioning as a kind of artist, in many ways not unlike a traditional landscape painter. The mammoth-plate print he pioneered in the early 1860s, and to which he remained committed throughout his career, may have first sprung from the need to deliver more convincing testimony in court, or to outdo his competitor Charles L. Weed,[20] but its centrality in Watkins's oeuvre derives from its unique presentational qualities, as these large photographs were shown to best effect on a wall. Watkins encouraged this idea by advertising landscapes suitable "for Framing and Stereoscopes" and by exhibiting them precisely this way: framed, on a wall. A number of photographs of interiors survive showing Watkins's pictures hanging salon-style in various public spaces—in the Senate chambers in Washington, D.C., the 1867 Paris International Exposition, the annual San Francisco Mechanics' Institute trade fairs, and Kern County agricultural exhibits—matted, in Eastlake or heavy walnut frames (figs. 4–7), and mounted by series. This evidently was not just a way to display works for purchase. Watkins's 1864 pocket ledger indicates that from early on his mammoth prints were sold to order in frames, and

his specifications for the 1867 display at the Paris International Exposition even included frames made of redwood for images of the Big Trees.[21] Our present acceptance of photography as an art form may render such framing procedures unremarkable, but documented instances of large photographs functioning in the nineteenth century as art for the wall are relatively rare. This suggests a conception of the medium that adjudges it a new, artistic third term—neither painting nor traditional private "view"—and its maker, by extension, a new kind of artist.

That Watkins intended his mammoth-plate photographs to be seen on the wall is significant. Though their creation involved great difficulty, no better means were available to achieve his scenographic mappings of rendered scale. Watkins constructed his large images formally to orchestrate a profusion of detail into orderly arrangements, often favoring diagonal massings of light and dark, and typically setting up near-far juxtapositions of landscape elements that suggest spatial penetration. He deployed a host of compositional innovations to signify planarity and depth—silhouetted screening trees and fences (pls. 10, 29, 38, and 62), foreground landforms (pls. 39, 51, 66, and 69), the plunging orthogonal of roads, fences, and railbeds (pls. 15, 18, 45, and 71)—but the interplay suggested by these elements never fully escapes the condition of two-dimensional design. This is most evident when Watkins centralizes his subject in the frame: his dignified strawberry

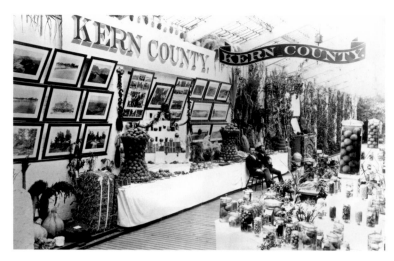

Figure 7. Carleton Watkins. *Kern County Exhibit. Twenty-Fourth Industrial Fair of the Mechanics' Institute*, 1889. Collection of The Huntington Library, Art Collections, and Botanical Gardens

tree (pl. 90), for example, sits amid a field of wooden stakes leading the eye back to its distant visual echo, but this recession ultimately loses out to an overall effect of schematic flatness, comparable (as John Szarkowski once noted) to that of a Japanese flag.[22] On the wall, such prints compel a physical relationship with the viewer that activates the space in which he or she resides, as the spectator first stands back the distance mandated by the large scale of the picture to acquire its general design, then collapses that distance, and with it the design, by moving in to examine its superabundance of detail. Watkins's detail often verges on the hallucinatory. Up close, the textures of granite, mining dirt, leaves, wood sidings, water, and assorted debris invite sustained, even obsessive, examination; we discover inconspicuous animals, small figures, incidental still lifes, and other pictorial minutiae, as graphic order dissolves into an energetic hopscotch activity of the eye. The picture unfolds with time and across the viewer's space. It is fully comprehended only through effort, as a writer indicated in the December 1866 issue of *Philadelphia Photographer*:

The tree [pl. 19] was manifestly a very fine one, but we felt disappointed in regard to the apparent size. . .a giant perhaps but not a very great one—tall, but not particularly gigantic. On looking more attentively and minutely at the photograph, we discovered a group of men at the base of the tree! They were so small that at first, they had escaped notice, but being once seen their effect upon the picture was magical. The tree rose and rose as we followed up its trunk. . .and towered aloft in majestic proportions, till at last the eye. . .took in the most stupendous growth, and we felt that we looked indeed upon a grizzly giant.[23]

By design, the capaciousness and hyperclarity of Watkins's large photographs beckon such attention, drawing the spectator into involvement with their delicate tapestries of optical amplification.

Watkins's preoccupation with size and scale emerged from both his situation and disposition. The titles he gave to his Yosemite subjects regularly include some statistic: the diameter of a trunk, the length of a waterfall, the elevation of a mountain peak. The former clerk was enamored of statistics, taking note in his personal papers of such things as the height of Niagara or the distance to the Pleiades, but their inclusion alongside his photographs conscripts the images as something like visual verification.[24] To observers outside California, reports of outsized western things seemed preposterous; the immensity of its mountains, trees, deserts, and ocean, as well as its mineral and agricultural wealth, was simply beyond belief, and it became a convention in California literature to report the fantastic proportions, and potential utility, of any newly discovered feature.[25] From the start, Watkins put his photographs in the service of the idea of measurement. His earliest mining images, used to settle land-claim disputes, had to convincingly demonstrate the distances between particular topographic features. A letter he sent to the *Philadelphia Photographer* to introduce his new Yosemite prints attests that "the horizon line in the picture of Mt. Starr King is from eight to ten miles distant, and the Bridal Veil is perhaps three-fourths of a mile.[26]

The notion of ratio entailed not only the land but also products of the land. Watkins's image of a colossal gold nugget (fig. 8), for example, or a 2200-pound "Mammoth Cheese," appropriates the rhetoric of contemporaneous local magazines, which published articles titled "A Large Pear" (two pounds twelve ounces) or "A California Grape," accompanied by substantiating woodcuts.[27] California agriculture matched or surpassed that of any other part of the globe, such reports contended, and both pride and economics

Figure 8. Carleton Watkins. *Nugget of Gold 201⁴³/₁₀₀ oz., Spanish Dry Digging, El Dorado County, California*, ca. 1876. Collection of The Bancroft Library, University of California, Berkeley

dictated its public assertion. Watkins's tour de force of still-life photography, *Late George Cling Peaches* (pl. 93), advertises the same latent capacity of the region: the testimonial affixed to its mount describes the fruit farm outside Bakersfield belonging to a Mr. Wibble, who planted his trees but eighteen months before this impressive crop was taken. Watkins also made views of Wibble's orchard and others nearby, showing "the size and thriftiness" of the trees (pl. 92) and including an affidavit from the president and secretary of the Kern County Board of Trade attesting to the truth of Wibble's claims.[28] The mammoth plate was itself a California feat. It gave Watkins not only means to provide the best visual explanation of his subject's physical character but also had an impressive object quality of its own that commanded wonder and respect.

The desire for means to accommodate his expansive imagery led Watkins, not surprisingly, to the panorama format. The panorama was an invention peculiar to the nineteenth century. It originally arose as a form of popular entertainment in which spectators sat at the hub of a specially designed circular building, surrounded by a continuous three hundred sixty-degree painting depicting a famous battlefield, palace, or city center. In the 1820s and 1830s myriad variants were conceived—the Cosmorama, Cyclorama, Diaphanorama, Diorama, and Géorama were just a

few—as an array of multimedia components were added to the basic formula to allow day-and-night effects, moving scenery, and other forms of illusionistic stagecraft.[29] Photographic panoramas seized upon the essential formal attribute of their painted counterparts: a radical elaboration of the horizon line and the consequent impression of an expanded field of vision organized along it. By mimicking the visual thrust of the horizon, the panorama altered normal perspective to produce an image impossible to take in at a single glance; vision had to be mobilized laterally (as in nature, by turning the head), and the view apprehended synthetically, part by part. When combined with the already eidetic talents of the camera, photographic panoramas quickly established themselves as perceptual novelties of the highest order. They were to ordinary photographs what CinemaScope and Panavision were to television screens during the 1950s.

In the Victorian period, photographic panoramas were expensive, difficult to make, and even harder to sell.[30] Most photographers who made panoramic views in the nineteenth century fashioned them as promotional or demonstration pieces, but Watkins, in selecting this format, bent it to the more conceptual task of characterizing the experience of western landscape. As early as 1858, he was piecing together separate large-plate images to broaden the scope of his forensic illustrations, and by the spring of 1864 had generated the first of several continuous panoramas showing San Francisco from Nob Hill.[31] These involved as many as five mammoth-plate negatives, meticulously contrived to overlap and form an eight-foot-long, one hundred eighty-degree vista. Watkins's three-part panoramas of Portland, Oregon (pls. 52–54), and Salt Lake City (pls. 80–82), from 1867 and 1873 respectively, retain the ideological overtones of the San Francisco productions: they provide unobstructed views of important western cities under development, spreading out in conformity to the emphatic pull of the horizon. The very word implied opportunity, the promise of fresh starts and unlimited possibilities, an idea figured here as sweeping visual access to everything beneath the heavens.[32] By avoiding compositional framing devices, Watkins organized the works from the center outward, staging these young cities as mere

density, with a logical imputation of radial expansion beyond the pictures' edges. The recently cleared woods in the foreground of the Portland panorama, in fact, bring the inexorable force of development right to the viewer's feet.

A unique feature of Watkins's panoramas is their modular construction. Though some adhere to the convention of an unbroken, panoptic vista comprising overlapping parts, others were assembled from mammoth-plate prints that could fit together and also function effectively as freestanding images. Watkins's installation views occasionally show this semicontinuous type of panorama on display, the seams between individual plates clearly visible. When taken apart, the components worked so well as separate photographs that in many cases their status as panoramic elements escaped notice for a hundred years.[33] The obvious advantage of this system lay in generating impressive exhibition pieces while adding more and more salable single pictures to stock.

Watkins's panoramas were also unusual in that his subjects included mining tracts and areas of incipient industrial development (pls. 55–56 and 63–65), as well as the pure landscape of Yosemite (pls. 30–32).[34] Technically, the lack of regular streets and architecture in these subjects facilitated their visual integration into panoramas, as it is rectilinear elements falling along the pictures' edges that most betray the distortions inherent in making perspectivally self-sufficient images coincide. Such two- or three-part images were part of an approach that might loosely be described as "cinematic": in Yosemite, on the Columbia River, in the mountains or on the coast, Watkins habitually blanketed his subjects with visual coverage, maneuvering his camera (miles, in some cases) to glean establishing shots and details (pls. 83 and 84), reverse-angle shots (pls. 61 and 70), pans (pls. 87 and 88), and so on—a kind of optical mapping, compensation for geographical remoteness and insurance against broken negatives.[35] Within this practice, Watkins would sometimes compose a panorama, or sometimes a near-panorama, where images from proximate camera positions relate but do not exactly align. This comprehensive method was tacitly predicated upon a mobile, provisional point of view, one whose range and scope were carefully orchestrated to give the viewer the psychological impression of unbridled seeing. The panorama actively served this object through the singularly modern way it liberated vision by controlling it.

The photographer's engagement with the phenomenology of perception is nowhere better illustrated than in his abiding passion for the stereo view. This format exploited a special dual-lens camera to create paired photographs two and a half inches apart—roughly the distance between normal human eyes—which were printed as small squares and mounted side by side on pasteboard cards. When such a card was placed in the appropriate binocular device (fig. 9), the user experienced a startling imitation of spatial depth. The discovery of this effect predated photography's invention, but it was only when wedded to the camera, in the 1850s, that the stereograph became

Figure 9. Advertisement in *The Californian*, September 1, 1866. Collection of the California State Library

a craze. By 1857 one London company had sold over half a million stereoscopes and was publishing a list of over 100,000 different views for sale.[36] The previous year a writer reported that "the stereoscope is now seen in every drawing-room; philosophers talk learnedly upon it, ladies are delighted with its magic representations, and children play with it."[37] Stereo views were inexpensive, mass-marketed entertainment—the "poor man's picture gallery"—and the most important and pervasive visual technology the nineteenth century produced, excepting photography itself. In the United States, stereography was heralded as a way of fulfilling the promise of a truly democratic society: schools and public libraries added stereo collections, with the goal of edification and "molding the artistic mind of our nation," as an article in the *Scientific American* announced in 1860.[38] These views were Watkins's bread and butter; throughout his career he made and sold more images in stereo than in any other format.

Because the stereo camera was lightweight and its exposures relatively brief, Watkins could use it to photograph a greater range

of subjects over a greater range of conditions, with dependable results. On his first trek to Yosemite, for instance, he managed about thirty mammoth plates and one hundred stereo views, using the big camera at dawn (to avoid wind) and moving to the stereo camera as light and weather shifted.[39] Watkins's aesthetic was forged in this oscillation between formats: some of the compositional cues that made for a lively delineation of space in a stereo card—framing trees, details in the immediate foreground, lines tethering near and far—could be incorporated into the flatter visual idiom of the mammoth print, just as the graphic drama of centralized composition and light-and-dark massing benefited the smaller format. But the photographer also recognized that the circumstances specific to viewing a big picture on the wall made for one kind of spectacle, and the stereo another. The extraordinary optical faculties of the stereo led Watkins, as it did other photographers, to formulate a wholly different kind of picture with it, one that capitalized upon its three-dimensional effects. Comparatively easy, cheap, and informal, the stereo encouraged visual experimentation, giving Watkins the opportunity to make some of his most immediate and daring images.

The stereoscope works by presenting each of the viewer's eyes with a slightly different image, the lateral displacement corresponding more or less to that of natural human sight. The device uses the brain's innate ability to read dual images as depth to recreate an approximation of spatial recession in the stereoscopic viewer. But the space one encounters here is radically different from the perspective of conventional pictures—in a way that no words on a page can adequately convey. Stereographic space is an optical illusion, its recession exaggerated and multilayered, lending it an oddly planar, "cutout" effect.[40] The intensity and peculiar artificiality of the sensation are encouraged by the stereoscope, whose eyepiece masks peripheral vision and concentrates attention on the kinesthetic scanning and refocusing demanded of the eyes. The most potent stereo images are filled with objects—the more convergent points of reference in the scene, the greater the apparent relief. If linear perspective is thought of as a unifying rationalization of pictorial space, the stereo image offers space deranged, its

elements unpredictably aggressive or flat in their dimensionality, its field a visual patchwork of distractions and delights. The distinct stereo experience simultaneously perturbed and exhilarated Victorian sensibilities, as its most intelligent critic, Oliver Wendell Holmes, indicates:

> The first effect of looking at a good photograph through the stereoscope is a surprise such as no painting ever produced. The mind feels its way into the very depths of the picture. The scraggy branches of a tree in the foreground run out at us as if they would scratch our eyes out. The elbow of a figure stands forth so as to make us almost uncomfortable. Then there is such a frightful amount of detail. . . . All must be there, every stick, straw, scratch.[41]

The ingredients that made for a good stereo view were therefore not those of other kinds of pictures; the stereo followed a visual logic of its own.

For Watkins, preoccupied with the challenge of offering his audience a visceral experience of western scale and space, the stereo format was both creative touchstone and practical tool. He was not averse to manipulating the optics of his camera—exaggerating the displacement of the binocular lenses, for example—if it facilitated the sensation of being surrounded by the stereo's photographic space. Objects receding from the near foreground augmented the immersive effect; close-ups and details dramatized it. Watkins's splendid cluster of water lilies (pl. 95) is deceptively flat and tranquil as a stereo card; when it is placed in a viewer, the unobtrusive central pole claims paramount attention, with plants circling it like an orrery. Watkins intuitively understood the genius of the stereo to live less in its pretense of solidity than in its cultivation of the ephemeral—the way it turned photographic reality into illusion. An early Yosemite view, to which he gave the uncharacteristically poetic title *"Inverted in the tide stand the grey rocks."* (pl. 22), features the Three Brothers entirely as reflection, capsized on the glassy surface of the Merced River and moored to land by the slightest of shorelines. Watkins also played with this visual idea in his large-format work, floating quixotic landscapes on the sur-

face of Mirror Lake (pl. 33), sometimes breaking his own spell with penetrating logs,[42] but with his stereos he found perceptual complexity raised to another order. In the "mirror view" stereos (pl. 36), for example, he could willfully drop a monumental feature such as Vernal Falls upside down into the complete pictorial chaos of river debris—a figurative and literal transposition of subject comprehensible only when experienced as a shimmering mirage in the stereoscope. With such passages, Watkins abandoned easy legibility for complication, discovering in the stereo format the same disembodied spectralization of space that, in another context, prompted Marcel Duchamp to make stereo cards and related devices he only half-ironically called "precision optics."[43]

The nineteenth-century mind evidently needed to contain the perceived anarchic implications of stereoscopic seeing, for commentators spoke more of its perfect illusionism and substantiality than its destabilizing adulteration of form. The stereo view and the panorama were discussed as analogous ways of seeing the world, modern technologies for gaining visual access to, and virtual ownership of, faraway places. "The stereoscope is the general panorama of the world," writes Antoine Claudet. "It brings to us in the cheapest and most portable form, not only the picture, but the model, in a tangible shape, of all that exists in the various countries of the globe."[44] Watkins manifests this semantic conflation in the several stereo panoramas he created—of Portland, San Francisco (pls. 3–8), San Jose, Virginia City, and other burgeoning communities—sets of stereos consisting of up to twenty cards which, when viewed in succession, provided the cumulative experience of a slow horizontal scan. Like the detail-filled mammoth plate and the multipart panorama, the stereo view and the stereo panorama forced their own brand of temporality upon the viewing of photographs, substituting bodily movement for the experience of time. Indeed, it was the ever-growing interchangeability of time and space in the nineteenth century that made Watkins's imagery—and an audience for that imagery—possible.

"Our age is ocular," Ralph Waldo Emerson once declared, summing up what many Victorians felt distinguished their experience of the world from that of previous generations.[45] To see something was to know it, and to know it was, in some sense, to control it. Photography was one of several nineteenth-century inventions, including the steamship and the electric telegraph, thought to collapse time and space in ways considered miraculous. An essay in the *Quarterly Review* in 1864 articulates the provocation the photographic medium represented to the established Newtonian universe:

> *Of all the marvelous discoveries which have marked the last hundred years, Photography is entitled in many respects to take its rank among the most remarkable. . . , [in the] perfect novelty of its results, and their direct connexion to the world of mind. It is not merely an improved mode of doing that which was done before. . . . It has forced the sun, which reveals to our senses every object around us, to write down his record in enduring characters, so that those who are far away or those who are yet unborn may read it. It has furnished to mankind a new kind of vision that can penetrate into the distant or the past—a retina, as faithful as that of the natural eye, but whose impressions do not perish with the wave of light that gave them birth. Philosophers have pleased themselves with the fancy that the scenes that passed upon the earth thousands of years ago have not really perished; but that the waves of light which left the earth then are still vibrating in the illimitable distances of space, and might even now be striking, in some far-off fixed star, an eye sensitive enough to discern them. Supposing that photographs are preserved with reasonable care, the philosophic dream may be a reality to our remote posterity.*[46]

Photography and its attendant technologies, the panorama and the stereoscope, amounted to a mechanized extension and symbolic perfection of visual memory and, at the same time, created a set of new visual habits specifically engendered by their use. The spectator of the era perceived "the world as picture," to use Martin Heidegger's famous phrase;[47] lived experience increasingly gave way to technologically mediated experience, in travel, communication, entertainment, and other spheres of daily commerce. If new modes of seeing (and, with them, a new kind of observer) were precipitated by the direct and popular usage of innovative

photographic technologies, the experience of other new technologies, such as the railroad, played an equally important if less direct role in shaping the visual temperament of Watkins's implied audience. The modern experience of railway travel, as much as any other factor, informs Watkins's art of perception and the distinctively ocular ideology of expansion he shared with his patrons.

In the late eighteenth century Immanuel Kant had codified the epistemological basis for a redescription of time and space. He argued these to be not the naturally occurring, empirically verifiable realities they had previously seemed, but rather two means of understanding that the human mind might project onto the world's phenomena—categories of subjective experience determined primarily by the mental apparatus of the individual observer. Once time and space were recognized as mental abstractions, they became available to investigation, and then to manipulation and eventual interchangeability. Within this framework, it is useful to compare Watkins's efforts with those of his chief rival of the 1870s, Eadweard Muybridge. Muybridge's motion studies of Leland Stanford's racehorses, and his subsequent enlargement of the project at the University of Pennsylvania in the 1880s, depended upon the realization that movement could be systematically parsed into component parts, themselves invisible to the unaided eye, which could then be photographically reassembled. In these studies time is dilated; the two-second transit of a walking figure explodes into thirty-six discrete views, ordered sequentially and scrutinized from multiple angles. By modifying an optical device to project these parts in succession, Muybridge discovered he could reanimate them, thus creating the first motion pictures. His zoopraxiscope (as he called his apparatus) effectively synthesized motion, starting from the notion that photography, properly configured, could act as an analytic repository of fragmented time.[48]

Watkins's images, in analogous fashion, functioned like photographic repositories of space. The nineteenth century had already witnessed the dismantling of Euclidean geometry, the centuries-old mathematical system for the reckoning of two- and three-dimensional spatial relations. In 1826 and 1854 respectively the mathematicians Nicolai Lobatchewsky and Bernhard Riemann developed non-Euclidean geometries that made possible what we now know as elliptical and hyperbolic space.[49] The post-Kantian world fixated upon the growing gap between objective geographical space and a subjective experience of scale: "Whether we call the conception of space a Condition of perception, a Form of perception, or an Idea, or by any other term," wrote the scientist William Whewell in the 1850s, "it is something originally inherent in the mind perceiving, and not in the objects perceived.[50] As the century progressed, science and technology threw those perceptions more and more into question.

Nothing warped the nineteenth-century individual's perception of space more than the railroad. Unlike travel by horse or coach, the railroad involved speeds that distorted the passenger's familiar bodily relationship with the landscape, sweeping its riders through space with such rapidity that visual impressions seemed to pile up progressively in number and intensity. The Victorian railway car imposed on passing scenery its own unique conditions of viewing; it elevated one's line of sight, it did not allow passengers to see ahead or be cognizant of the source of its forward propulsion (the engine), and it made its occupants passive onlookers as the countryside moved past its windows. John Ruskin voiced the sentiment of many when he described being rendered a mere parcel by the railroad; the locomotive limited sensory engagement with the terrain being traversed, promoting instead corporeal immobility and idle spectatorship. Moreover, that terrain no longer seemed altogether natural. In order to operate efficiently, railroads needed to be built as straight and level as possible. Rights-of-way were therefore routed and graded to overcome topographic irregularities, heightening the sensation of alienation and driving monotony in a conveyance that many writers compared to a projectile penetrating the landscape.[51]

Watkins's fortunes were intricately tied to the railroad. His early association with fellow Oneontan Collis Huntington con-

Figure 10. Watkins's rail pass signed by Collis P. Huntington, 1896. Collection of the Society of California Pioneers

tinued well after the Sacramento hardware salesman was approached in 1860 by an engineer named Theodore Judah with a plan to build a railroad across the Sierra Nevada Mountains, and from there across the continent. Together with Charles Crocker, a dry-goods merchant; Leland Stanford, then a lawyer who was living off mining wealth and a wholesale grocery business; and Mark Hopkins, his partner in Gold Rush hardware, Huntington poured his fortune into a scheme that shortly became known as the Central Pacific Railroad. The venture made these four the richest and most powerful men on the West Coast. Like Watkins, all had come to California from upstate New York, practical tradesmen with middle-class origins; all were members of the new Republican Party and Unionists in a heavily Democratic state. Through luck, cunning, and outright deceit, the Big Four gained federal subsidies for the construction of their road—and Stanford the governor's office, running on what he called the "Railroad Ticket." The Civil War made it militarily prudent for the Republican president and Congress to construct the line to San Francisco, although the Central Pacific did not meet up with the Union Pacific until four years after the war. The completed transcontinental railroad transformed the West, supplying a vital trade link to the East and, most importantly, creating a new industry in California tourism.

A Huntington intimate, Watkins functioned as unofficial photographer for the Central Pacific and its subsequent extension, the Southern Pacific. In 1869 he acquired and began publishing as his own the stereo negatives of Alfred A. Hart, the railroad's official photographer, and after 1873 he traveled the length of the Central and Southern Pacific, using free yearly passes provided by Huntington (fig. 10) to go wherever he wished. It is hardly astonishing then to find the railroad a persistent presence in Watkins's images after the mid-1860s; most of them, in fact, were taken from or near the new tracks. These were landscapes engendered by the railroad, places whose significance derived from the access, connectedness, and promise of development the railroad brought them. This was true both literally and figuratively. The government offered the Big Four vast land grants upon which to build their lines, which the company was allowed to sell at profitable

Figure 11. Interior view of passenger car, Chicago & Alton Railroad, 1882

rates as it developed towns and industry along its routes.[52] By the 1880s the Central and Southern Pacific Company was a ruthless monopoly and the largest landowner in the state. Much of the landscape Watkins photographed in his later career was therefore either directly or indirectly owned and controlled by his friend Huntington, whose rapacious and sometimes violent backing of California's agribusiness was chronicled by Frank Norris in his classic novel *The Octopus.*[53]

Watkins's vision of the West is in many respects railroad vision. The semicontinuous, flattened, enframed but open-ended treatment of landscape in his mammoth-plate panoramas bears a striking resemblance to what one would have seen through the windows of a Pullman passenger car (fig. 11); travelers in the moving compartment would find the foreground indistinct, but the middle ground and distance visually arresting, since these went by more slowly. Observers in the nineteenth century referred to their railway experience as panoramic, their view arranged as a restricted visual arc swinging from what had just passed to what was approaching; they also noticed how the train's frequent stops altered their perception of distance and attention to surrounding detail. Like that other great invention of the 1850s, the department-store window, the railway car encouraged passive visual consumption; both train travel and window shopping entailed a mobile viewer who engaged a fenestrated display not with hands and feet but with the eyes.[54] Publications such as the 1883 *Tourists' Illustrated Guide* carried Watkins's full-page advertisements and employed his

photographs as the basis for its illustrations. With time his list of available photographs corresponded expressly to that of the resort areas in California and Arizona that the Southern Pacific Company was constructing to increase revenue along its lines.[55] Just as the view of the West most travelers acquired after 1869 was shaped by the railroad, so, as time went on, did Watkins cater to the ventures that his friend Huntington was so aggressively capitalizing.

In the late 1870s Watkins completed an ambitious stereo panorama from the upper tower of Governor Stanford's San Francisco mansion atop Nob Hill. He made almost identical works from the roofs of the mansions owned by Mark Hopkins, Charles Crocker, and Huntington, all located on the same opulent block. This was, characteristically, the point of view Watkins preferred in his landscape photographs—elevated above his subject, practically floating. It was the position one took to gain what the era appropriately termed a "commanding view": the hilltop position a surveyor, town planner, or military strategist might assume to reconnoiter the territory before him. Watkins's photographs are consonant with the visual ideology expressed in the commanding view: they take optical possession of the terrain they survey, asserting a Victorian confidence in vision that understood implicitly the onlooker's power to rationalize and transform what lay ahead.[56] Watkins's images regularly afforded his audience this visual perch, the bird's-eye view of contemporary lithographs, which was also the view from the geologist's base camp, the edge of the hydraulic mine, the railroad cut, and the railroad tycoon's palace—places that Watkins's audience aspired to know and enjoyed occupying, if only vicariously through the photograph.

European art has traditionally been the province of elites—royalty, the Church, the governing aristocracy—of a class of people generally conversant with the classics and the Bible. At certain times and in certain places, however, picture-making has found itself addressing other kinds of patrons. In fifteenth-century Florence or seventeenth-century Holland, for instance, paintings were apt to be purchased by individuals who had earned their wealth, that is, by merchants and businessmen whose educations more likely stressed mathematics than literature. Such merchants depended for their livelihood upon visual skills that allowed them to quickly calculate the volume (and hence value) of a barrel on a dock or a bale in a shed. Not surprisingly, the pictorial art made for these middle-class clients tended to engage the same visual skills that they employed professionally; the measured and supremely legible spaces of a Piero della Francesca or the detailed description of textiles in a Vermeer spoke to their respective audiences in a visual language that came as second nature to both painter and patron.[57] Looking at pictures was a distinctive way of knowing the world, as much a confirmation of established cognitive tendencies as a redefinition of them.

Watkins's situation was little different. His viewers—the entrepreneurs, scientists, and first-class coach passengers who bought his photographs—were disciplined in habits of seeing specific to nineteenth-century bourgeois experience; they shared with the photographer a common visual idiom of factuality, mensuration, and sheer optical spectacle that retains much of its currency to this day. His photographs defeat interpretations of the narrative or symbolic sort because they aspired to be something altogether different from traditional art: they aspired to be perceptual, to engage the sensibilities of their beholders in an exercise of ocular gratification and visual intelligence. Watkins offered his audience the opportunity to participate in a negotiation between order and confusion, carried out, in conspicuously Victorian ways, upon the field of the visual. If the nineteenth century is indeed the seedbed for our own, figures such as Watkins demonstrate how the proliferating technologies of vision that so engage us today in fact have a lineage, one forged in the crucible of modern society's changing circumstances and given form by the rare individual astute enough to recognize them.

NOTES

1. Harry C. Peterson, curator of the Stanford Museum, had been cataloguing Watkins's collection in early 1906, presumably for purchase by the university or the state of California. He found in the photographer's possession, among other things, a chest full of early California daguerreotypes, including rare images of Captain John Sutter at Sutter's Mill. The Sunday before the great earthquake Peterson had been arranging items for removal to his home in Palo Alto; his plan to return the following week to begin transporting the material was obviated by the total destruction of Watkins's studio in the fires. See Robert Taft, *Photography and the American Scene. A Social History 1839–1889* (New York: Macmillan, 1939), pp. 255–56.

2. Beaumont Newhall did not include photographs by Watkins in the catalogue to his 1937 Museum of Modern Art survey exhibition, *Photography 1839–1937*; in his book *Photography: A Short Critical History* published the next year; nor in the four editions (1949, 1964, 1971, 1978) of the text derived from it, *The History of Photography from 1839 to the Present Day*. (The omission was redressed in the final, 1982 edition.) Newhall knew of Watkins's work as early as 1938; he had been the Macmillan Company's reader for Robert Taft's manuscript, wherein, as indicated above, the earliest discussion of Watkins and frontier photography may be found. Newhall's close friend Ansel Adams recognized Watkins's importance, featuring four of his large plates in the exhibition *A Pageant of Photography* that he organized for the 1940 Golden Gate International Exposition in San Francisco. In 1936, three years before meeting Newhall, Adams forwarded a small collection of nineteenth-century western views, chiefly by Timothy O'Sullivan, for inclusion in Newhall's historic survey, which were accepted and displayed as Adams suggested. It remains a matter of speculation why Adams would have proposed O'Sullivan over Watkins to represent western photography in nineteenth-century America, though the overlap between Watkins's work and Adams's own early subjects is inescapable.

3. The most important of these was the catalogue and exhibition assembled by Weston J. Naef and James N. Wood, *Era of Exploration: The Rise of Landscape Photography in the American West, 1860–1885* (New York: Albright-Knox Art Gallery and the Metropolitan Museum of Art, 1975). See also Karen Current and William R. Current, *Photography and the Old West* (New York: Harry N. Abrams, 1978). Like O'Sullivan and Jackson, Watkins was associated with survey work at points throughout his career—most notably, for Josiah Whitney, Clarence King, and George Davidson—but his reputation rested then (as now) much more squarely on images produced for private industry or photography's open market. O'Sullivan made his services available to well-funded, government-sponsored surveys led not only by civilians such as King but also to projects with overt military objectives such as the Navy Department's 1870 survey of the Isthmus of Panama or the several mapping campaigns of the American interior led by the former army lieutenant George M. Wheeler. Watkins's occasional expedition work in California was limited to relatively underfunded geological surveys of a more strictly scientific nature.

4. In 1983 Peter Palmquist and Martha A. Sandweiss offered the first retrospective monographic treatment of Watkins in an exhibition and catalogue titled *Carleton E. Watkins: Photographer of the American West* (Albuquerque: University of New Mexico Press, 1983), which included a biographical essay by Palmquist tracing the range and diversity of Watkins's activities as a journeyman photographer, with an emphasis on his non-Yosemite work. Most subsequent scholarship has built upon this foundation, acknowledging the distortion inherent in viewing Watkins as a photographer of pure landscape. See particularly George Dimock, *Exploiting the View: Photographs of Yosemite and Mariposa by Carleton Watkins* (North Bennington, Vt.: Park-McCullough House, 1984), and Mary Warner Marien, "Imaging the Corporate Sublime," in Amy Rule, ed. *Carleton Watkins: Selected Texts and Bibliography*. (Oxford, England: Clio Press, 1993).

5. John Coplans, "C. E. Watkins at Yosemite," *Art in America*, vol. 66, no. 6 (November/December 1978), p. 102.

6. On Watkins's association with these painters, see Naef and Wood, *Era of Exploration*, p. 63, and Elizabeth Lindquist-Cock, *The Influence of Photography on American Landscape Painting, 1839–1880* (New York: Garland, 1977).

7. In her foreword to *Carleton E. Watkins: Photographer of the American West*, Martha Sandweiss makes passing suggestion of Watkins's employment of "the iconography of contemporary Luminist painting" (p. xiii), an idea treated more expansively by Weston Naef in his essay "'New Eyes'—Luminism and Photography," in John Wilmerding, ed., *American Light: The Luminist Movement, 1850–1875* (Washington, D. C.: National Gallery of Art, 1980). Mary Warner Marien takes specific issue with such "atmospheric" readings of cultural transmission, arguing that "diffusionism is. . .a derelict idea" that begs the question of what historical mechanism could provide for the simultaneous appearance of the same style or tendency in far-removed localities by individuals devoid of direct contact (p. 28). In such readings, she suggests, these tendencies are either so generic that their assertion is practically meaningless or else depend upon the kind of "zeitgeist" abandoned by cultural historians decades ago.

8. Coplans, "Watkins at Yosemite," pp. 103–6. Naef suggests "the changes in Watkins's style. . .can be ascribed at least in part to the influence of a philosophical point-of-view such as King could have supplied" (p. 272), referring to the pantheistic, transcendentalist leanings Clarence King carried with him as he passed through San Francisco in 1863 on his way to work with Whitney in Yosemite.

9. Marien, "Imaging the Corporate Sublime," p. 12.

10. Edward L. Wilson, "Views in the Yosemite Valley," *Philadelphia Photographer*, vol. 3, no. 28 (April 1866), pp. 106–7.

11. Watkins, deposition of 27 August 1858 in the case *United States v. Charles Fossat*, quoted in Palmquist and Sandweiss, *Photographer of the American West*, p. 9.

12. Jonathan Crary. *Techniques of the Observer: On Vision and Modernity in the Nineteenth Century* (Cambridge, Mass.: MIT Press, 1990), p. 5.

13. Crary is careful to note that the modern viewer he proposes is a hypothetical entity: "Obviously there was no single nineteenth-century observer, no example that can be located empirically. . . . If it can be said there is an observer specific to the nineteenth century, or to any period, it is only as an *effect* of an irreducibly heterogeneous system of discursive, social, technological, and institutional relations." Ibid., pp. 6–7.

14. See Carol Armstrong, *Odd Man Out: Readings of the Work and Reputation of Edgar Degas* (Chicago: University of Chicago Press, 1991), especially pp. 45–49, 125–33.

15. Kirk Varnedoe has offered an alternate articulation of that indirect relationship, first in two essays, "The Artifice of Candor: Impressionism and Photography Reconsidered," *Art in America*, vol. 68, no. 1 (January 1980), pp. 66–78, and "The Ideology of Time: Degas and Photography," *Art in America*, vol. 68, no. 6 (summer 1980), pp. 96–101, and, more synthetically, in *A Fine Disregard: What Makes Modern Art Modern* (New York: Harry N. Abrams, 1990), esp. chaps. 2 and 3.

16. Joel Snyder, "Territorial Photography," in W. J. T. Mitchell, ed., *Landscape and Power* (Chicago: University of Chicago Press, 1994).

17. "Aesthetic discourse as it developed in the nineteenth century organized itself increasingly around what could be called the space of exhibition. Whether public museum, official salon, or private showing, the space of exhibition was constituted in part by the continuous surface of the wall—a wall increasingly structured solely for the display of art. . . . The gallery wall became a signifier of inclusion and, thus, can be seen as constituting in itself a representation of what could be called *exhibitionality*. . . . And in the last half of the nineteenth century, painting—particularly landscape painting—responded with its own corresponding set of depictions. It began to internalize the space of exhibi-

tion—the wall—and to represent it." Rosalind Krauss, "Photography's Discursive Spaces: Landscape/View," *Art Journal*, vol. 42, no. 4 (winter 1982), p. 312.

18. See Peter E. Palmquist, "Watkins—The Photographer as Publisher," *California History*, vol. 57, no. 3 (fall 1978), pp. 252–57.

19. Watkins's extensive stereo catalogue is reconstructed in Peter Palmquist, "Watkins' 'New Series' Stereographs," *The Photographic Collector*, vol. 3, no. 4 (winter 1982–83), pp. 11–21. The numbering of the mammoth-plate photographs after 1867 is discussed in Nanette Sexton, "Carleton E. Watkins: Pioneer California Photographer (1829–1916): A Study in the Evolution of Photographic Style during the First Decade of Wet Plate Photography," Ph.D. diss., Harvard University, 1982, pp. 311–12 .

20. Palmquist speculates that Watkins's work for the 1861 court case *United States v. D. and V. Peralta*, also known as the San Antonio Rancho case, made the photographer aware of the limitations of his technique and the need for a larger-field camera. This, as well as his immediate plans to compete head to head with Charles L. Weed's views of Yosemite later the same summer, prompted Watkins to have a local cabinet-maker construct an instrument capable of handling plates up to eighteen by twenty-two inches in size. See Palmquist and Sandweiss, *Photographer of the American West*, pp. 11–12.

21. Watkins's Daily Pocket Remembrancer for 1864, Bancroft Library, University of California at Berkeley. The matting and framing of Watkins's contribution to the International Exposition is described in the report of William Blake, United States commissioner to the fair: "These views are of large size, and were sent by the exhibitor in 'passe partout' and ready to hang. The views of the Mariposa trees were framed in the wood of the trees appropriately carved. These photographs attracted much attention." The fifty-foot display at the Paris exposition was evidently secured for Watkins with the help of the painter Albert Bierstadt, who once affirmed that he considered Watkins "the prince of photographers." See Sexton, "Pioneer California Photographer," pp. 308–10. Palmquist notes a contemporary interior view showing the office of Harvard naturalist Asa Gray decorated with Watkins's tree portraits (Palmquist and Sandweiss, *Photographer of the American West*, p. 30, n. 82). Watkins's friend and biographer Charles Turrill writes of Watkins's framing preferences for his New Series photographs: "It was his habit along about this time to sell many of his photographs already framed. They were always framed in heavy black walnut frames, usually with a gilt band close to the picture, which was always raised. He also sold his larger views in portfolio form." Charles B. Turrill, "An Early California Photographer: C. E. Watkins," *News Notes of California Libraries*, vol. 13, no. 1 (1918), p. 82.

22. John Szarkowski, *Looking at Photographs: 100 Pictures from the Collection of The Museum of Modern Art* (New York: The Museum of Modern Art, 1973), p. 20.

23. The Reverend H. J. Morton, "The Yosemite Valley," *Philadelphia Photographer*, vol. 3, no. 36 (December 1866), p. 377.

24. Watkins noted the height of Niagara in his Daily Remembrancer for 1864, Bancroft Library. His continuing fascination with the mathematical sublime is indicated in an 1891 letter to his wife: "Helena and myself went up [to] the Presbyterian Church last night to hear a lecture on stars and the man said that the Pleadies [*sic*] were 9 hundred and 99 million ooooooooooooooooooooo miles away. The first time you gave a think and then you kept up thinking all your life and you were just as far off when you got through as when you commenced." Watkins to Frances ("Frankie") Watkins, 1891, reproduced in Rule, ed., *Selected Texts*, p. 67.

25. In the summer of 1854, for example, an ex-miner named George Gale visited the Calaveras Grove of Big Trees, stripped the bark from one of the largest (ninety feet round at the base), then had the pieces reassembled in the East and shown as a marvel of nature. His audience did not believe a tree of such magnitude existed and suspected a hoax. Another reconstructed tree met with similar skepticism when shown at the Crystal Palace in Sydenham, England, in the late 1850s. See Simon Schama, *Landscape and Memory* (London: HarperCollins, 1995), pp. 186–88.

26. Quoted in Wilson, "Views in the Yosemite Valley," p. 73. Watkins's testimony about photographically represented distance in the 1858 Guadalupe quicksilver mine case, the 1861 San Antonio Rancho case, and the 1881 Kern County water-rights case of *Lux v. Haggin* are detailed in Palmquist and Sandweiss, *Photographer of the American West*, pp. 9, 11–12, 75–76.

27. "A Large Pear," *Hutchings' Illustrated California Magazine*, vol. I, no. 5 (November 1856), p. 203; "A California Grape," *Hutchings'*, vol. 2, no. 6 (December 1857), p. 244. The "Mammoth Cheese," made for San Francisco's What Cheer House and displayed in one of the early Mechanics' Institute exhibitions, is represented in a pre–1865 Watkins glass stereo view retained by the California Historical Society, San Francisco.

28. These photographs, made around 1888, reside in a unique album titled *Photographic Views of Kern County, California*, in the collection of the Huntington Library, San Marino, California. The album's structure is not without interest. Its first plate is of the Kern County exhibit at the 1889 Mechanics' Institute Industrial Exhibition (fig. 7), in which Watkins's images of Kern County farms were displayed on the wall above a cornucopia of actual produce from the area, suggesting a kind of cause-and-effect relationship analogous to the trees-to-peaches sequencing in the album itself. The last plate represents the locomotive "El Gobernador,"

weighing seventy-three tons and built at the Southern Pacific Railroad shops in Sacramento—implicitly the engine of development in the region.

29. On the association between the panorama, diorama, and other optical entertainments, see Crary, *Techniques of the Observer*, pp. 112–13, and Stephan Oettermann, *The Panorama: History of a Mass Medium*, Deborah Lucas Schneider, trans. (New York: Zone Books, 1997).

30. David Harris, *Eadweard Muybridge and the Photographic Panorama of San Francisco, 1850–1880* (Montreal: Canadian Centre for Architecture, 1993), pp. 37–38. Sandweiss notes the strong interrelation of photography and panorama painting in the West in the period from 1850 to 1870. J. Wesley Jones, for example, with a team of nine assistants, made a series of 1500 daguerreotypes tracing the land route from Sacramento to Saint Louis, which were then rendered on a painted canvas reported to be one mile in length. Jones called his creation the "Pantoscope of California." Alfred A. Hart and Andrew J. Russell were both panorama painters before taking up photography in the West. Russell had previously employed Mathew Brady's Civil War photographs as the basis for his painted "Panorama of the War for the Union." See Sandweiss, "Undecisive Moments: The Narrative Tradition in Western Photography," in Martha A. Sandweiss, ed., *Photography in Nineteenth Century America* (Fort Worth: Amon Carter Museum, 1991), pp. 105–8.

31. See Palmquist and Sandweiss, *Photographer of the American West*, p. 12. Watkins's construction of multi-part panoramas of San Francisco is discussed by Sandweiss, ibid., p. 115, and in Harris, *Eadweard Muybridge and the Photographic Panorama*, p. 89.

32. Oettermann, *The Panorama*, p. 9. Watkins also made mammoth-plate panoramas of mining boom-towns around the Comstock Lode in Nevada, such as Virginia City (1876), as well as whole-plate versions in areas being developed for tourism, such as Monterey, California (ca. 1882). Palmquist notes that these were sometimes composed of as many as twenty negatives. Palmquist and Sandweiss, *Photographer of the American West*, p. 57.

33. David Featherstone, "Carleton E. Watkins: The Columbia River and Oregon Expedition," in *Carleton E. Watkins: Photographs of the Columbia River and Oregon*, James Alinder, ed. (Carmel, Calif.: The Friends of Photography, 1979), pp. 13 and 24, n. 11.

34. Featherstone observes that the Oregon Iron Company (pls. 55 and 56) was the first facility on the Pacific Coast to manufacture pig iron with a blast furnace. Watkins's photographs were made only weeks before the plant began operations; its recent construction is evident, and another view of the works (pl. 58) shows great piles of firewood ready to power the operation. See Featherstone, "Columbia River and Oregon Expedition," pp. 13–14.

35. On Watkins's shooting methodology on the Columbia River, see Terry Toedemeier, "Oregon Photography: The First Fifty Years," in *Oregon Historical Quarterly*, vol. 94, no.1 (spring 1993), pp. 52–53.

36. William Culp Darrah, *Stereo Views: A History of Stereographs in America and Their Collection* (Gettysburg, Pa.: Darrah, 1964), p. 7.

37. Robert Hunt, "The Stereoscope," *The Art Journal* (April 1856), p. 118.

38. "Stereoscopes for Amateurs—Process of Producing Stereoscopic Photographs," *Scientific American*, 2 June 1860, p. 361, cited in Edward W. Earle, ed., *Points of View: The Stereograph in America—A Cultural History* (Rochester, N. Y.: Visual Studies Workshop Press, 1979), p. 13.

39. Watkins would often photograph the same subject as stereo- and mammoth-plate negatives (and, later in his career, in intermediate formats as well), with an eye to the different markets to which these might appeal; he also produced great numbers of images that could only function stereographically.

40. See the discussion in Krauss, "Photography's Discursive Spaces," pp. 290–91, and in Crary, *Techniques of the Observer*, p. 125.

41. Oliver Wendell Holmes, "The Stereoscope and the Stereograph," *Atlantic Monthly*, vol. 3 (June 1859), pp. 738–48, reprinted in Beaumont Newhall, ed., *Photography: Essays & Images* (New York: The Museum of Modern Art, 1980), pp. 57–58. Holmes requested, and received from Watkins, a set of his Yosemite stereos in 1862.

42. The critic for the *Philadelphia Photographer* remarked on the spatial ambiguity of *Mirror Lake (View of Mt. Watkins)*: "We were absolutely at a loss at first to which way we were to hold the print. The clear, sharp figure of woods, and the wonderfully sharp and perfect details of distant rock masses, were all rendered as well by the reflections, as by the real objects represented, and it was only after some study that we saw how the print was to be held and examined." The Reverend H. J. Morton, "The Yosemite Valley," p. 378, as cited by Sexton, "Pioneer California Photographer," p. 244. Holmes's essay on the stereoscope plays heavily on the trope of the mirror, with its Neoplatonic implication of the noumenal, and ends famously with the line "Form is henceforth divorced from matter" (p. 60).

43. In this vein Duchamp created not only spatially ambiguous geometric stereo views but also such devices as the rotary demisphere and the "rotorelief"—disks with spiral designs that, when spun on a phonograph, produced an illusion of volumetric dimensionality. On Duchamp, Max Ernst, and the modernist fascination with optical devices, see Rosalind Krauss, "The Im/Pulse to See," in Hal Foster, ed., *Vision and Visuality: Discussions in Contemporary Culture* (Seattle, Wash.: Bay Press, 1988), pp. 51–75, and her elaboration of the subject in *The Optical Unconscious* (Cambridge, Mass.: MIT Press, 1993), pp. 95–146.

44. Antoine Claudet, "Photography in Its Relation to the Fine Arts," *Journal of the Photographic Society*, vol. 6, no. 98 (15 June 1860), p. 265, as cited in Britt Salvesen, "Selling Sight: Stereoscopy in Mid-Victorian Britain," Ph.D. diss., University of Chicago (Ann Arbor, Mich.: UMI, 1997), p. 4.

45. Quoted by Naef, "'New Eyes'—Luminism and Photography," p. 269.

46. "Photography," *Quarterly Review*, vol. 116, no. 232 (July-October 1864), pp. 482–83.

47. Martin Heidegger, "The Age of the World Picture," in *The Question Concerning Technology and Other Essays* (New York: Garland Publishing, 1977), p. 134.

48. For a discussion of Muybridge's work in relation to nineteenth-century scientific culture, see Marta Brown, *Picturing Time: The Work of Etienne-Jules Marey (1830–1904)* (Chicago and London: University of Chicago Press, 1992), pp. 228–62.

49. Stephen Kern, *The Culture of Time and Space, 1880–1918* (Cambridge, Mass.: Harvard University Press, 1983), pp. 132–33.

50. William Whewell, *History of Scientific Ideas (Being the First Part of the Philosophy of the Inductive Sciences)*, 3rd ed. (London: Parker and Sons, 1858), vol. 1, p. 118, as cited in Salvesen, "Selling Sight," p. 32.

51. See Wolfgang Schivelbusch, *The Railway Journey: The Industrialization of Time and Space in the 19th Century* (Berkeley and Los Angeles: University of California Press, 1986), p. 54. It might be more accurate to say that the railroad system altered both time and space; in 1883 five standard time zones were adopted in the United States to facilitate running trains on one schedule, and the next year, for the same reason, the system known as Greenwich mean time was devised for worldwide use. See Kern, "Culture of Time and Space," p. 12.

52. These properties were advertised and made available through an agency calling itself the Pacific Coast Land Bureau. A typical promotional pamphlet issued by the company is titled *The Lands of the Central Pacific and Southern Pacific Railroad Companies. Homes for All in California, Nevada and Utah. Advantages for Settlement* (San Francisco: Pacific Coast Land Bureau, ca. 1880). The offices of this agency were located at 22 Montgomery Street in San Francisco, the former address of Watkins's Yosemite Art Gallery.

53. Frank Norris, *The Octopus: A Story of California* (New York: Doubleday, Page and Co., 1901).

54. Schivelbusch, *The Railway Journey*, pp. 188–97.

55. The company had hoped that its control of transcontinental and intrastate passenger travel would assure its success, but this did not prove to be the case. The Southern Pacific was therefore compelled to secure a monopoly for freight transportation in California, with prices as high as fluctuating markets would allow, and to construct resorts, such as the Hotel Del Monte near Monterey, to increase passenger travel along underused spur lines. See Ben C. Truman, *The Tourists' Illustrated Guide to the Celebrated Summer and Winter Resorts of California Adjacent to and upon the Lines of the Central and Southern Pacific Railroads* (San Francisco: H.S. Crocker and Company, 1883).

56. Albert Boime, *The Magisterial Gaze: Manifest Destiny and American Landscape Painting ca. 1830–1865* (Washington, D.C.: Smithsonian Institution Press, 1991).

57. See Michael Baxandall, *Painting and Experience in Fifteenth-Century Italy: A Primer in the Social History of Pictorial Style* (Oxford, England: Oxford University Press, 1972); Svetlana Alpers, *The Art of Describing: Dutch Art in the Seventeenth Century* (Chicago: University of Chicago Press, 1983).

SAN FRANCISCO AND VICINITY

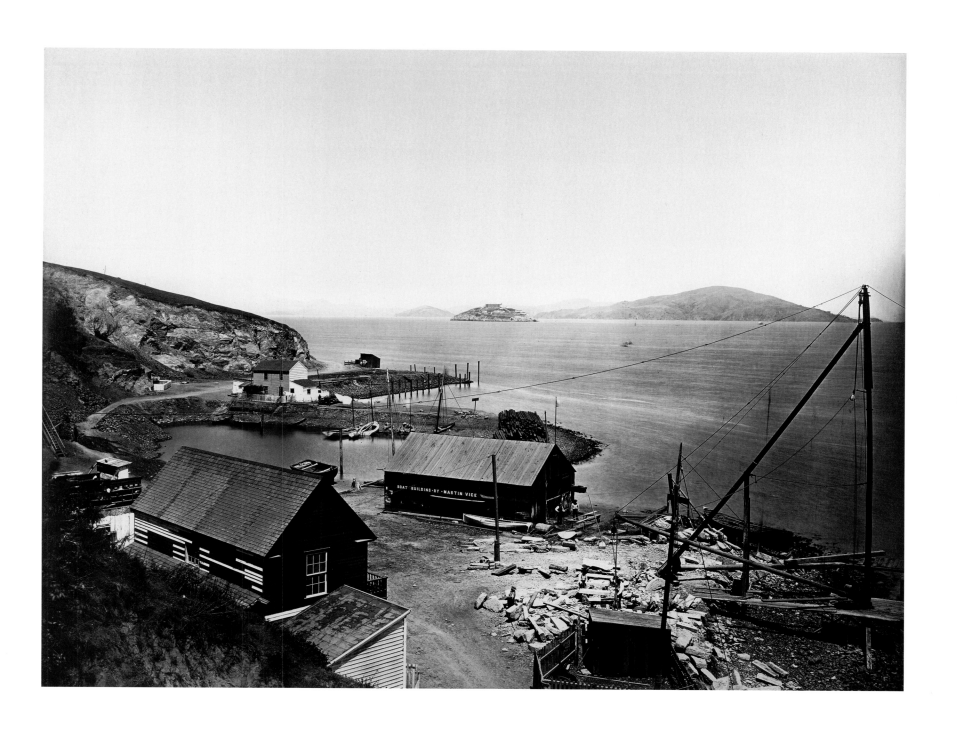

PLATE 1. *Alcatraz, from North Point,* ca. 1866

PLATE 2. *Russian Hill Observatory*, ca. 1865

Russian Hill Observatory 761 Watkins San Francisco

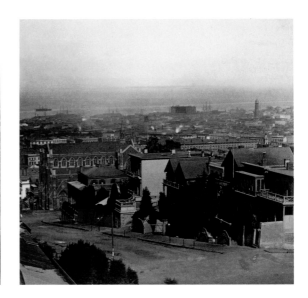

PLATES 3, 5–8. *View from California and Powell Streets, San Francisco,* 1874 (stereo halves)

PLATE 4. *Panorama from California and Powell Streets, San Francisco,* 1874 (stereo half)

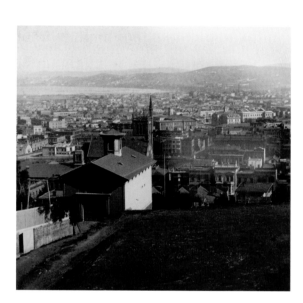

PLATE 9. *The Golden Gate from Telegraph Hill,* ca. 1868

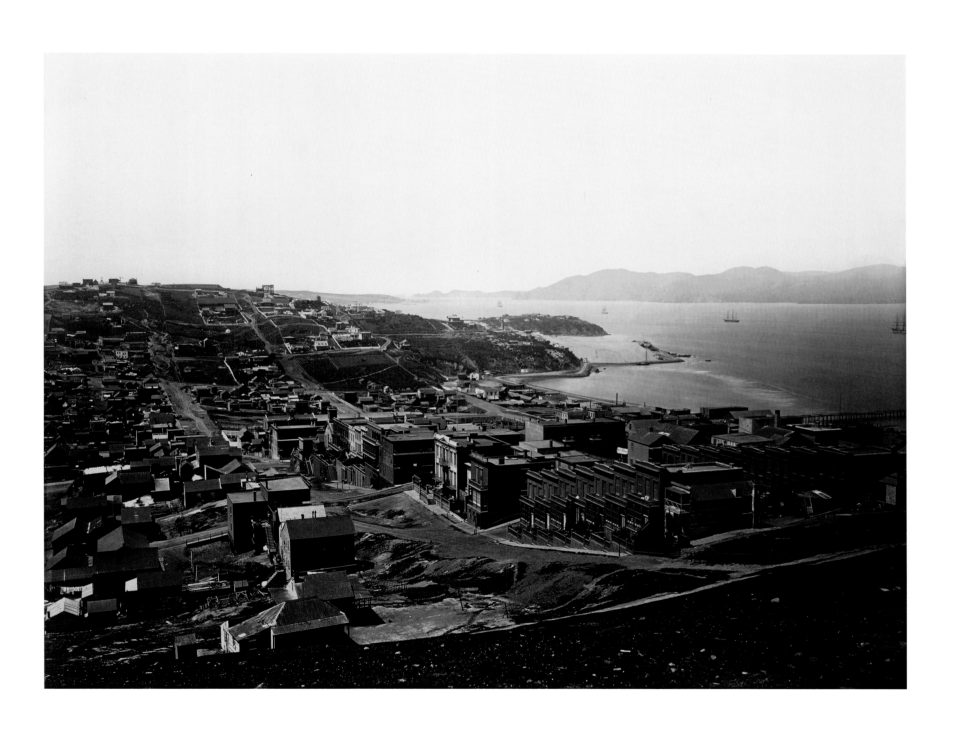

PLATE 10. *San Francisco from Twin Peaks, Looking Northeast, 1866–69*

PLATE 11. *Lone Mountain, from the Orphan Asylum,* 1866–69

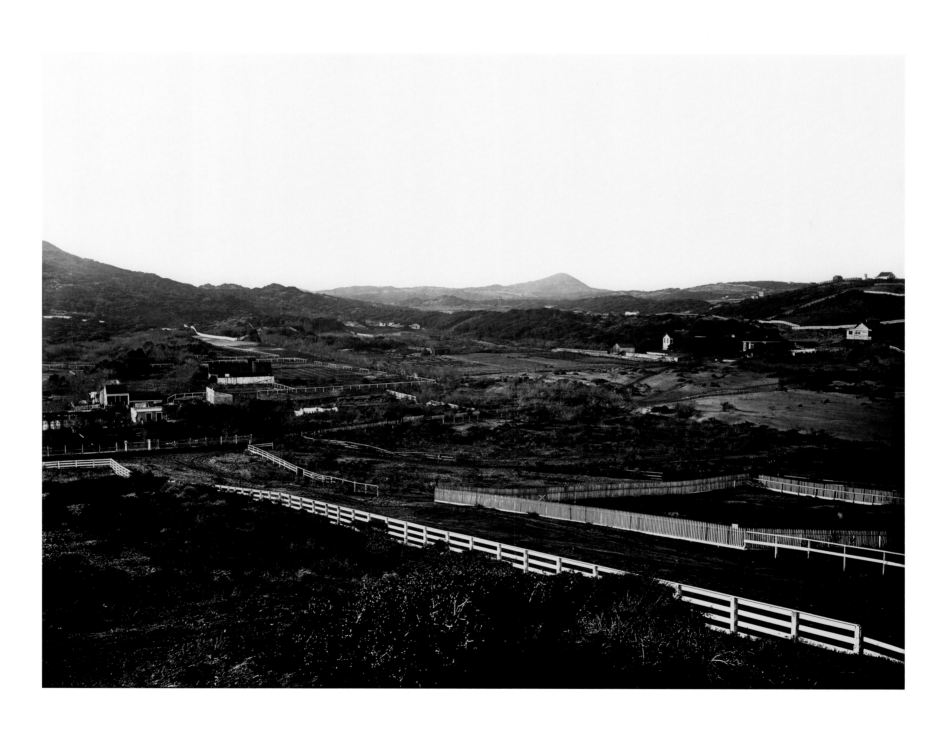

PLATE 12. *The Wreck of the Viscata, 1868*

48

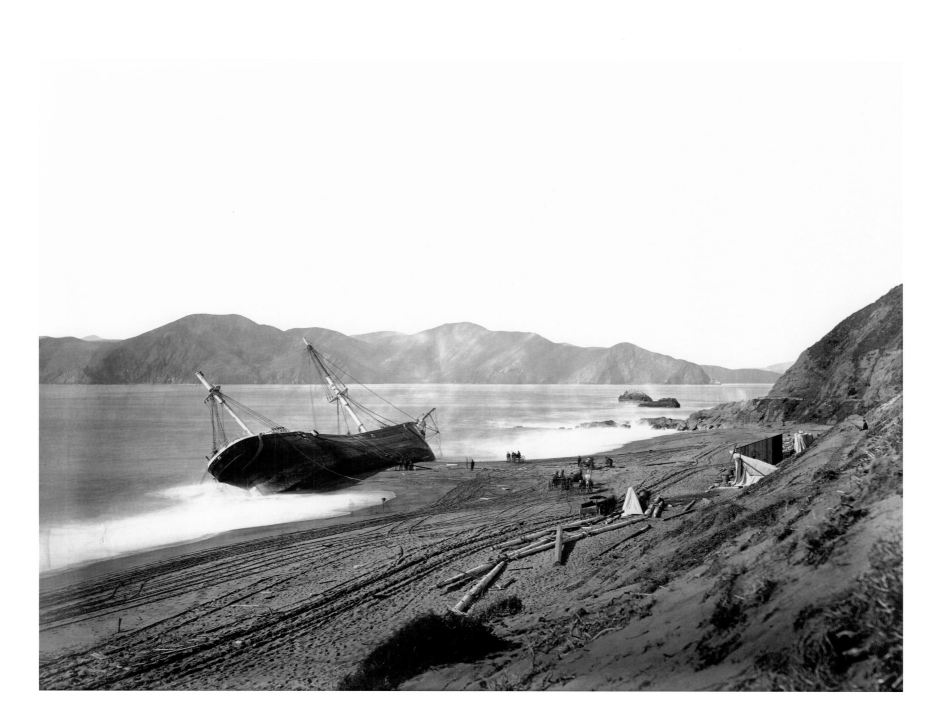

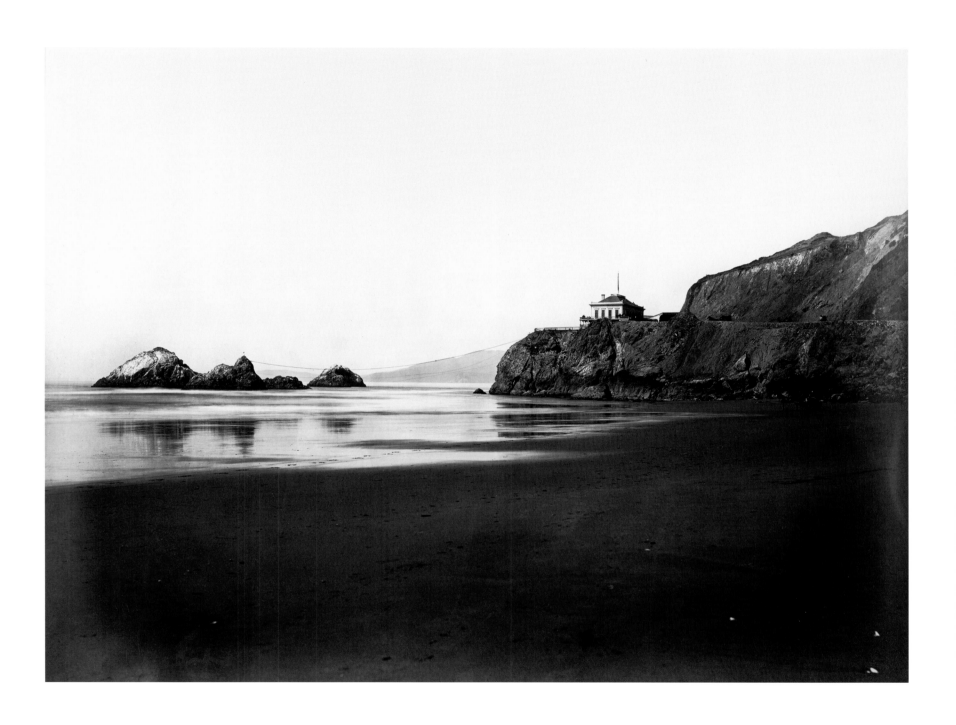

PLATE 14. *Strait of Carquennes, from South Vallejo,* 1868–69

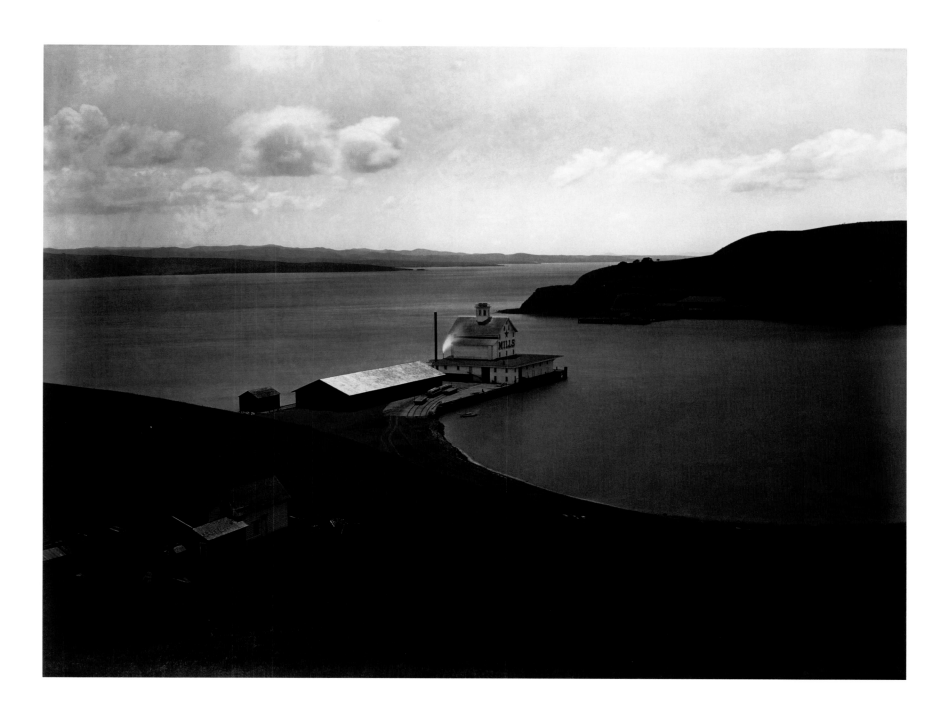

PLATE 15. *Twin Redwoods, Palo Alto, 1870*

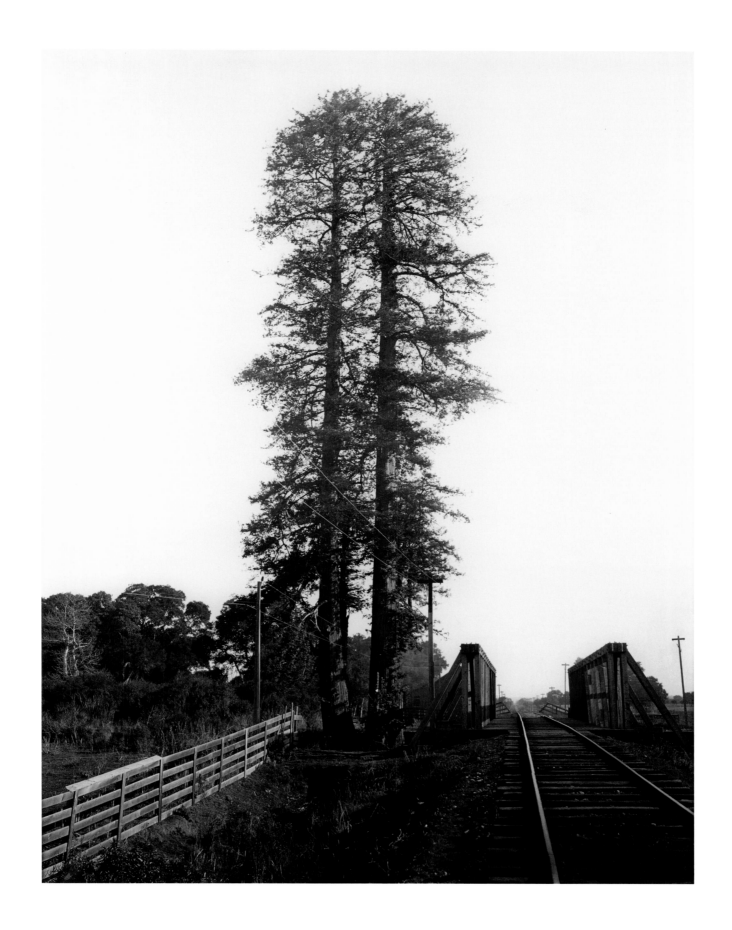

PLATE 16. *The Town on the Hill, New Almaden,* 1863

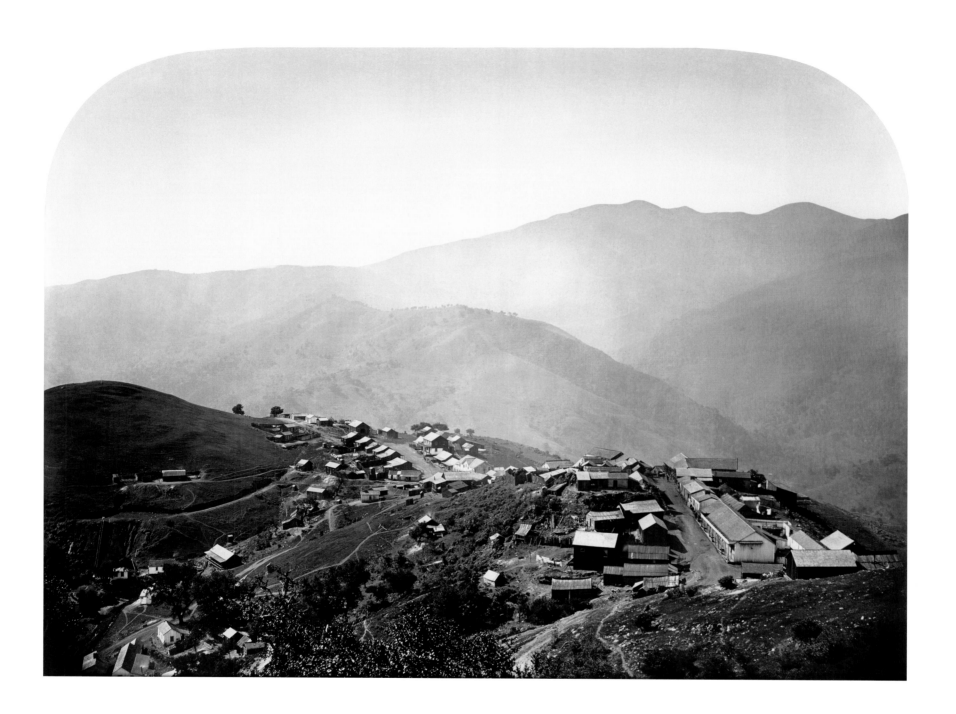

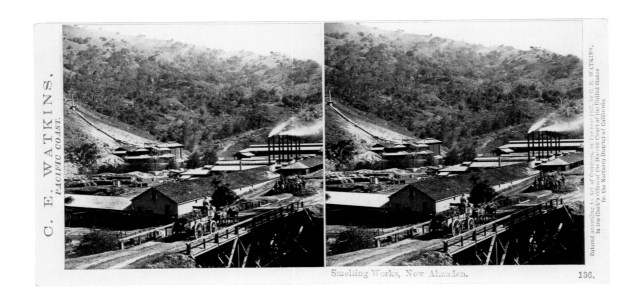

PLATE 17. *Smelting Works, New Almaden*, 1863

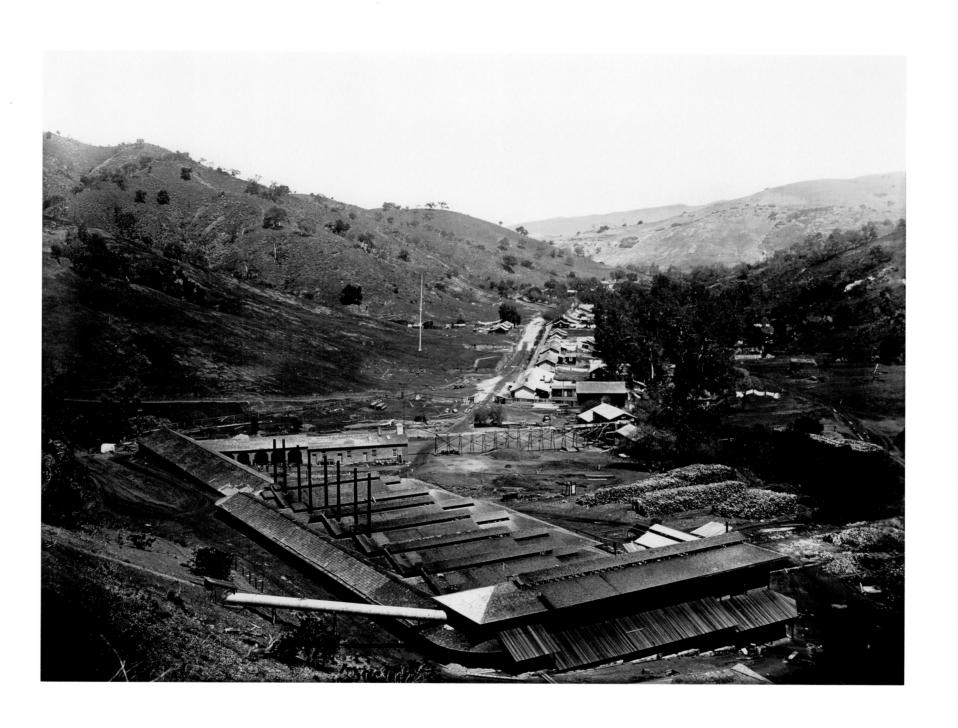

PLATE 18. *Hacienda, View East, New Almaden mines, California*, 1863

YOSEMITE

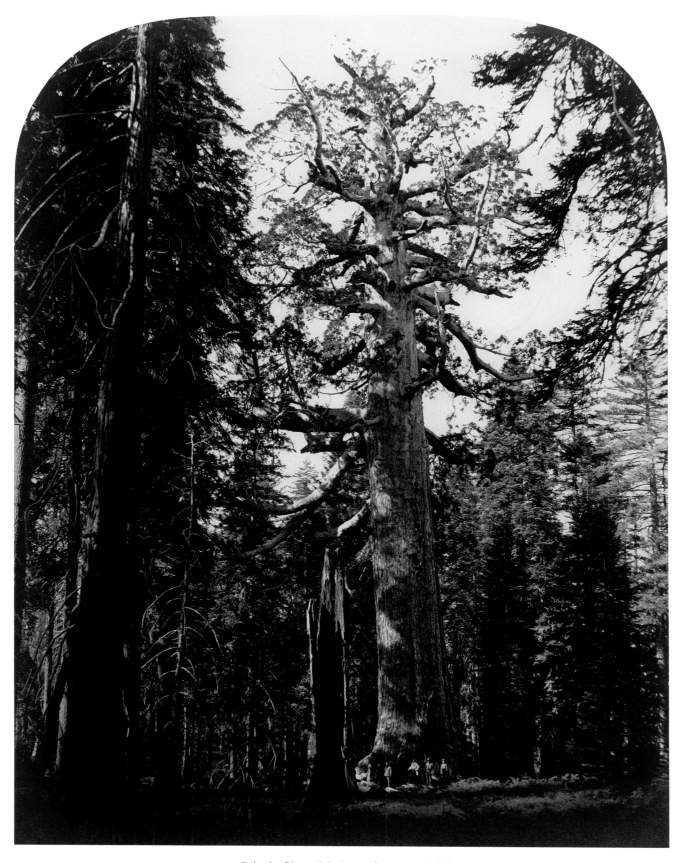

PLATE 19. *Grizzly Giant, Mariposa Grove, 33 ft. Diam.*, 1861

PLATE 20. *Cathedral Rock, Yosemite,* 1861

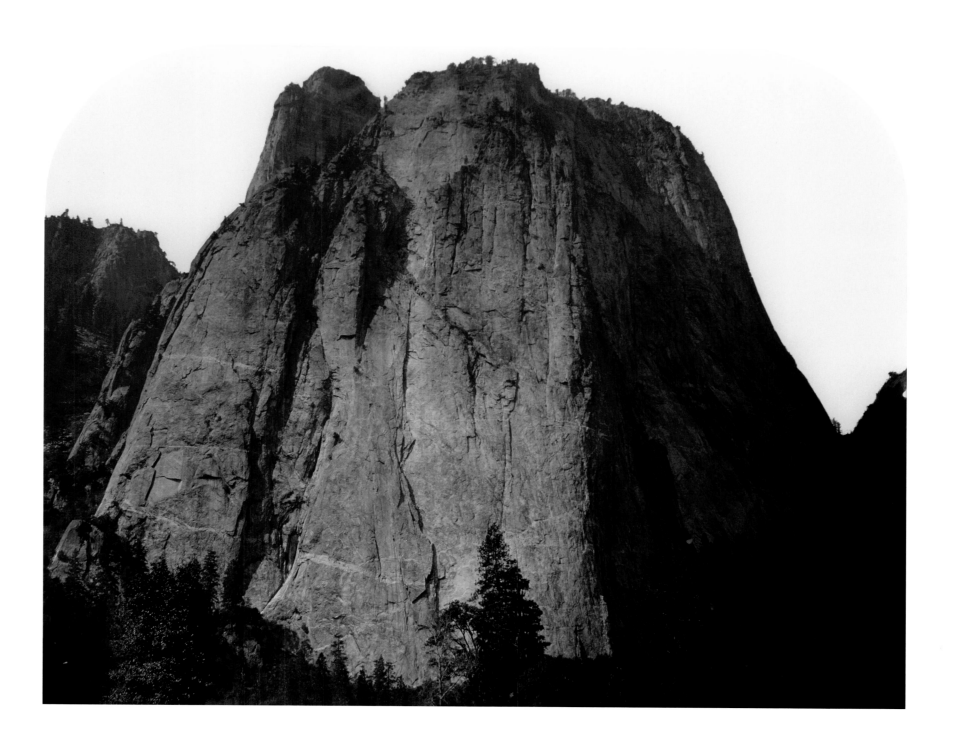

PLATE 21. *Lower Cathedral Rock*, ca. 1865–66

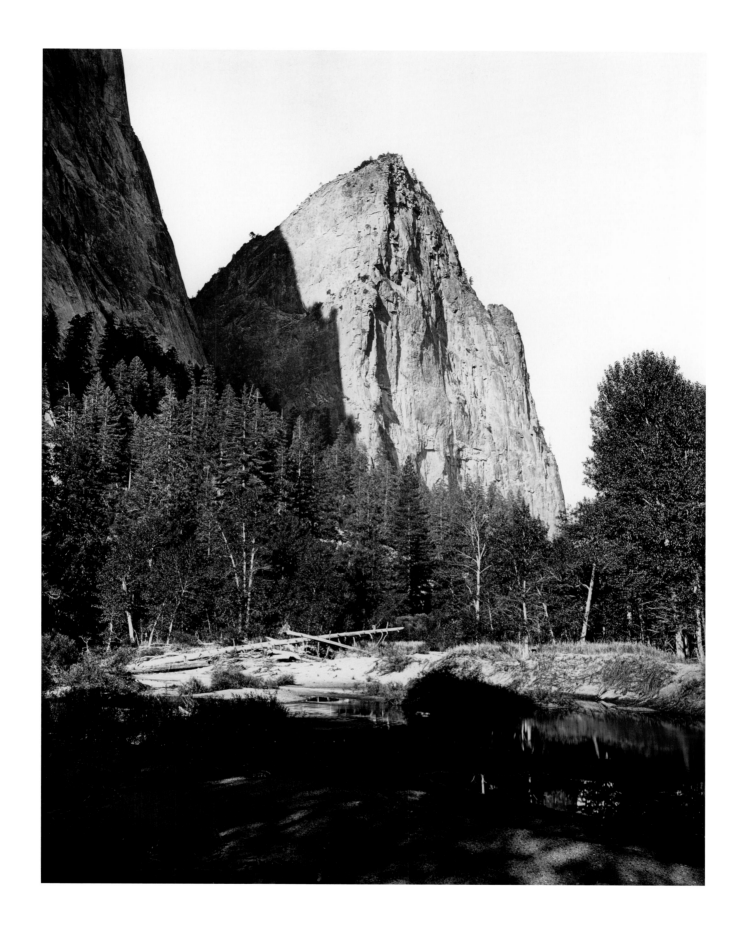

PLATE 22. *"Inverted in the tide stand the grey rocks.,"* 1861

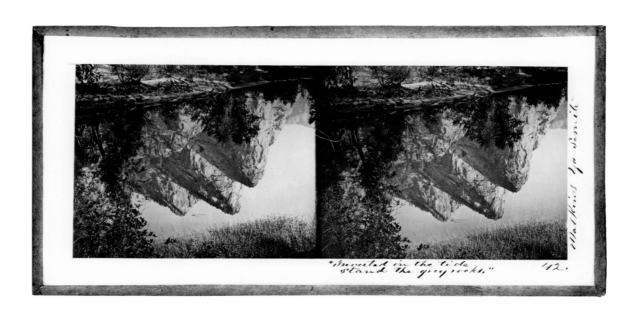

"Inverted in the tide
stand the grey rocks," 42.

PLATE 23. *Mt. Broderick, Nevada Fall, 700 ft., Yosemite,* 1861

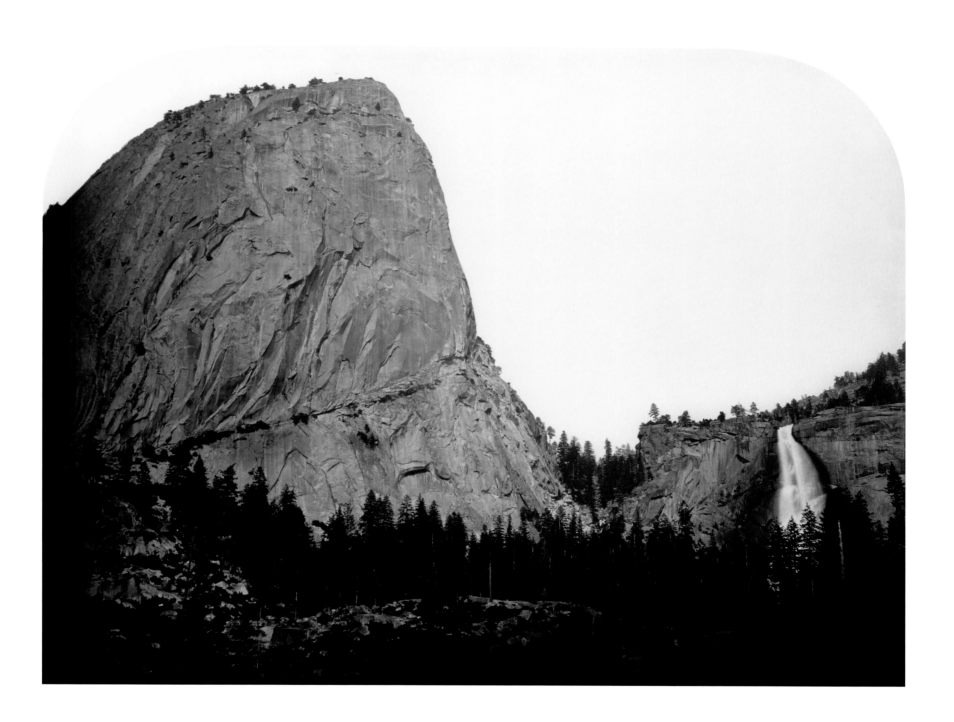

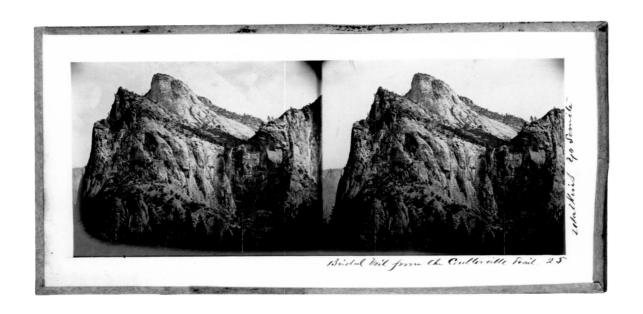

PLATE 24. *Bridal Veil from the Coulterville Trail,* 1861

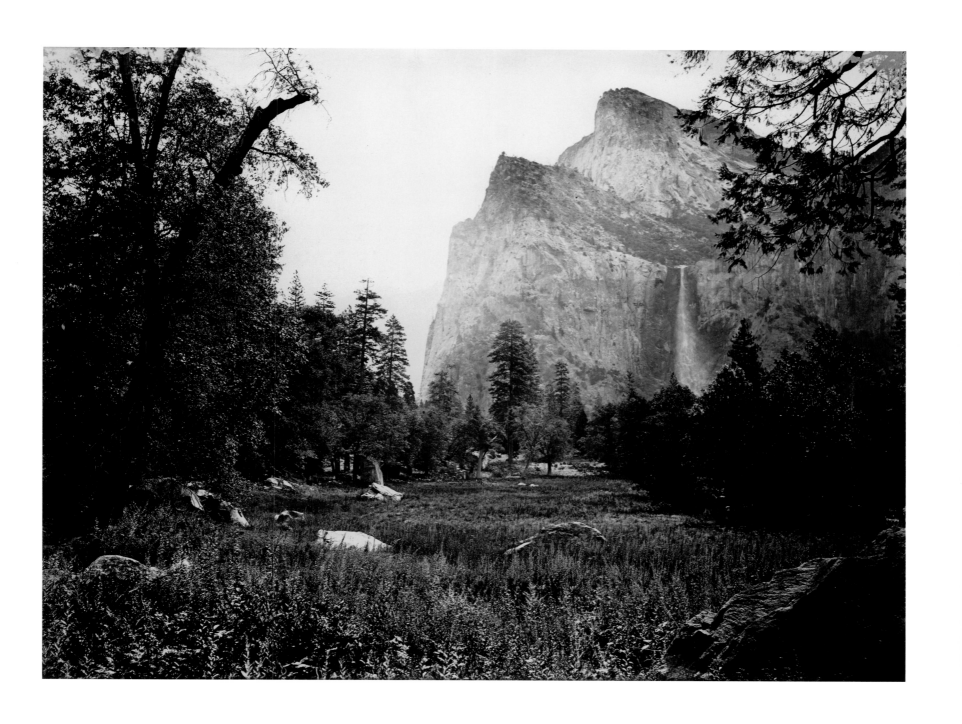

PLATE 25. *Bridal Veil, Yosemite,* ca. 1865–66

PLATE 26. *River View up the Valley*, ca. 1865–66

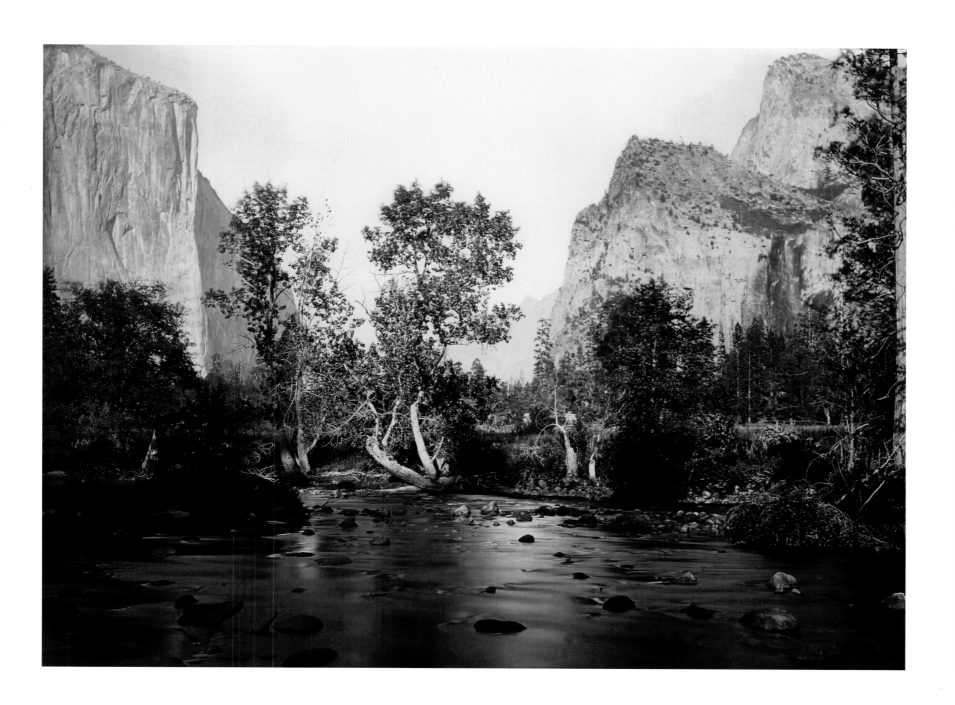

PLATE 27. *Yosemite Falls (River View)*, 1861

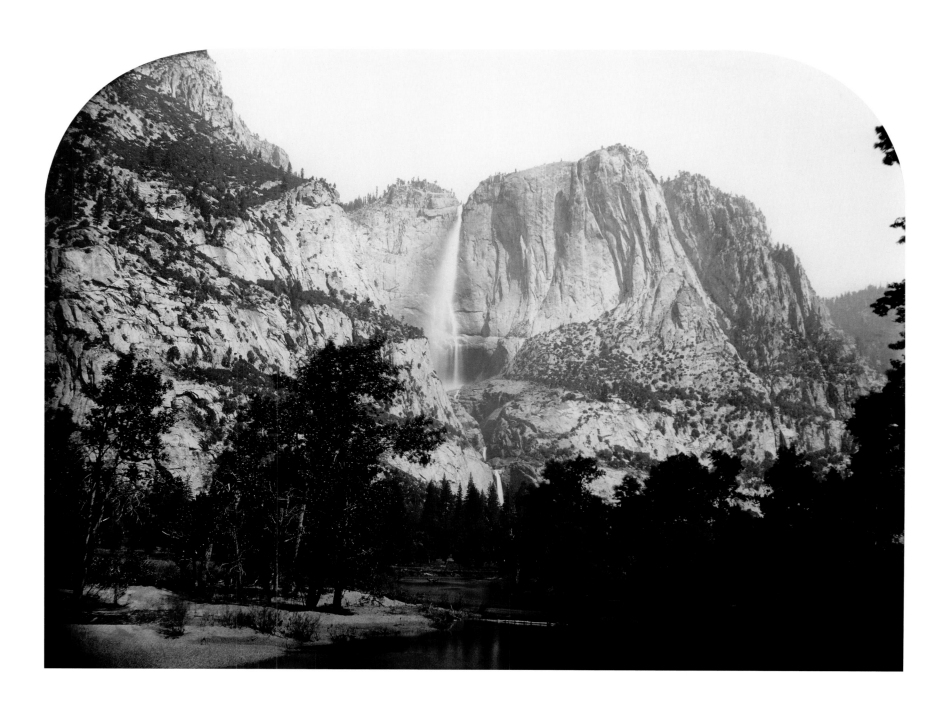

PLATE 28. *Over the Vernal Fall,* 1861

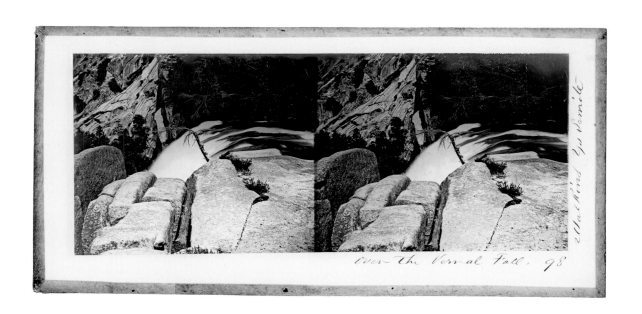

Over the Vernal Fall. 98

PLATE 29. *Yosemite from Mariposa Trail (Yosemite Valley No. 1)*, ca. 1865

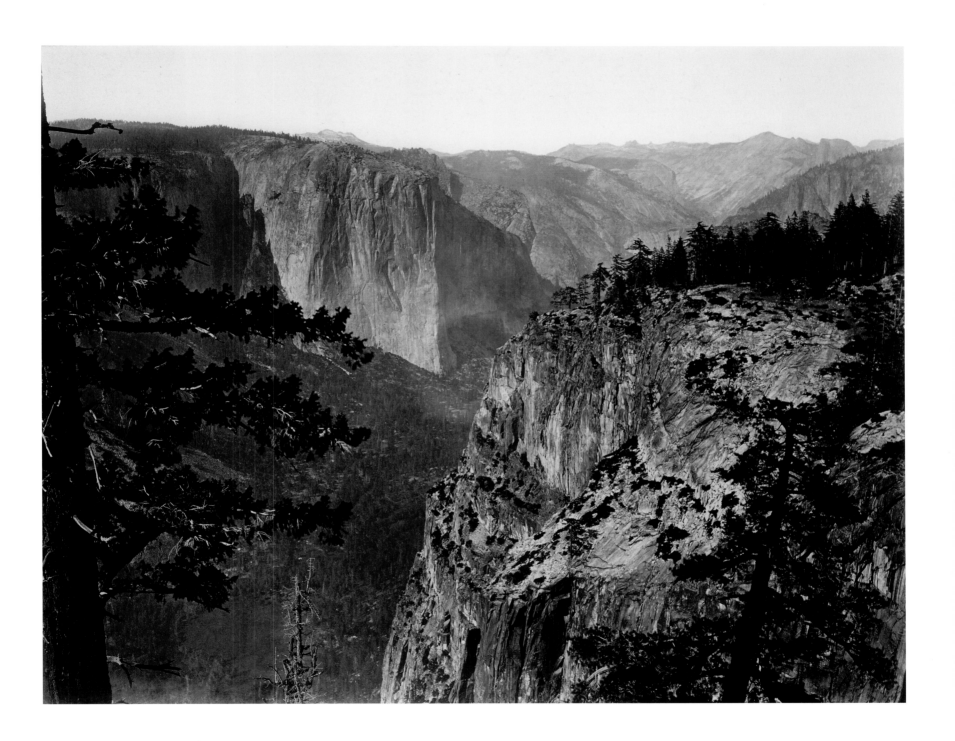

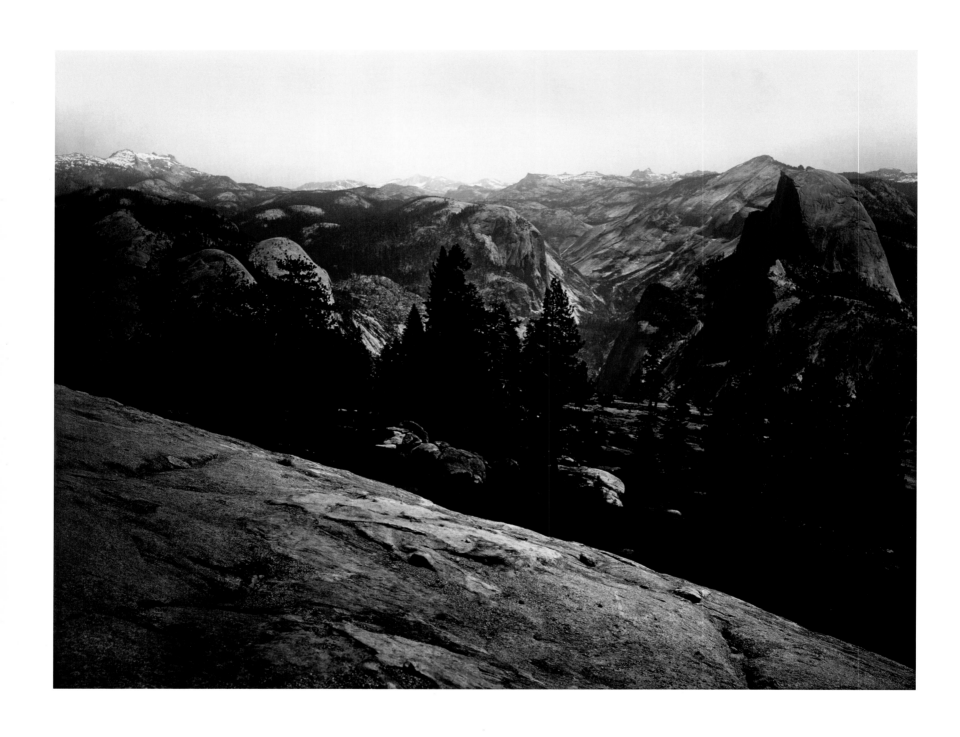

PLATES 30–32. *View from the Sentinel Dome, Yosemite, 1865–66*

PLATE 33. *Mirror Lake (View of Mt. Watkins)*, ca. 1878–81

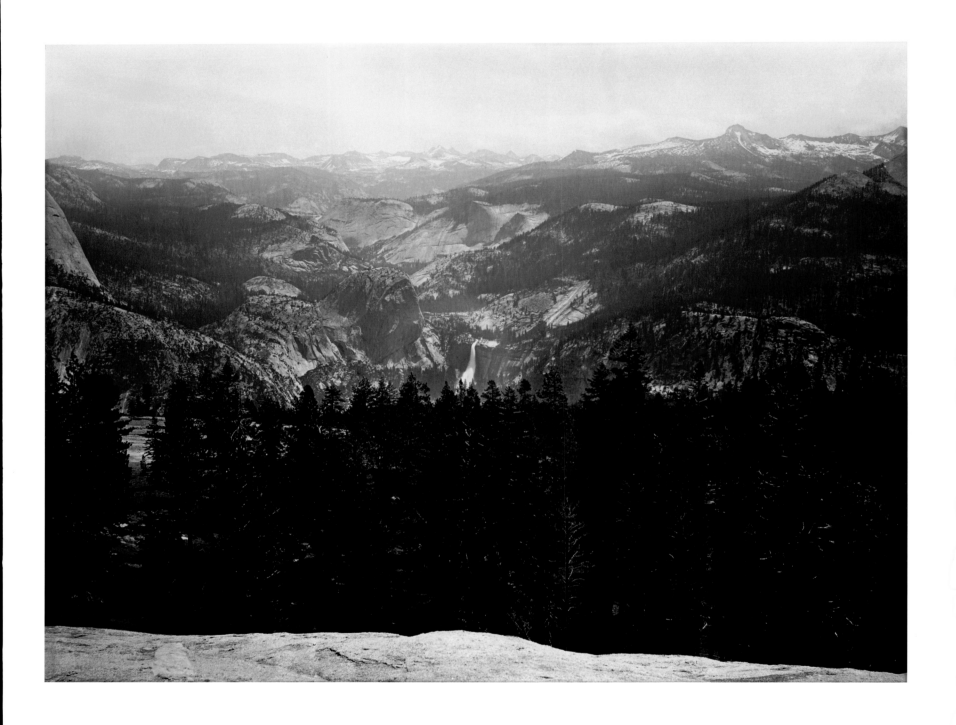

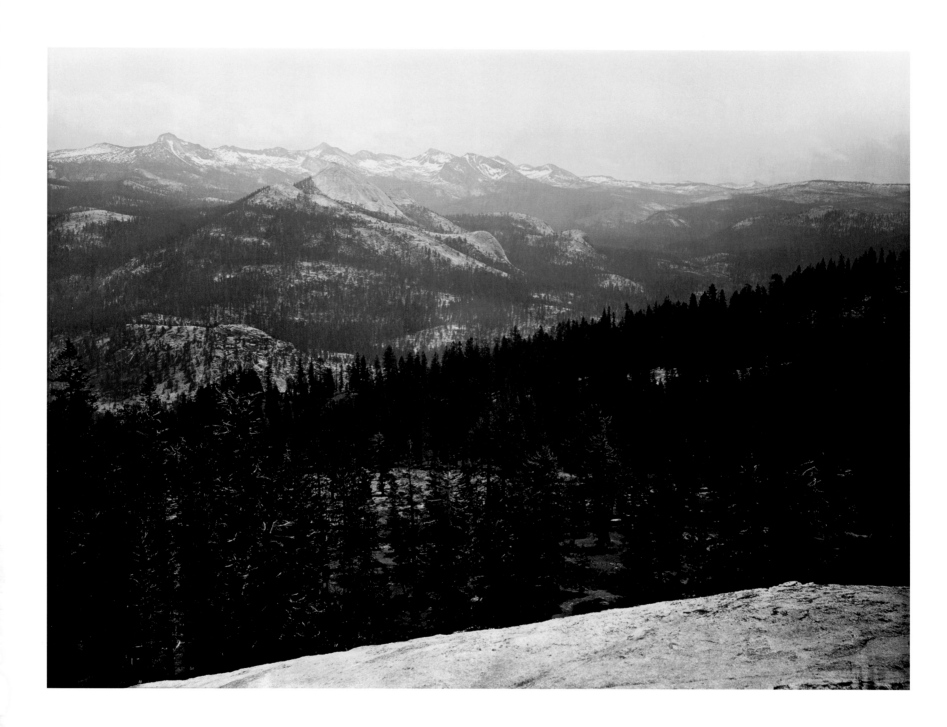

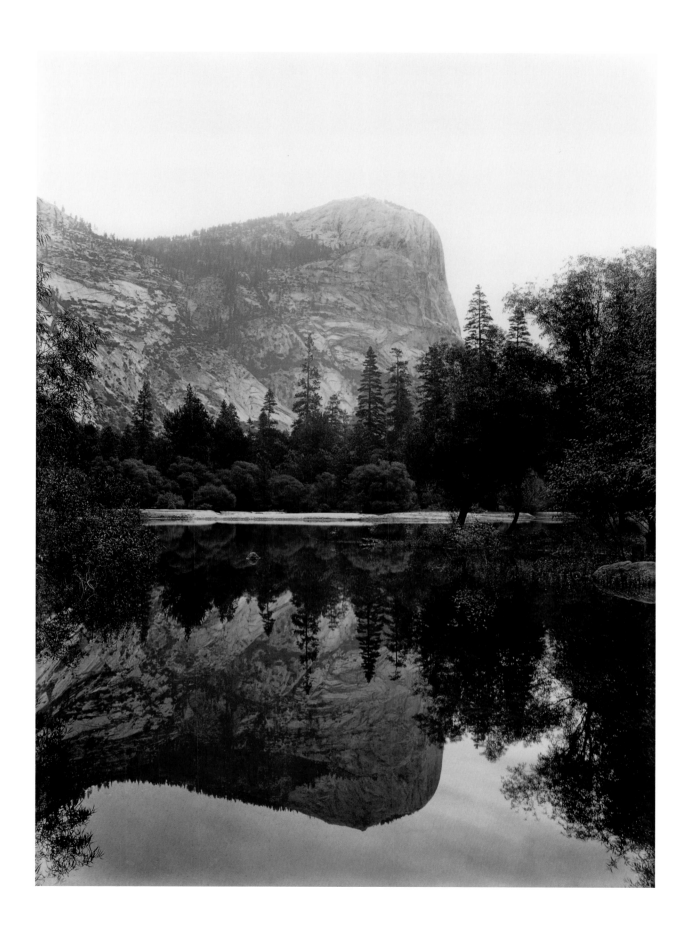

PLATE 34. *Mirror View of El Capitan*, ca. 1872

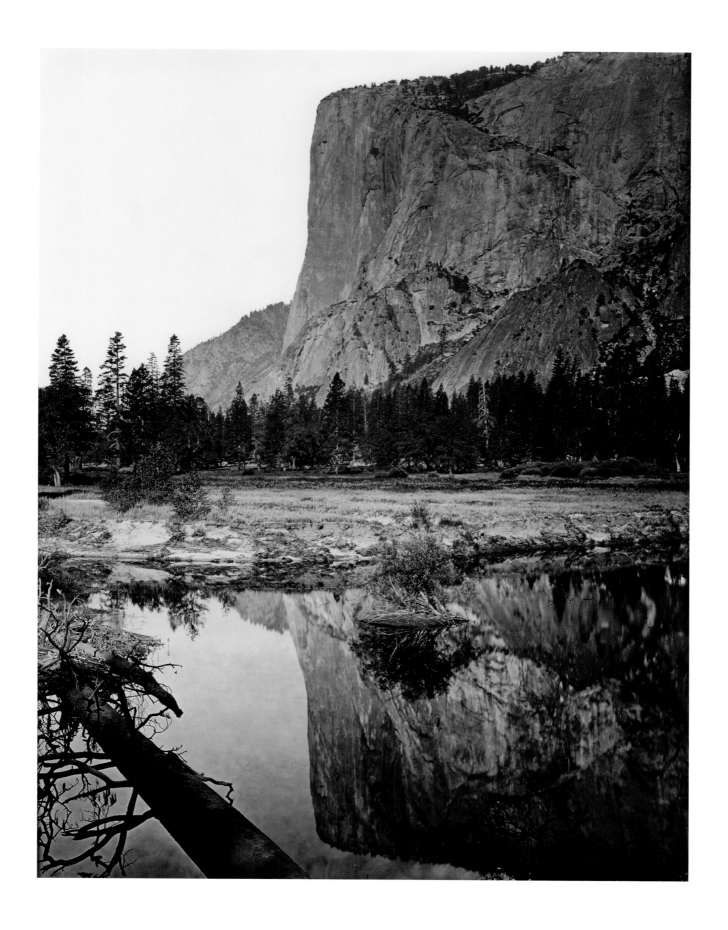

PLATE 35. *Washington Column, 2052 ft., Yosemite,* CA. 1872

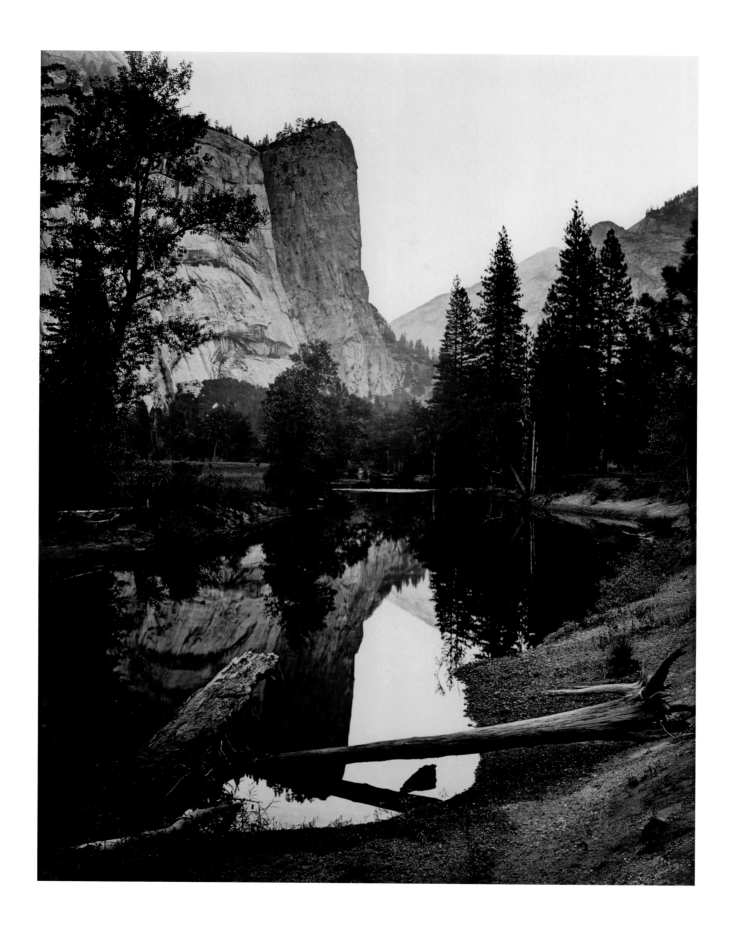

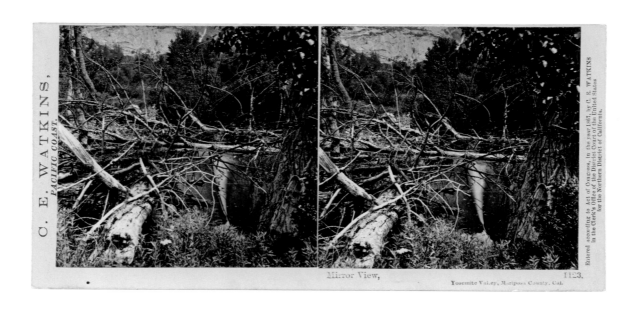

Mirror View,

1123.

Yosemite Valley, Mariposa County, Cal.

PLATE 37. *El Capitan 3600 ft.*, 1865–66 (stereo half)

92

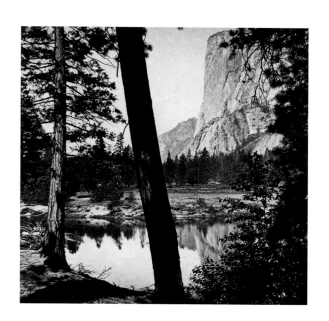

PLATE 38. *Yosemite Valley from "Best General View,"* ca. 1865

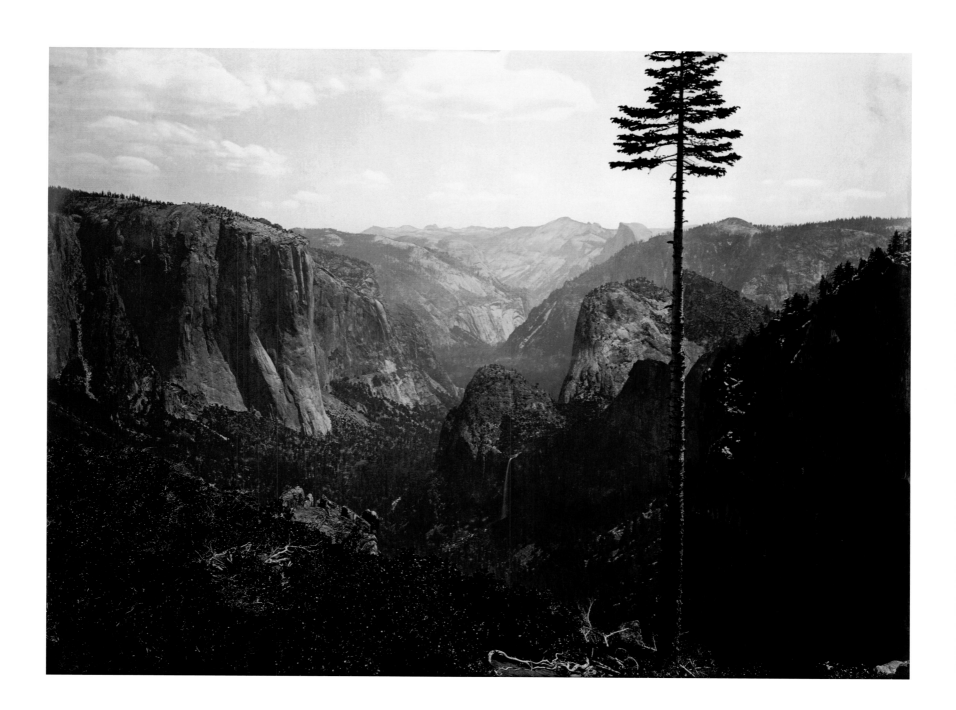

PLATE 39. *The Half-Dome from Glacier Point*, ca. 1878–81

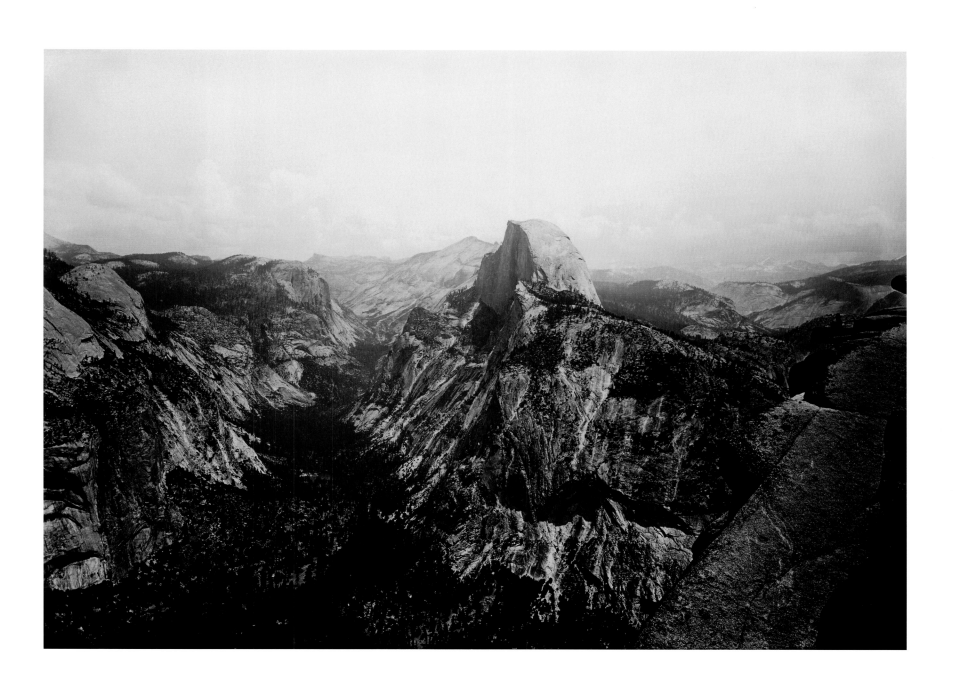

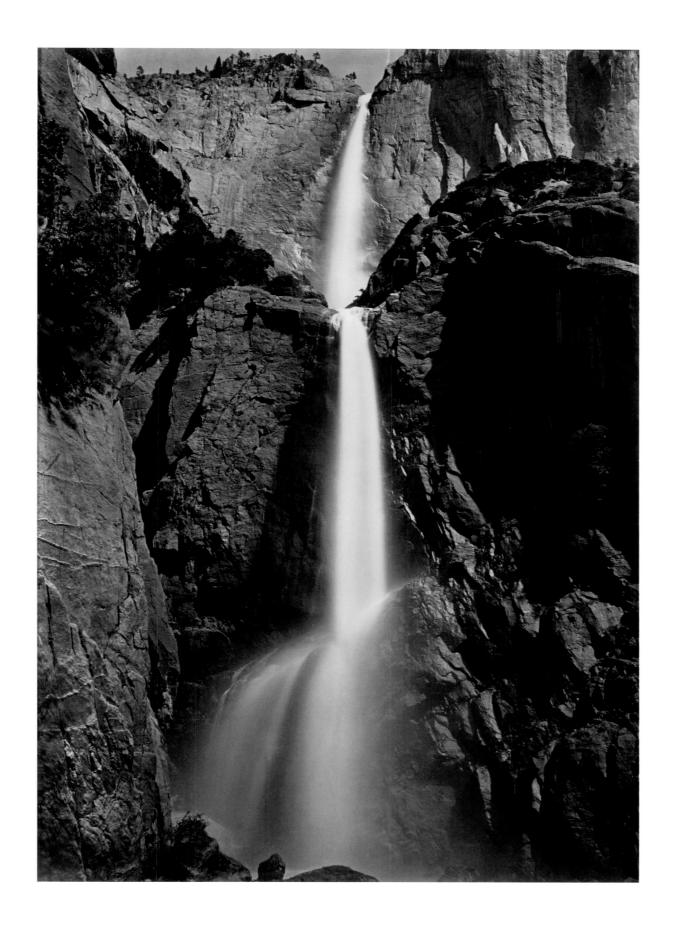

PLATE 41. *Agassiz Rock and the Yosemite Falls, from Union Point,* 1878–81

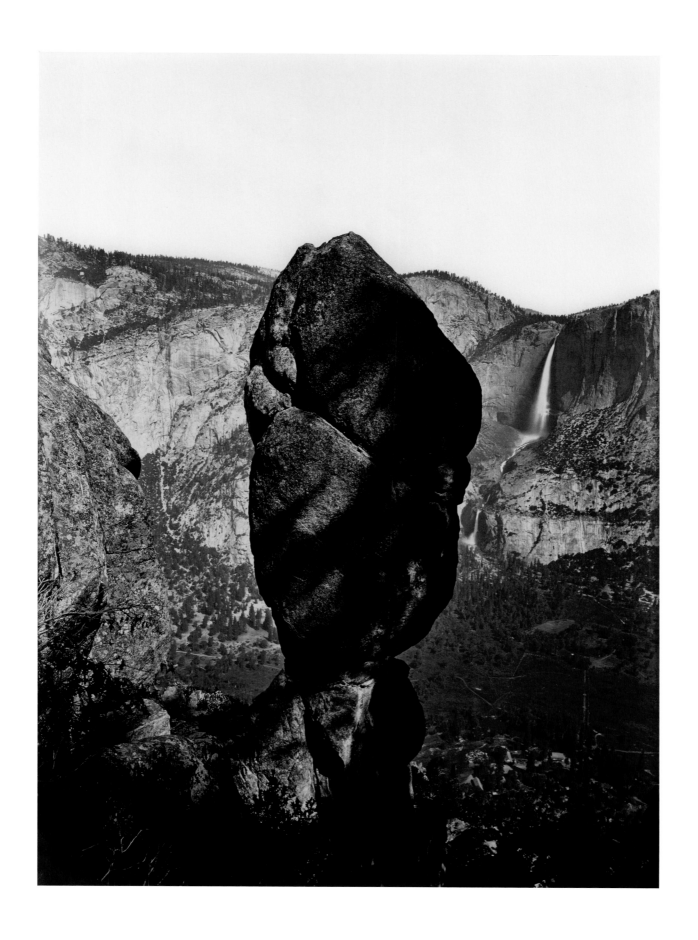

MENDOCINO

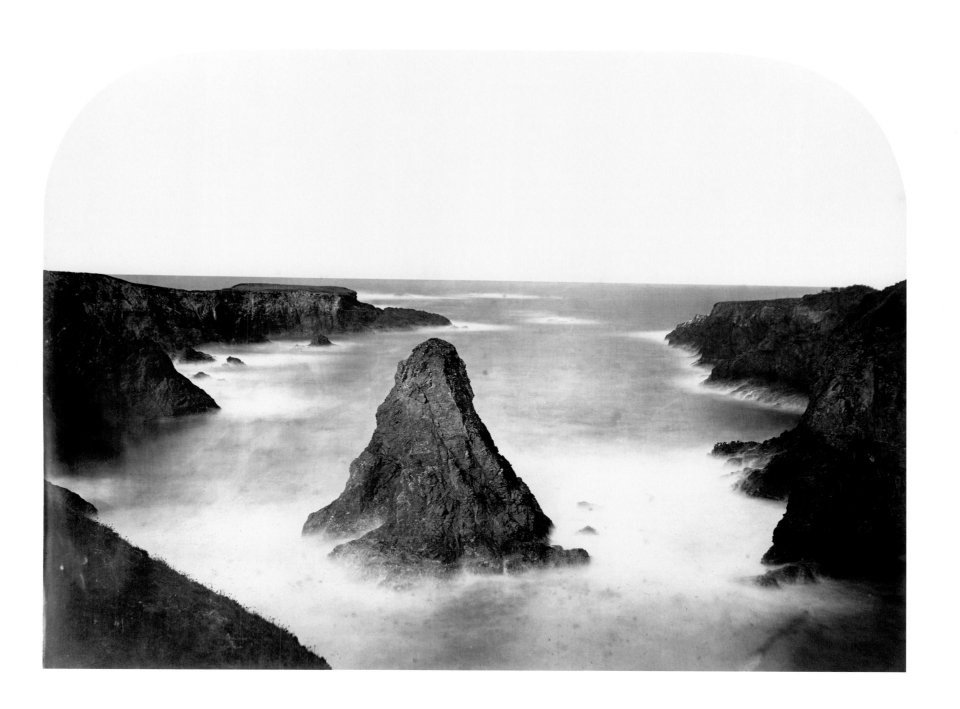

PLATE 42. *Coast View Number One*, 1863

PLATE 43. *Coast View, Mendocino County*, 1863

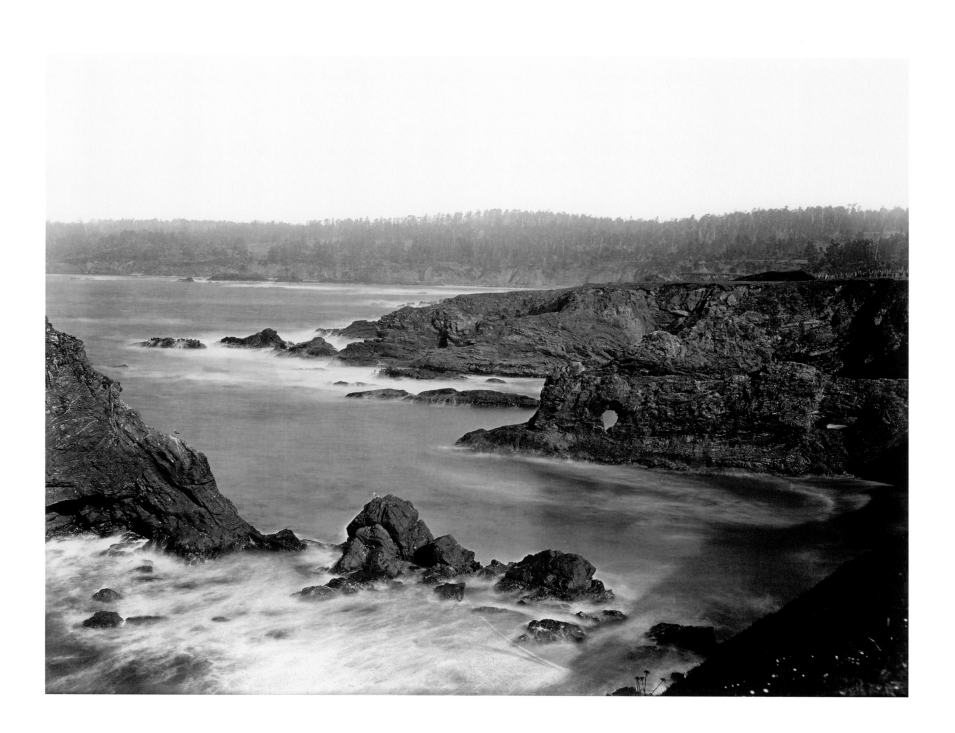

PLATE 44. *Mendocino River, From the Rancherie, Mendocino County, California, 1863*

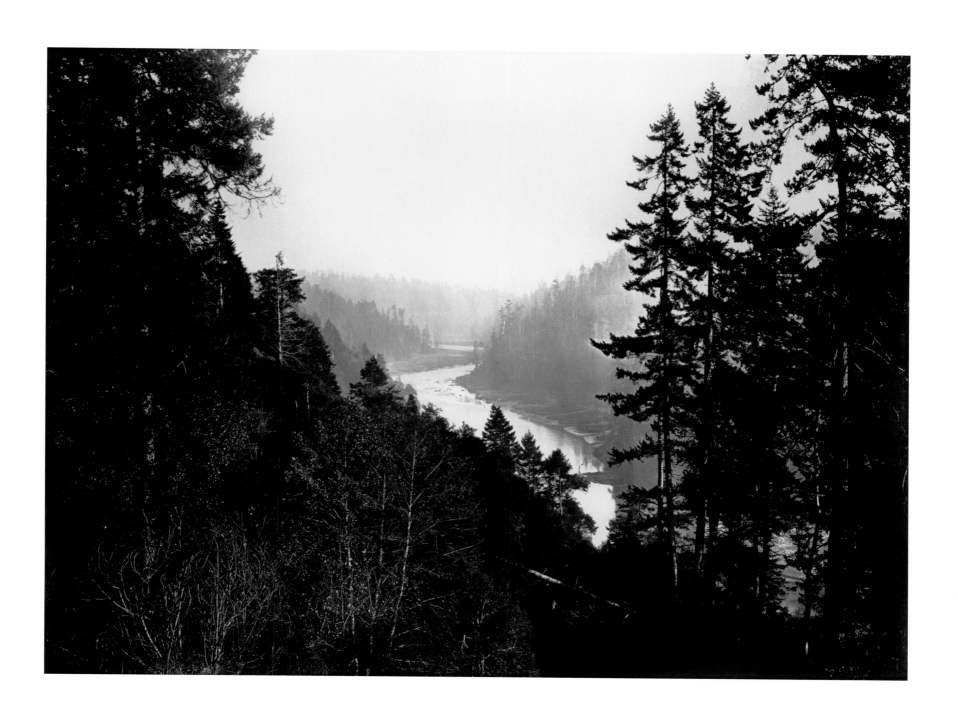

PLATE 45. *Albion River, Mendocino Co., Cal.*, 1863

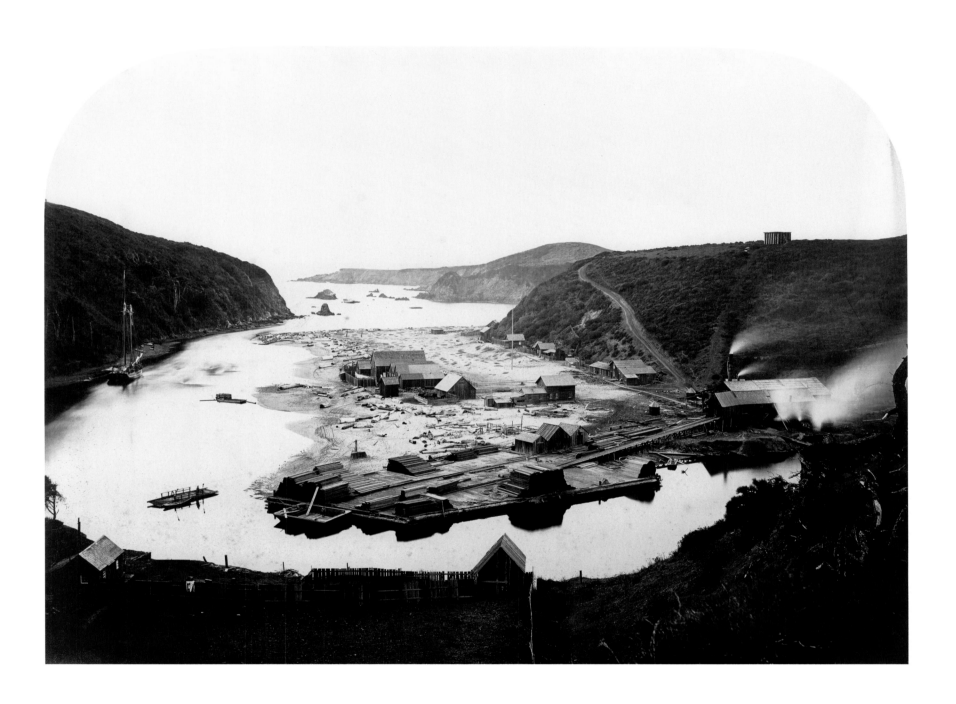

PLATE 46. *(Indian) Sweat House, Mendocino Co., Cal.*, 1863

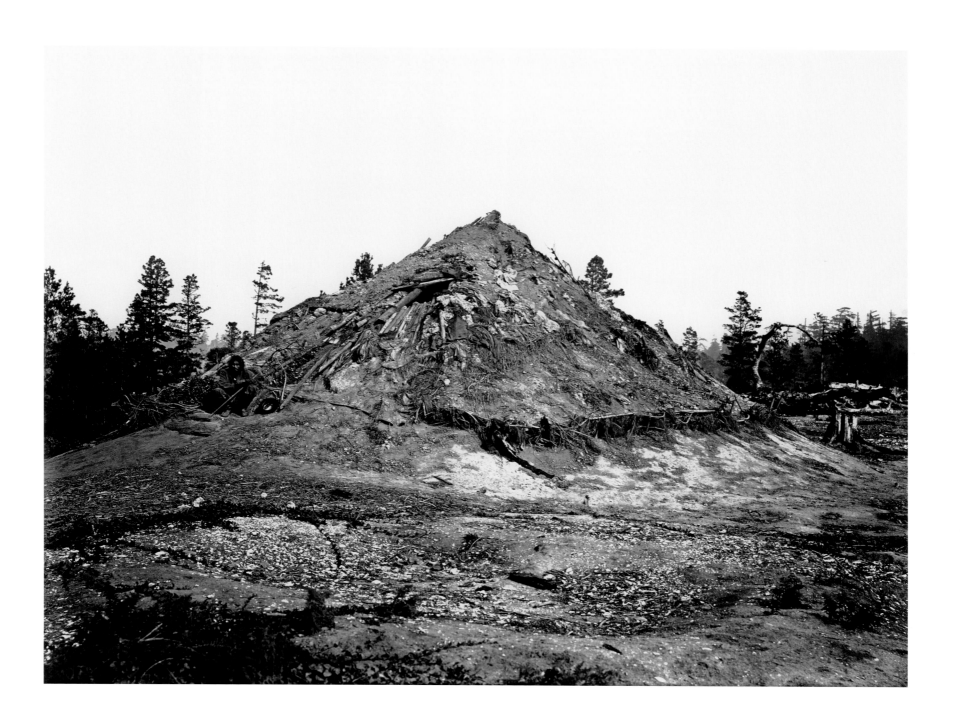

PLATE 47. *Residence of Mr. Freund*, 1863

PLATE 48. *The Church, Mendocino*, 1863

PLATE 49. *Kents Landing, Mendocino Co., Cal.*, 1863

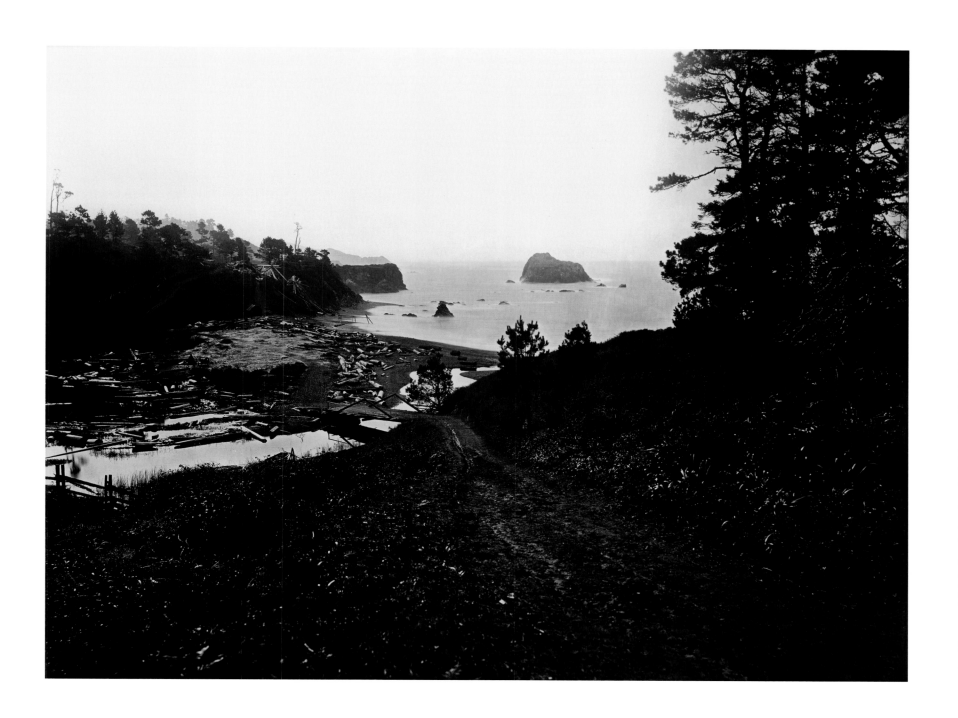

COLUMBIA RIVER

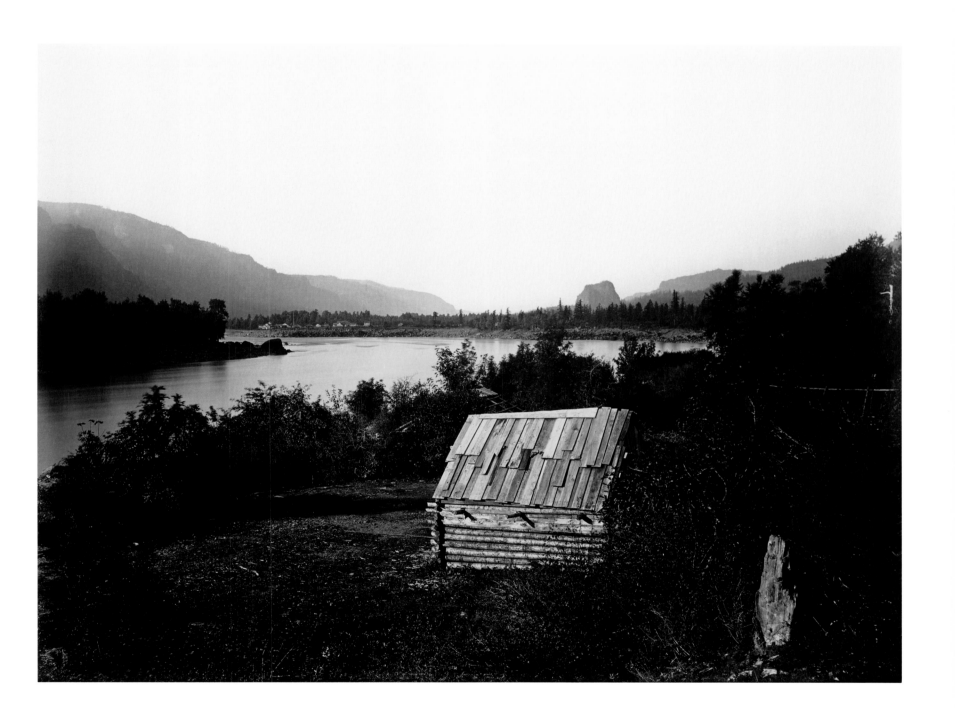

PLATE 50. *The Garrison, Columbia River, 1867*

PLATE 51. *Oswego Iron Works. Willamette River,* 1867

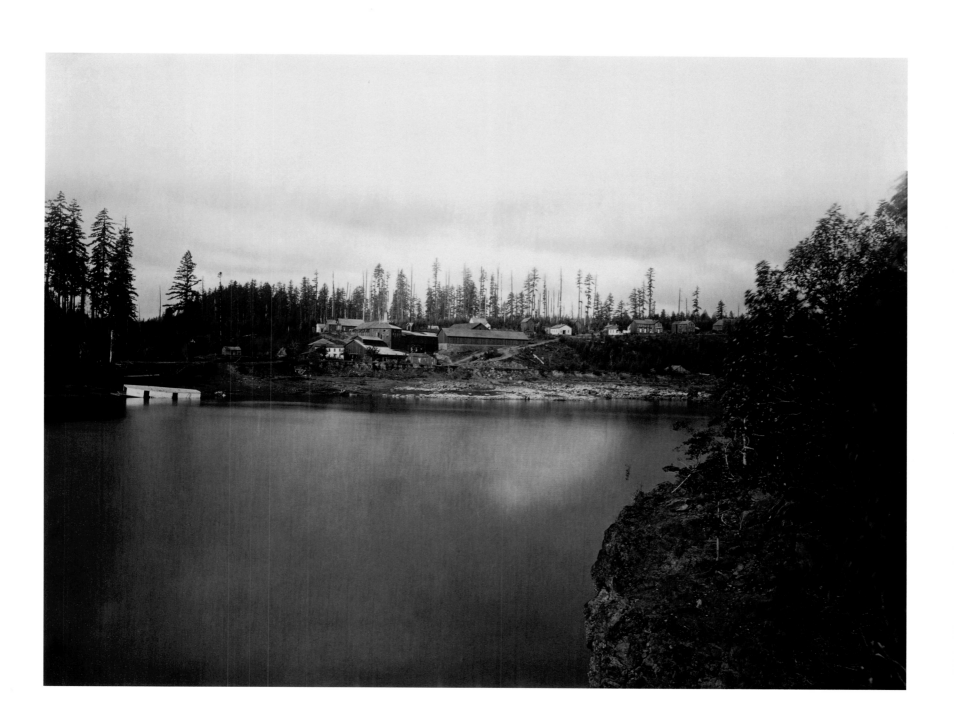

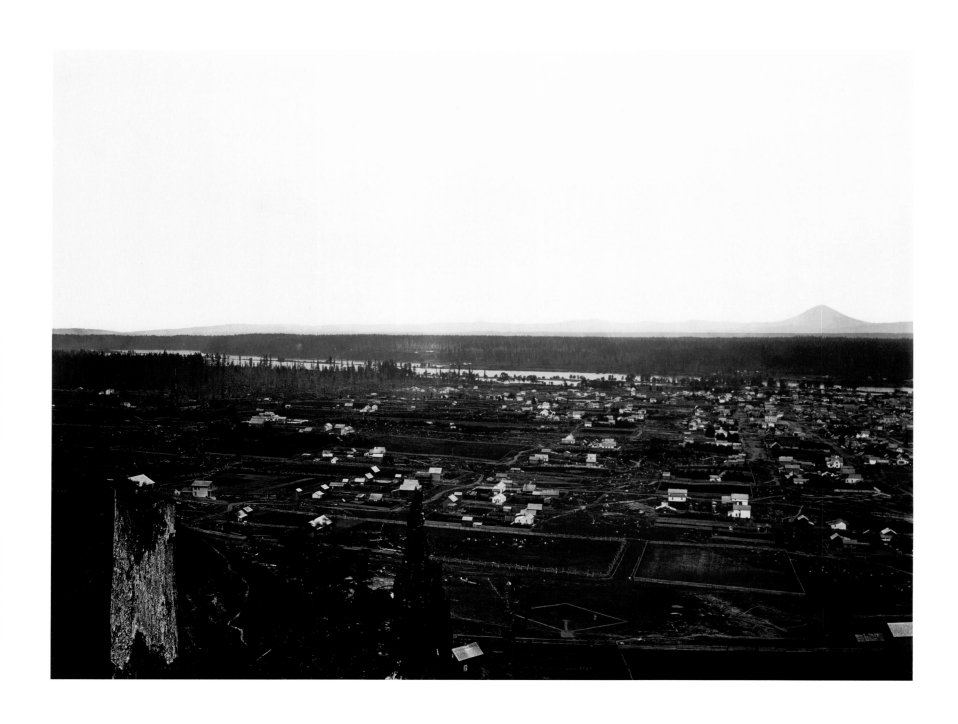

PLATES 52–54. *City of Portland and the Willamette River,* 1867

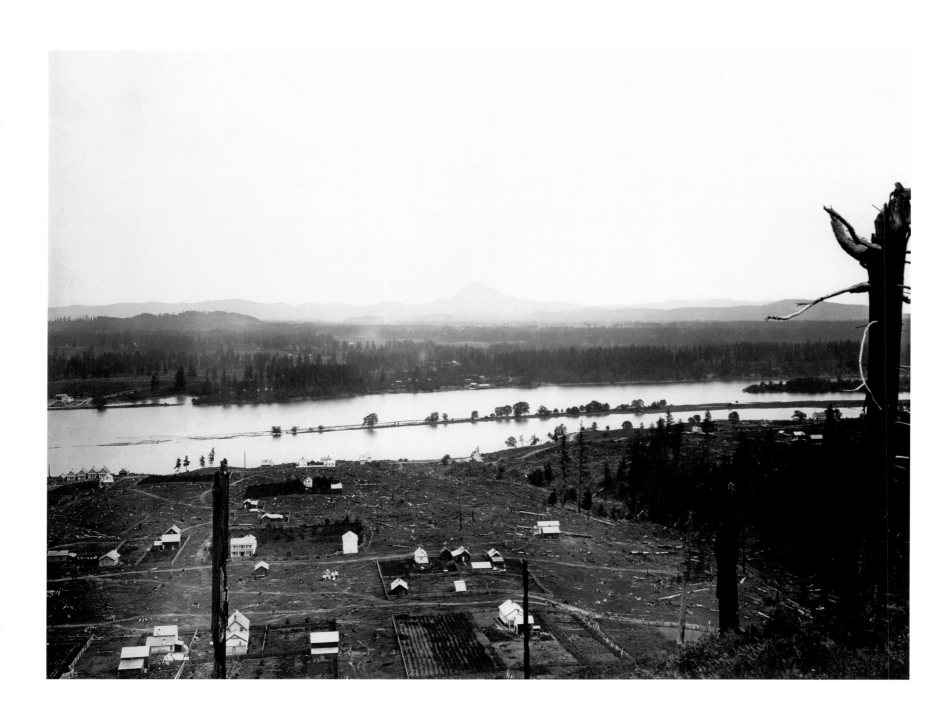

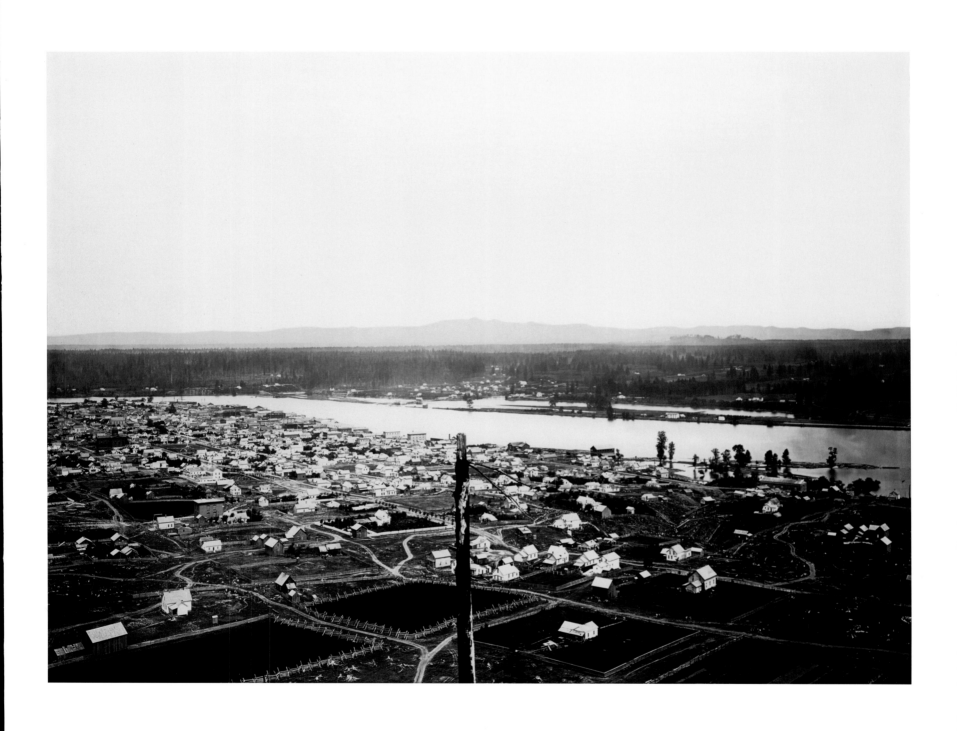

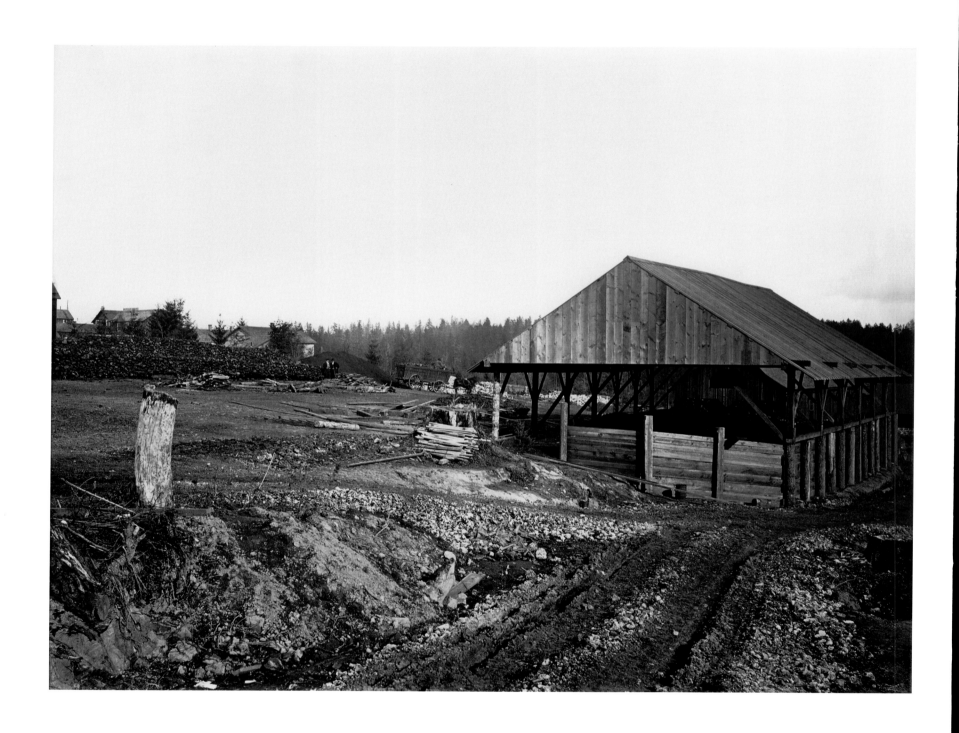

PLATES 55–56. *Oswego Iron Works, Willamette River*, 1867

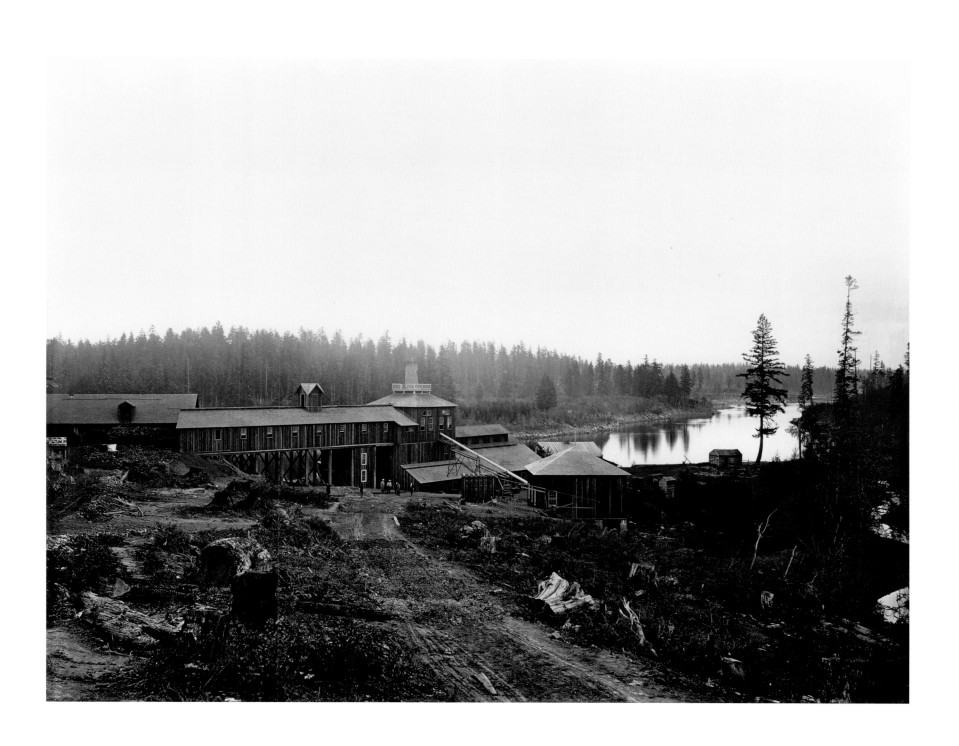

PLATE 57. *O.S.N Co's Warehouse, Celilo, Columbia River.*, 1867

128

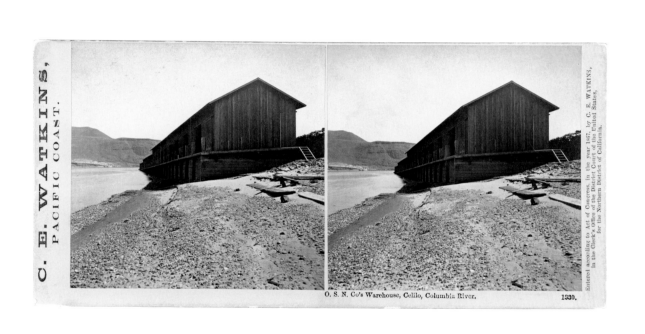

O. S. N. Co's Warehouse, Celilo, Columbia River. 1330.

PLATE 58. *Oregon Iron Company at Oswego*, 1867

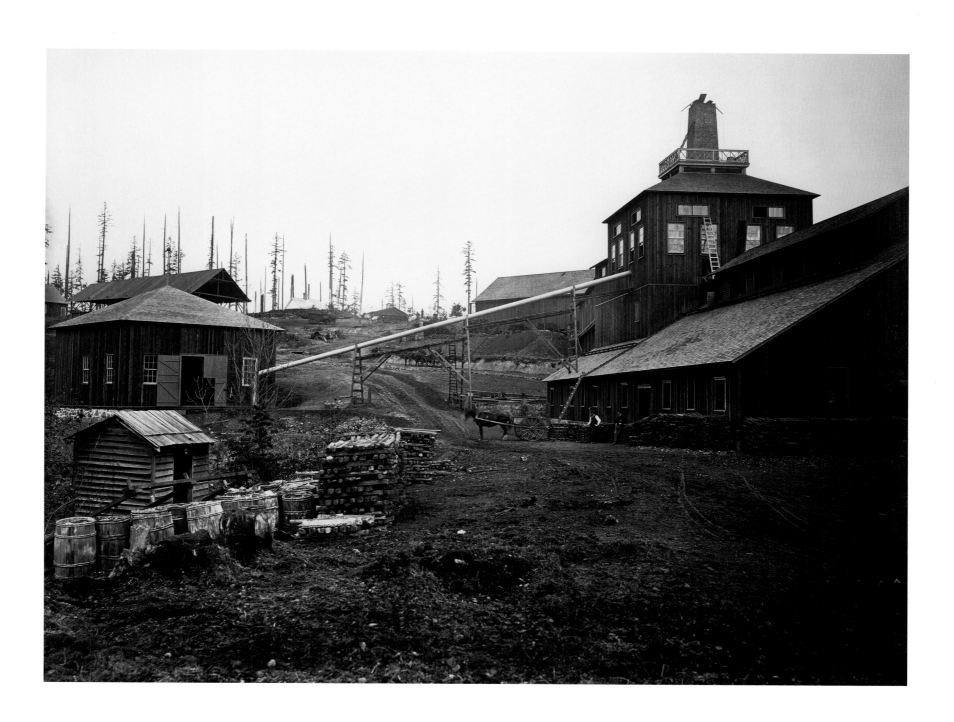

PLATE 59. *Flour and Woolen Mills, Oregon City,* 1867

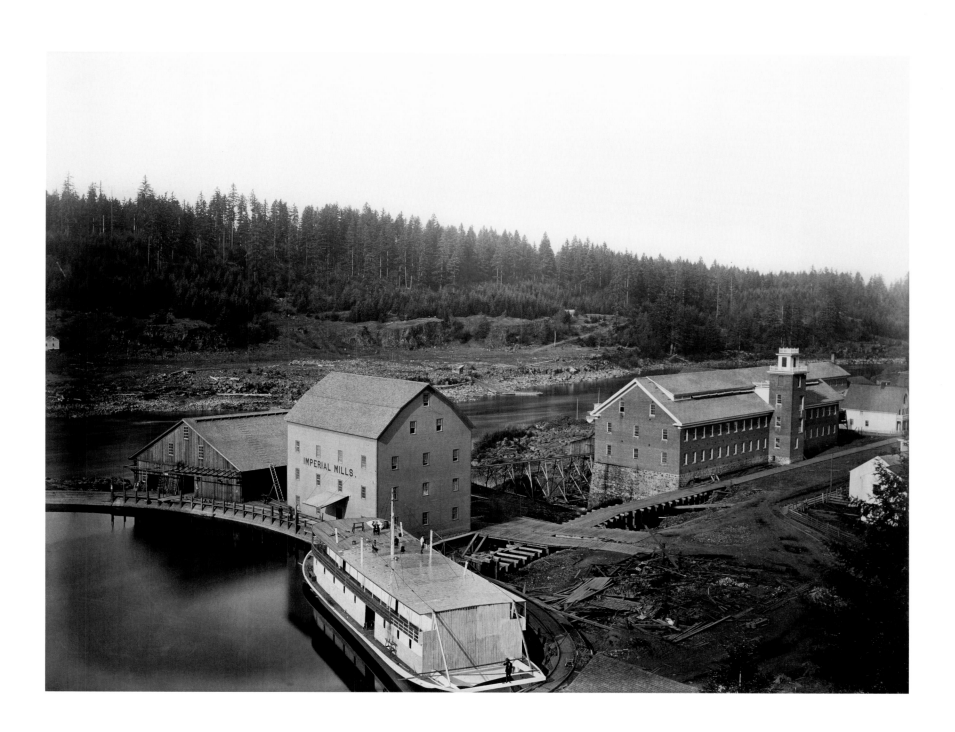

PLATE 60. *Upper Cascades, Columbia River,* 1867

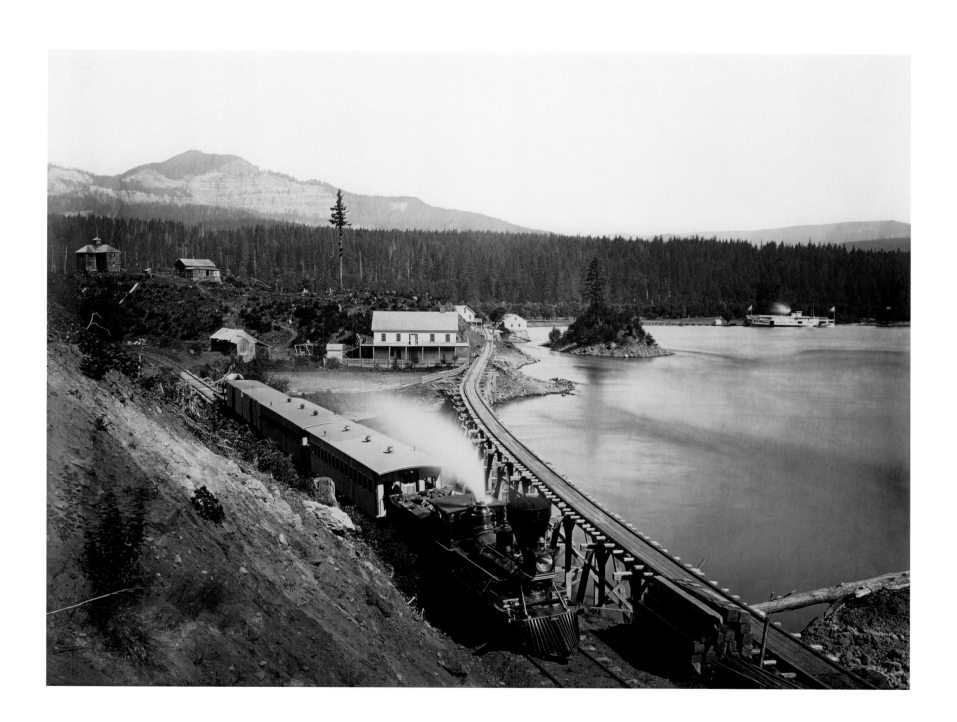

PLATE 61. *Eagle Creek, Columbia River,* 1867

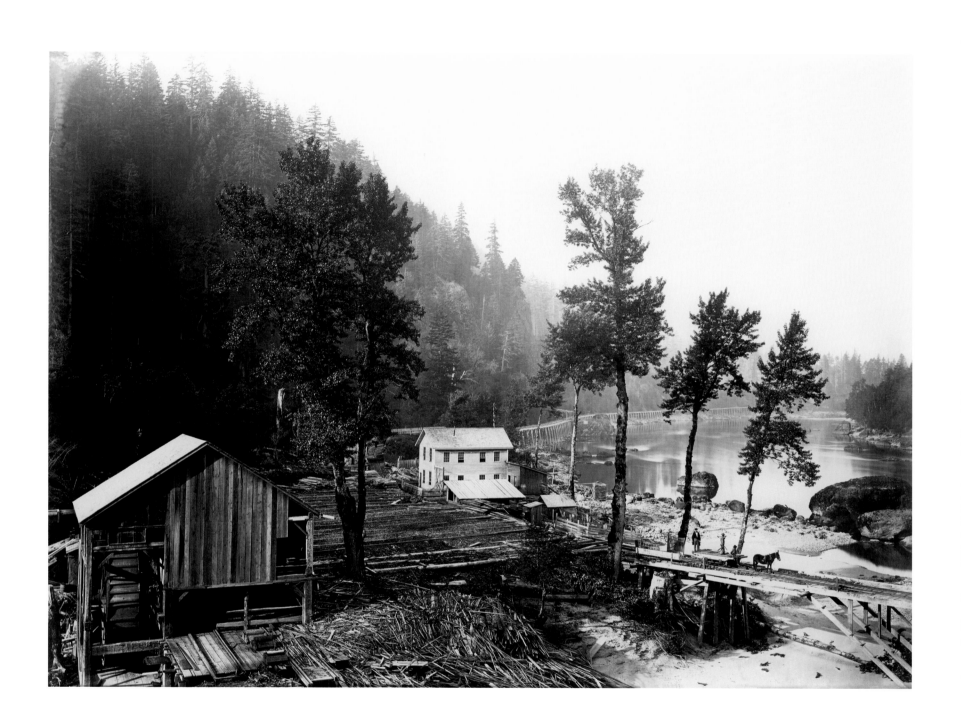

PLATE 62. *View on the Columbia, Cascades,* 1867

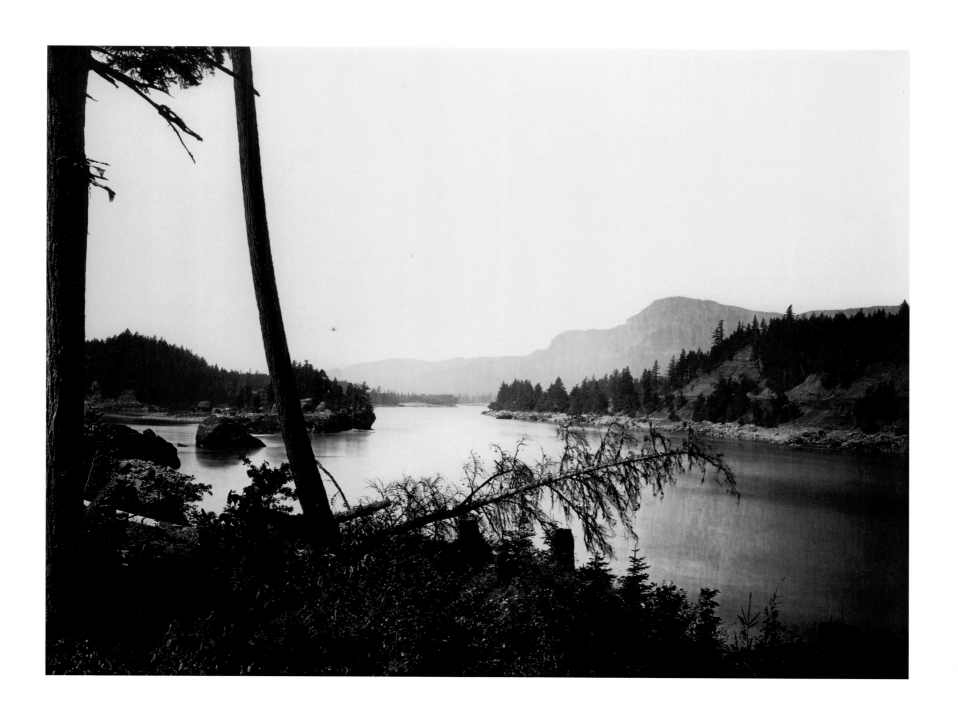

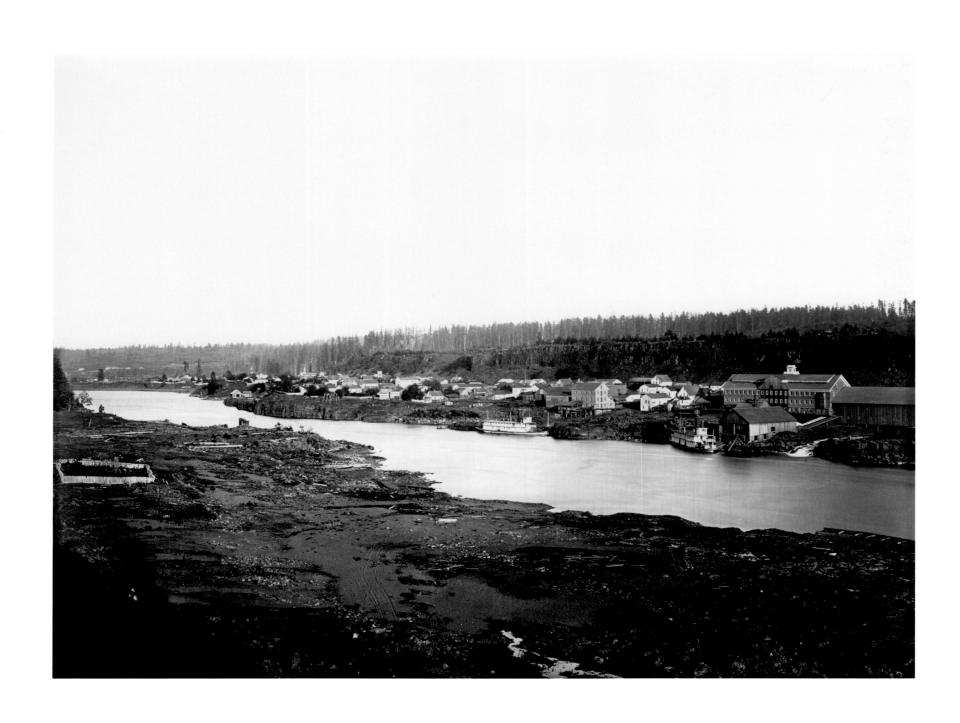

PLATES 63–65. *Panorama of Oregon City and Willamette Falls*, 1867

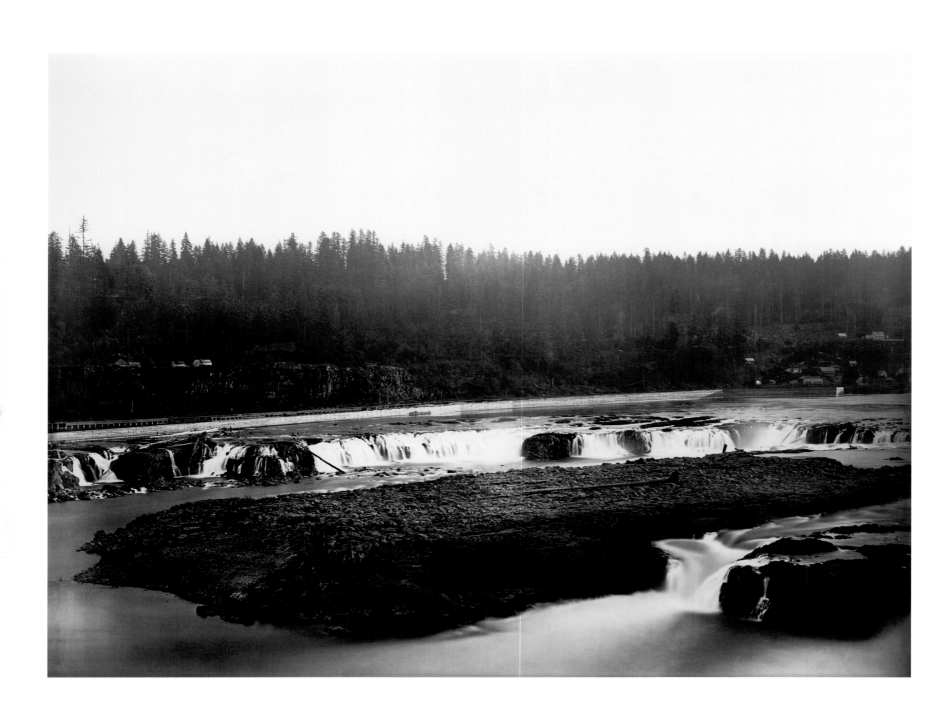

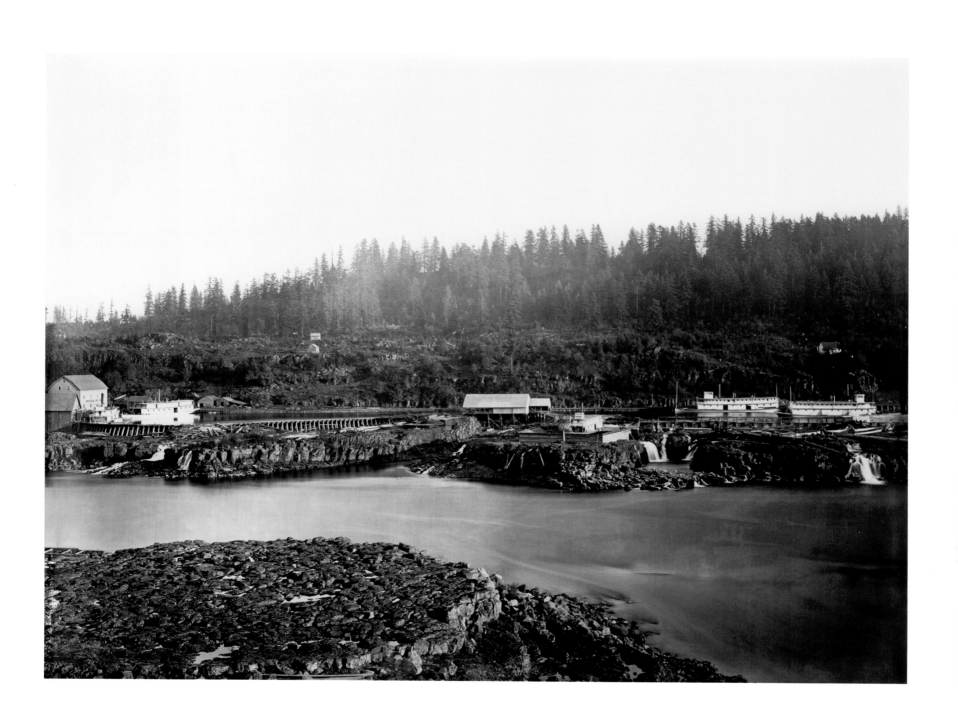

PLATE 66. *Castle Rock, Columbia River,* 1867

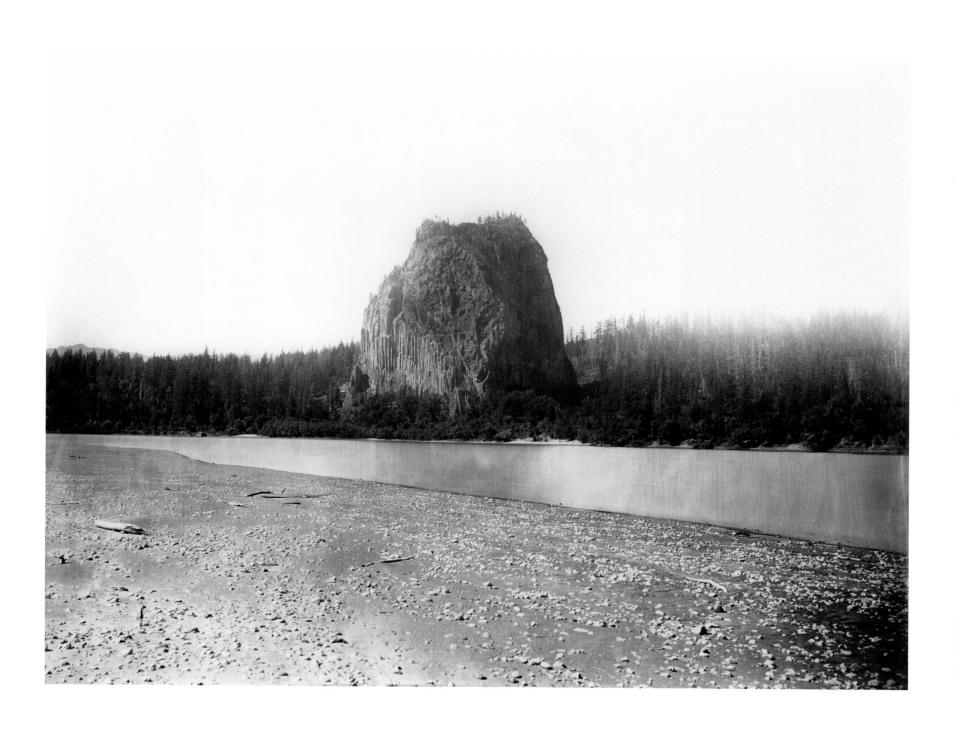

PLATE 67. *Multnomah Falls, Columbia River,* 1867 (stereo half)

PLATE 68. *Multnomah Falls, Cascades, Columbia River,* 1867

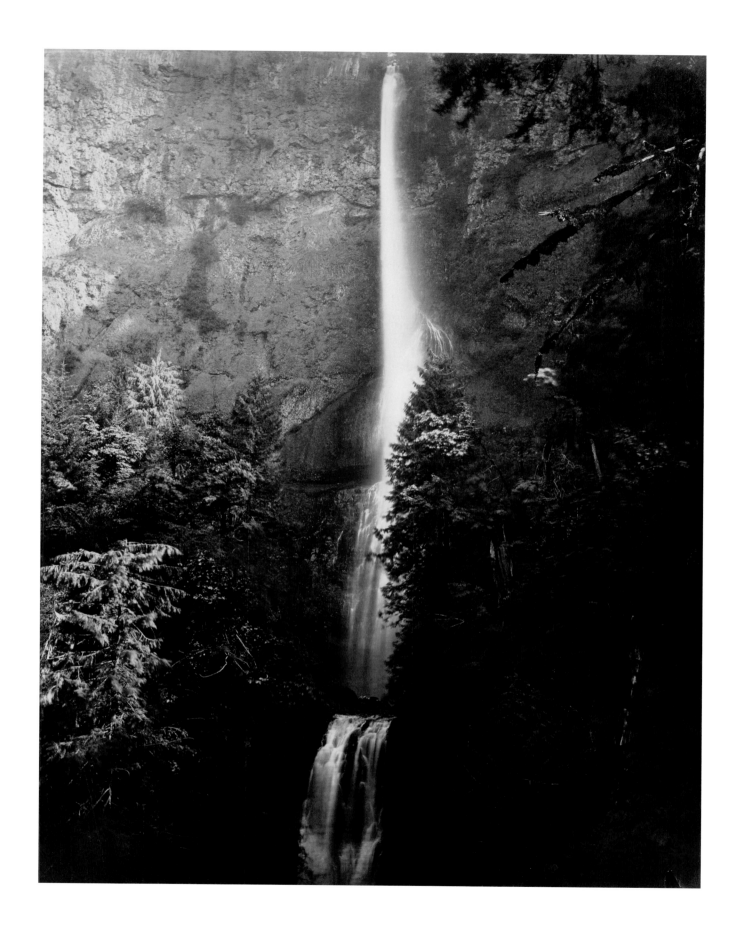

PLATE 69. *Cape Horn, Columbia River,* 1867

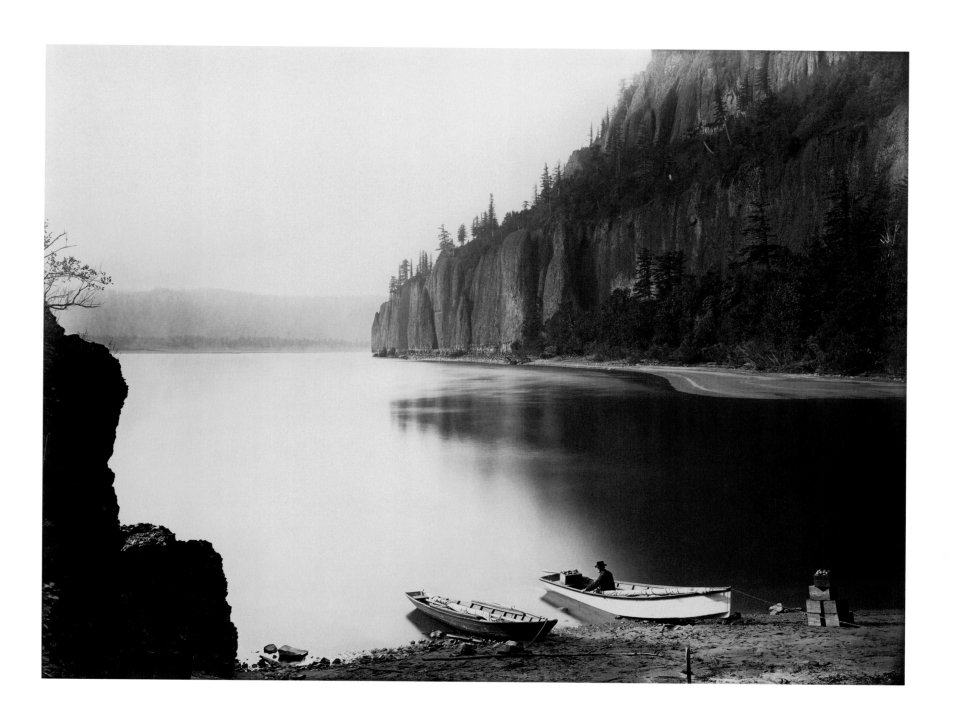

PLATE 70. *The Tooth Bridge, O.R.R. Cascades, Columbia River,* 1867

150

The Tooth Bridge, O. R. R. Cascades, Columbia River. 1299.

PLATE 71. *Cape Horn near Celilo,* 1867

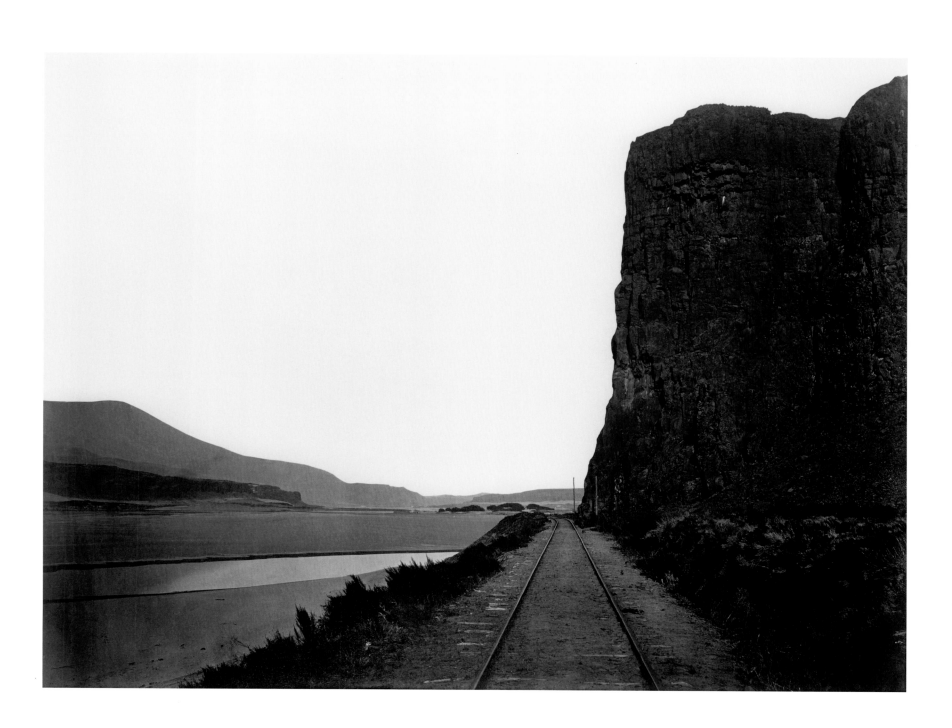

PLATE 72. *Mt. Hood and the Dalles, Columbia River*, 1867

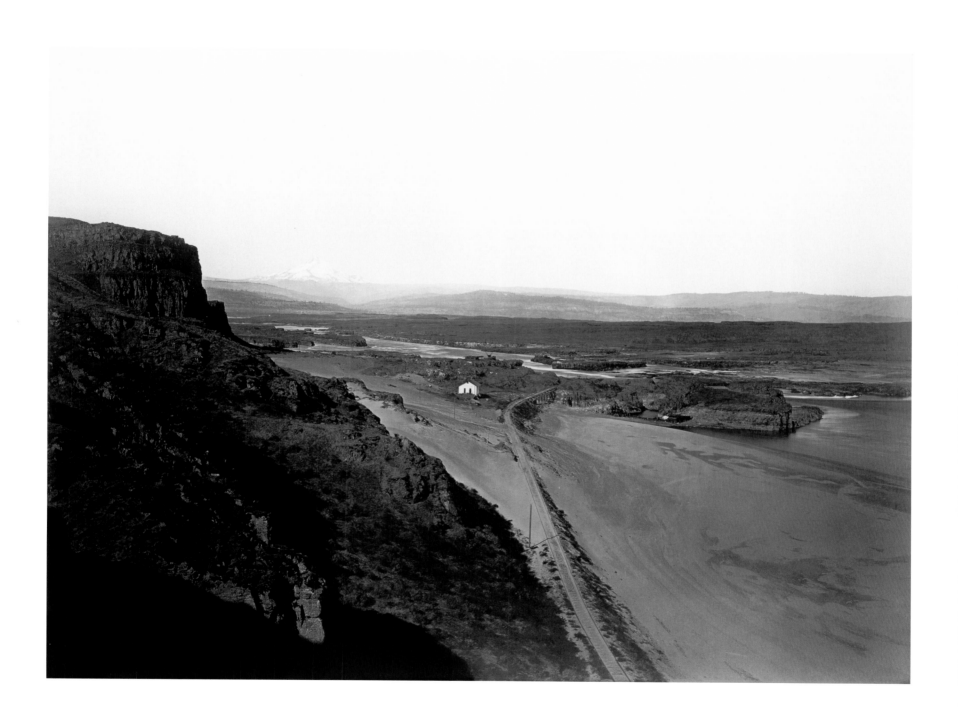

PACIFIC COAST AND MINING

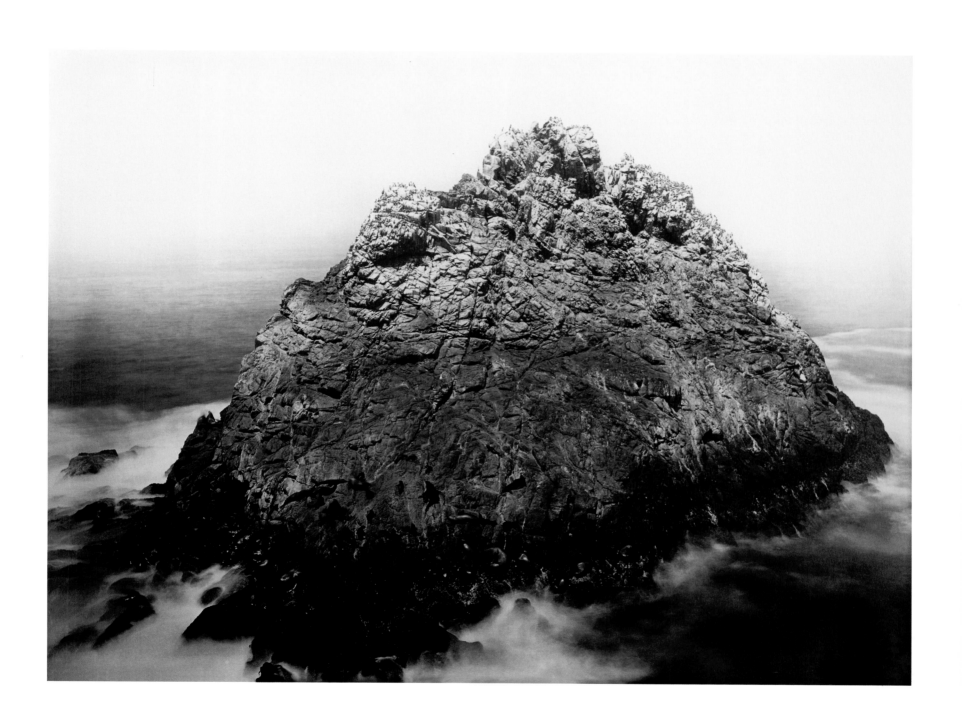

PLATE 73. *Sugar Loaf Islands, Farallons,* 1869

PLATE 74. *Sugar Loaf Islands, Farallons,* 1869

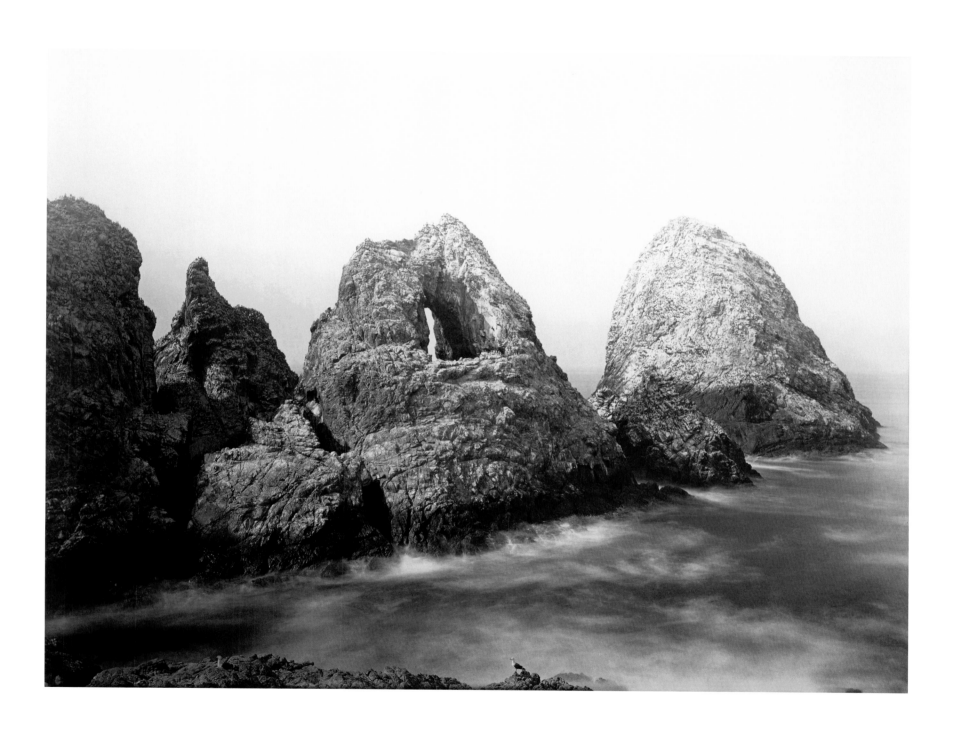

PLATE 75. *On the Sugar Loaf Islands, Farallone Islands, Pacific Ocean.*, 1869

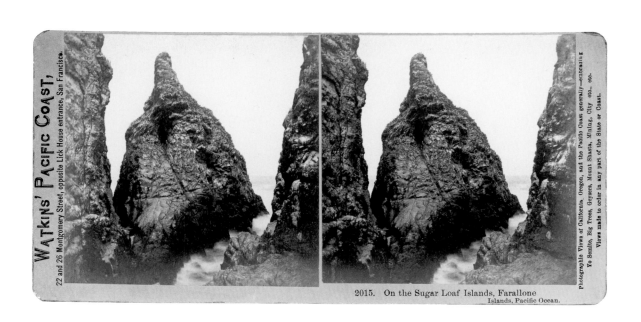

2015. On the Sugar Loaf Islands, Farallone
Islands, Pacific Ocean.

PLATE 76. *Arch at the West End Farallons*, 1869

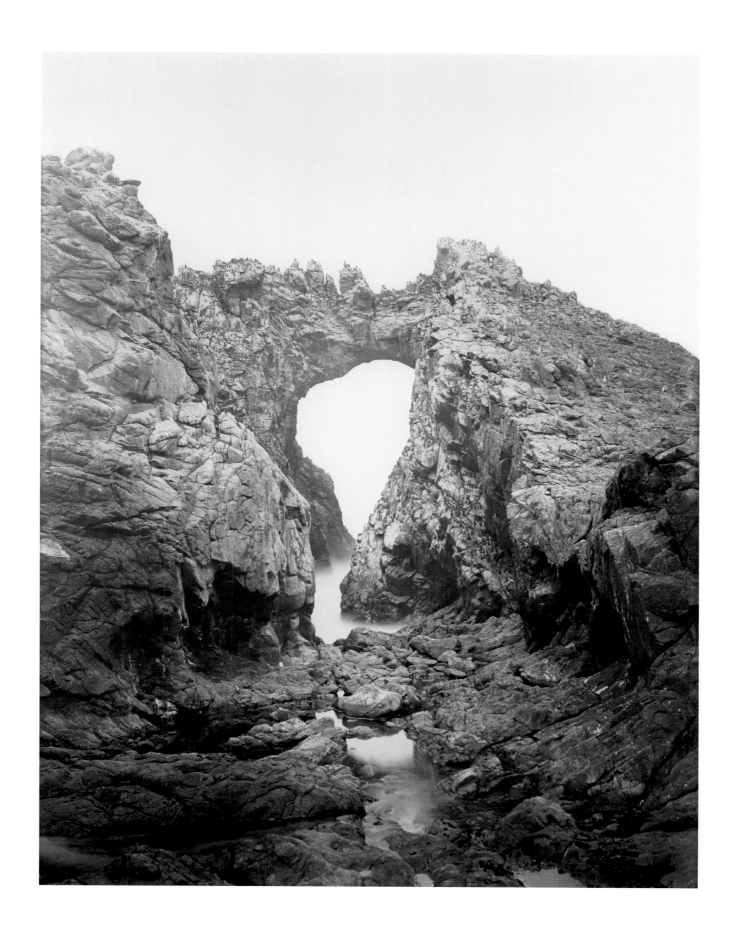

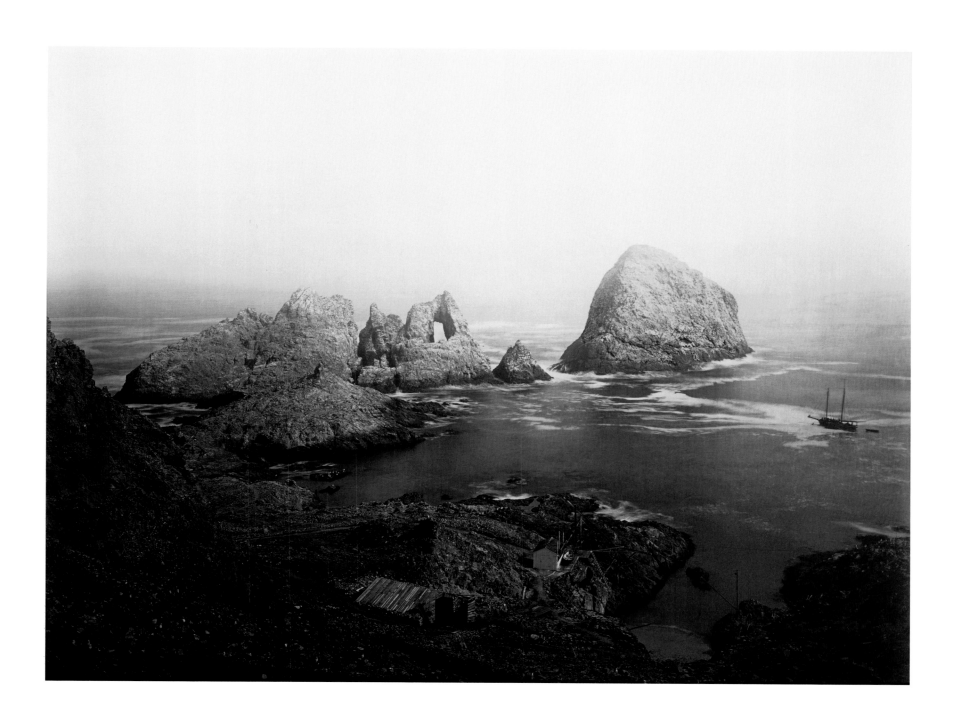

PLATE 78. *View in Weber Cañon, Utah*, 1873–74

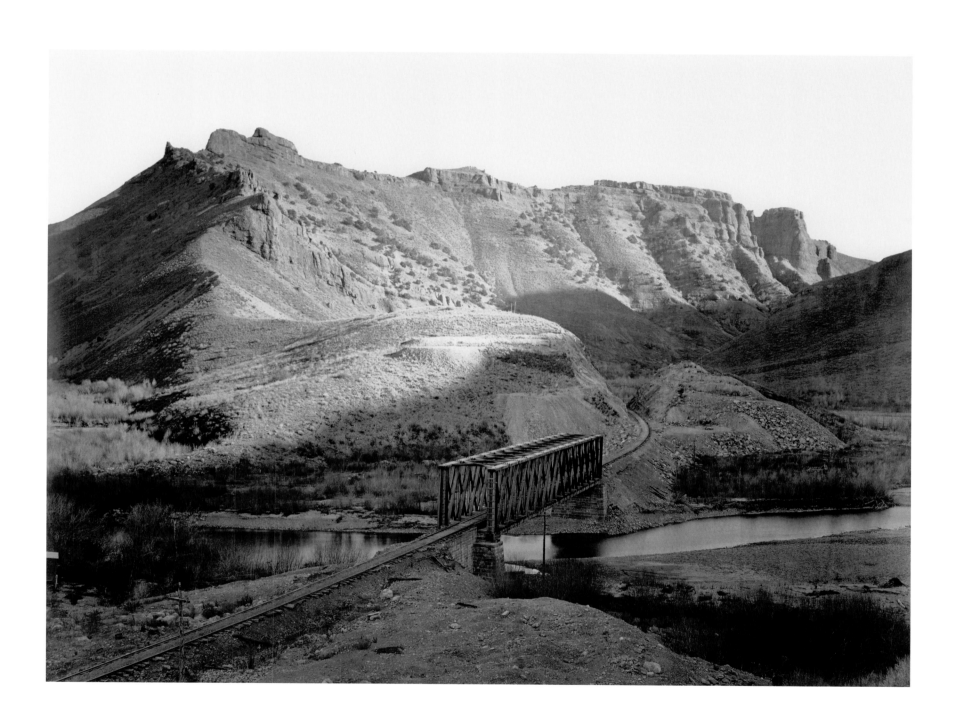

PLATE 79. *Hanging [Profile] Rock, Echo Canyon, Utah*, 1873–74

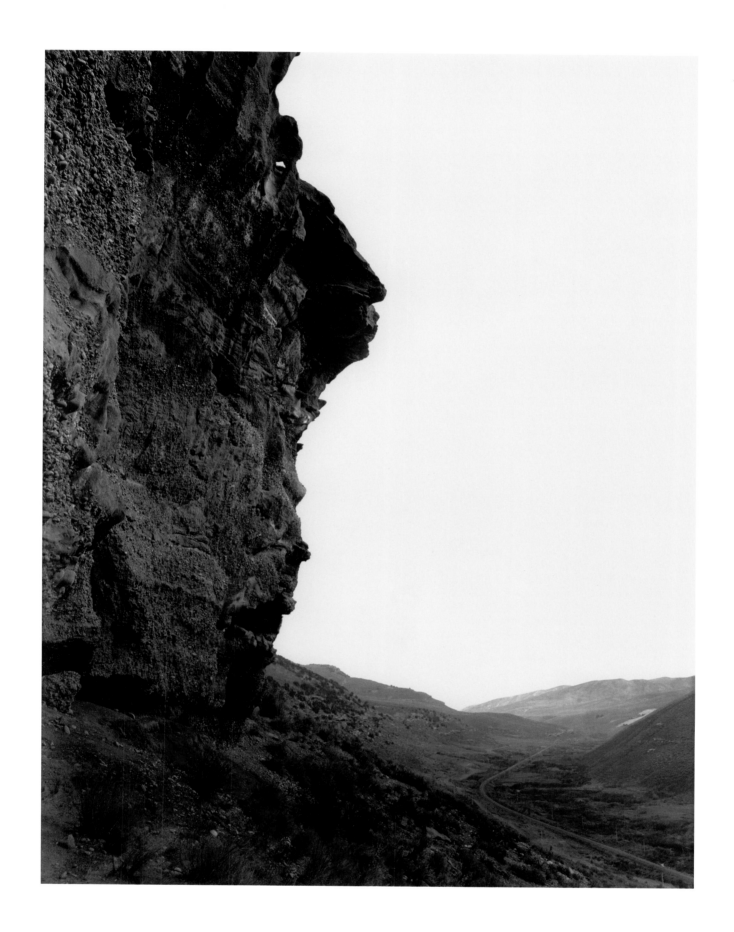

PLATES 80–82. *Panorama of Salt Lake City, Utah, 1873–74*

PLATE 83. *Dams and Lake, Nevada County, Distant View,* ca. 1871

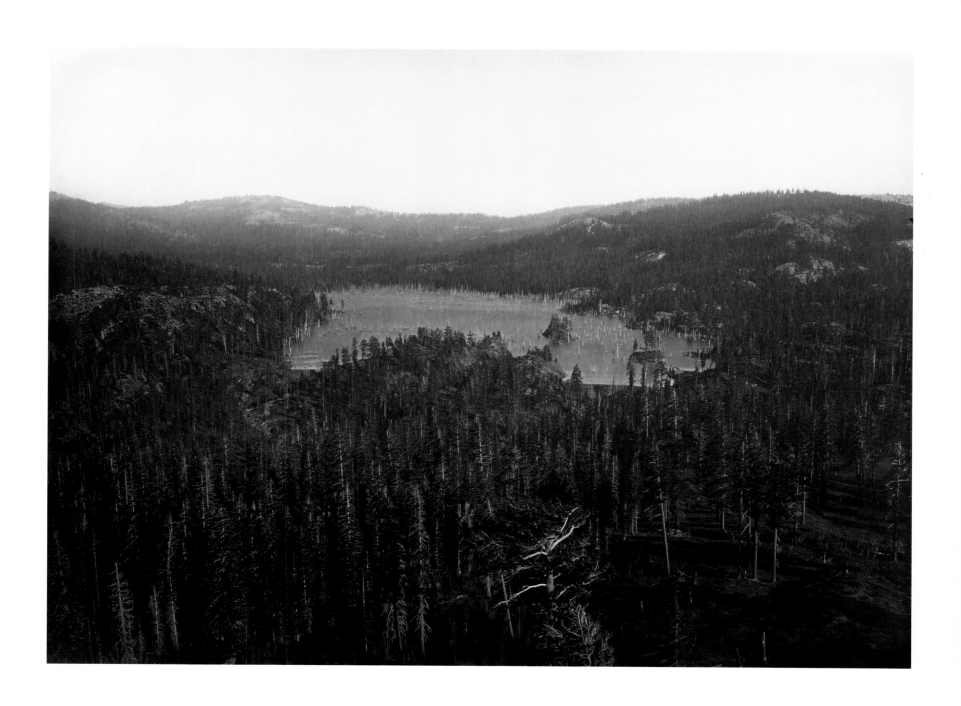

PLATE 84. *Dam and Lake, Nevada County, Near View*, ca. 1871

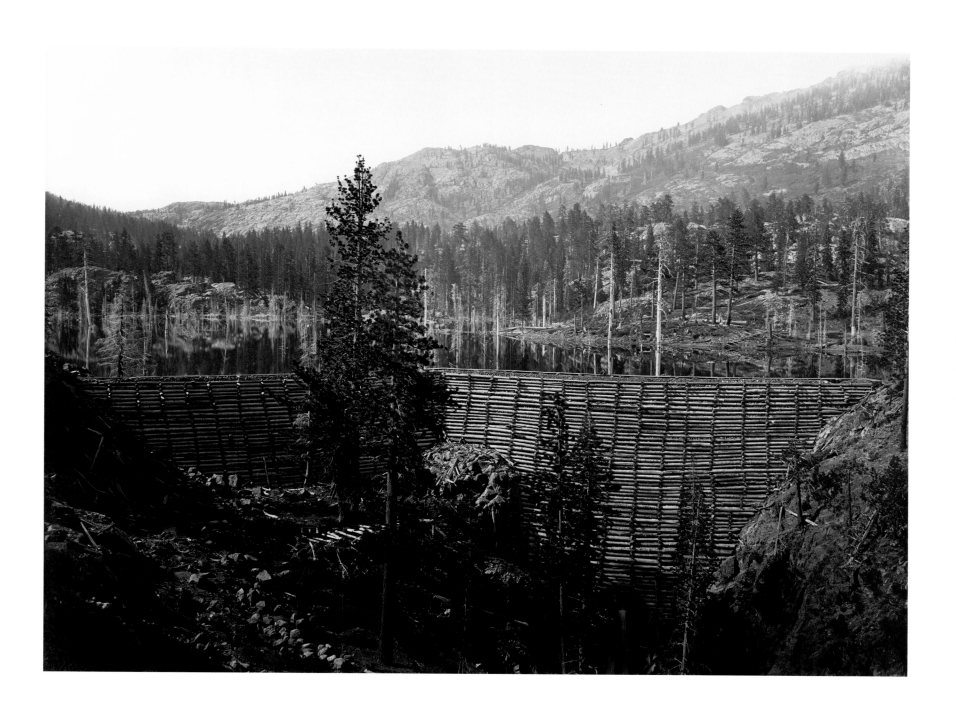

PLATE 85. *Malakoff Diggins, North Bloomfield, Nevada Co., Cal.*, ca. 1869–72

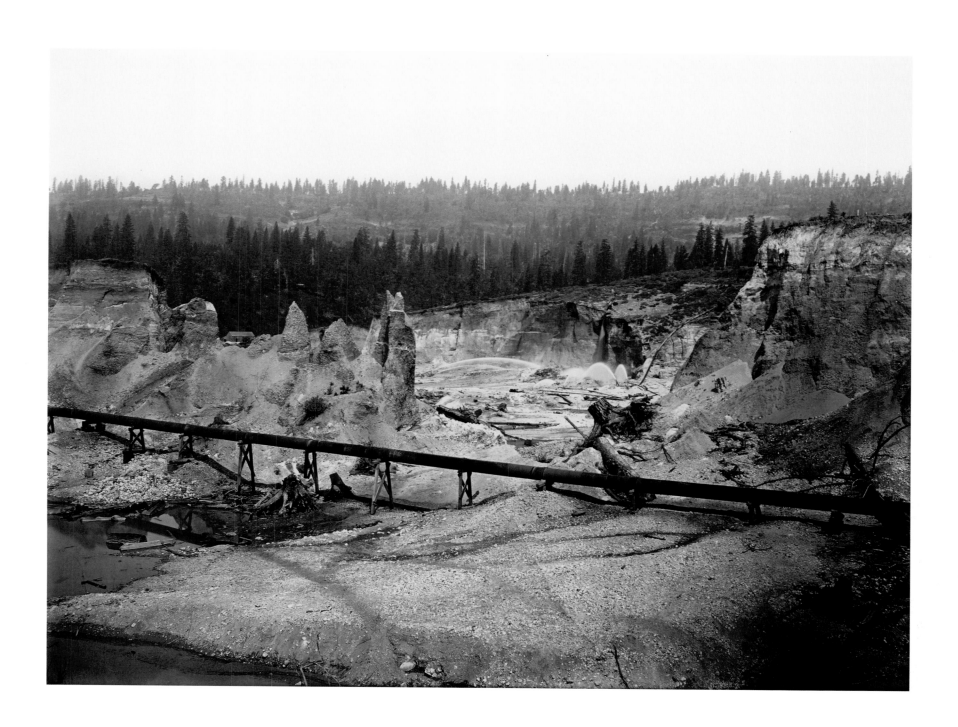

PLATE 86. *North Bloomfield Gravel Mines, Nevada Co., Cal.*, ca. 1869–72

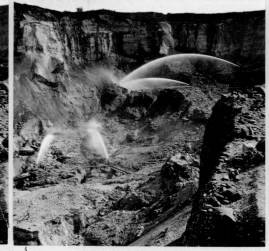

North Bloomfield Gravel Mines, Nevada Co., Cal. 3395

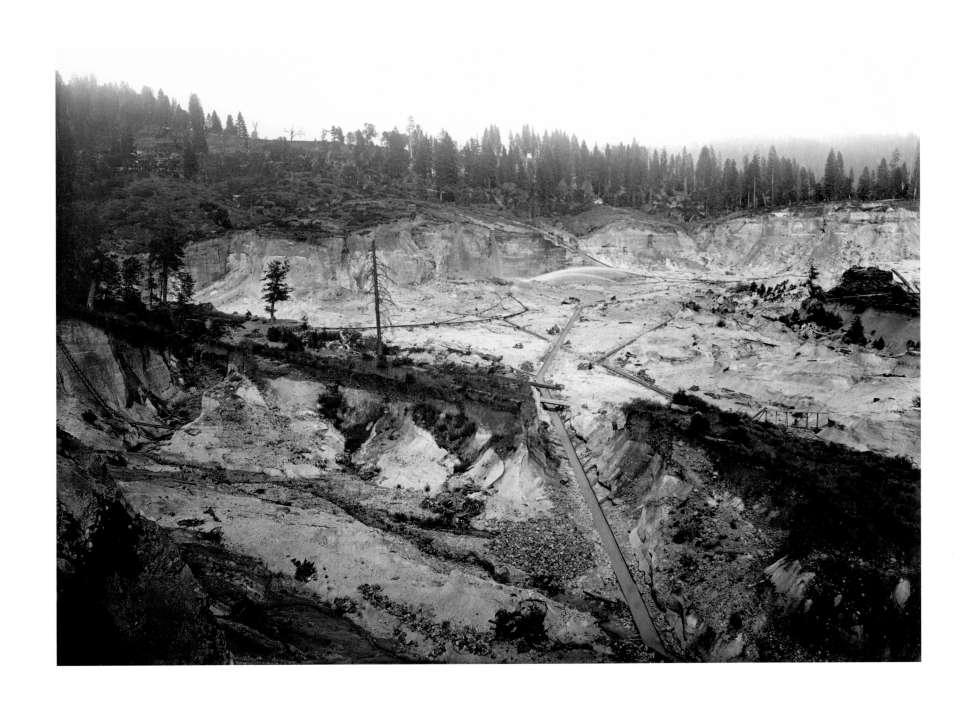

PLATE 87. *Malakoff Diggings. North Bloomfield Gravel Mining Company*, ca. 1869–72

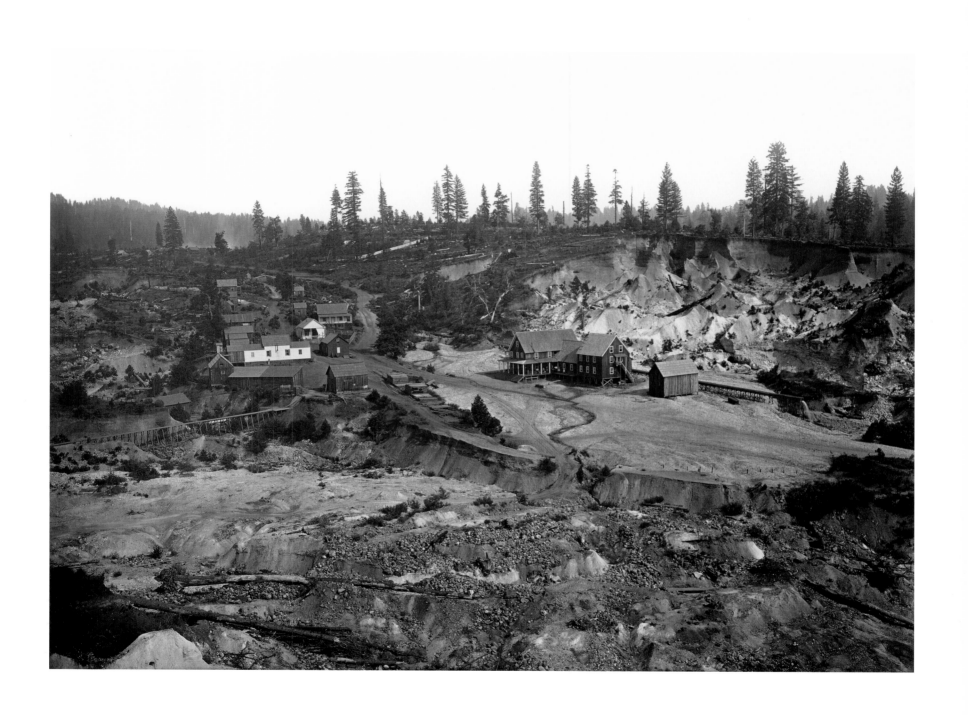

PLATE 88. *Malakoff. North Bloomfield Gravel Mining Company*, ca. 1869–72

PLATE 89. *Round Top from Western Part of Ridge*, 1879

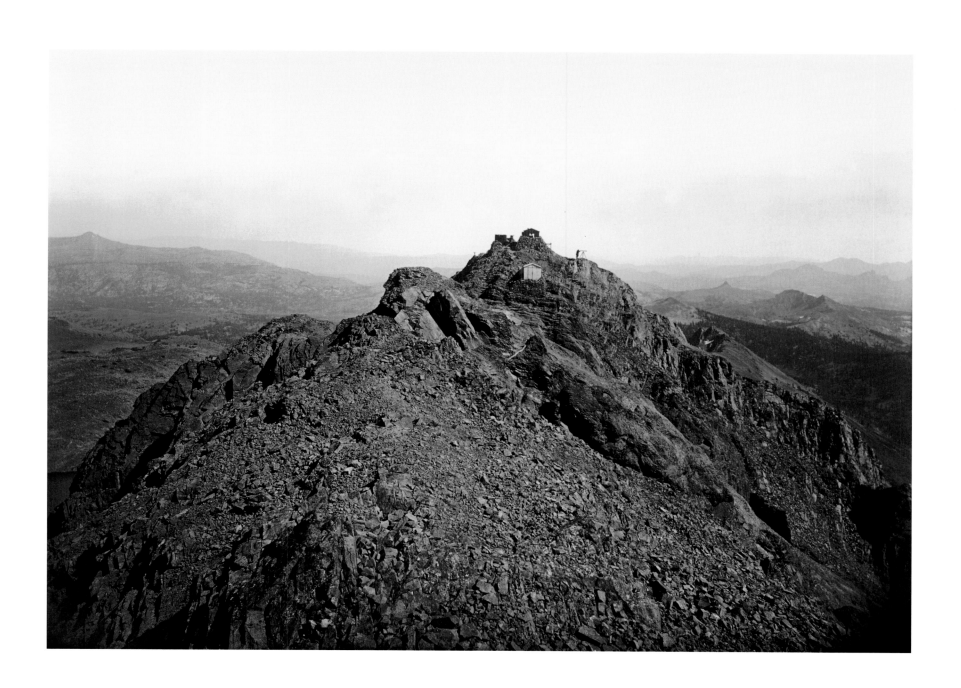

NEW SERIES

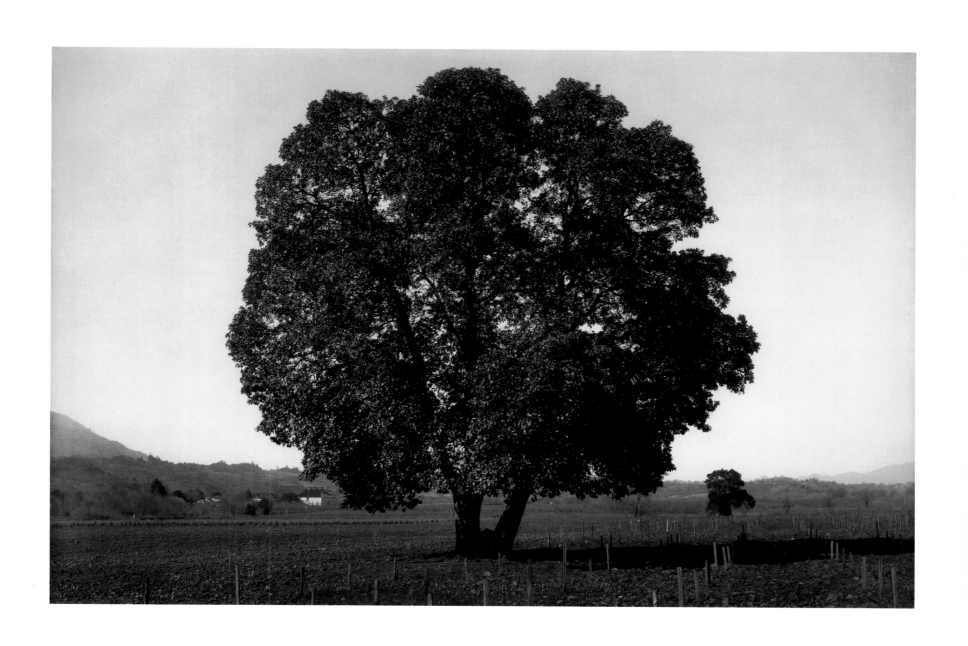

PLATE 90. *Arbutus Menziesii Pursh*, ca. 1872–78

PLATE 91. *Buckeye Tree, California,* ca. 1872–78

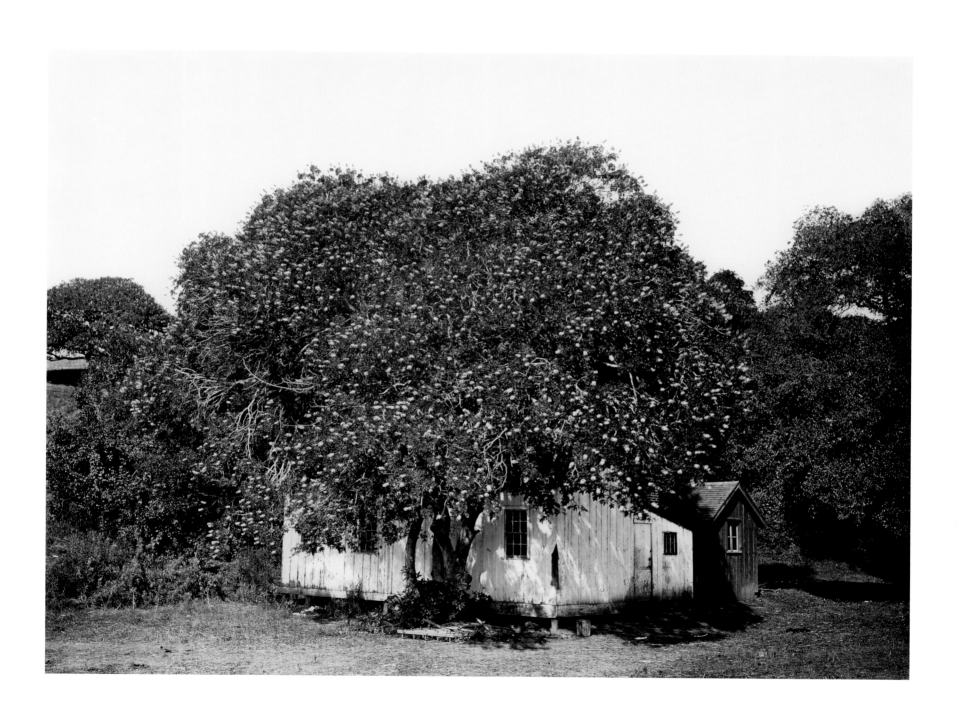

PLATE 92. *Orange Cling Peach, Waul Orchard, Kern County, California,* ca. 1887–88

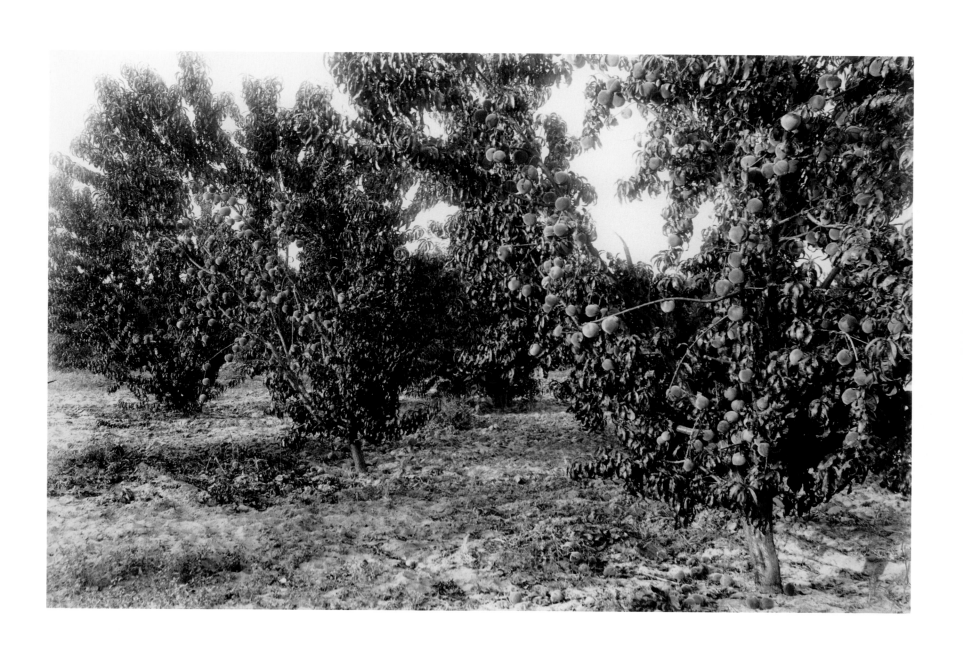

PLATE 93. *Late George Cling Peaches,* ca. 1887–88

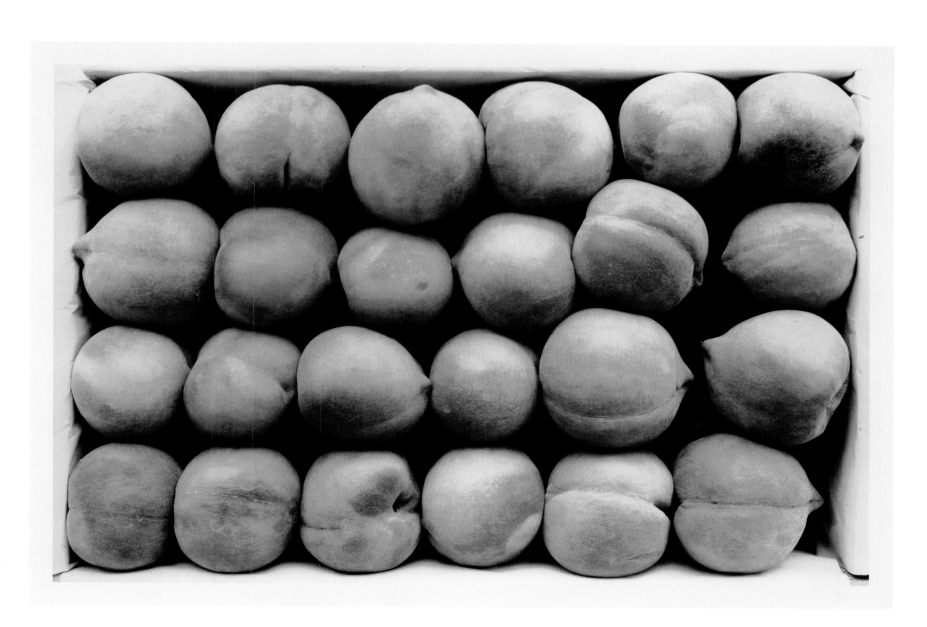

PLATE 94. *Looking up among the sugar pines—Calaveras Grove,* from an untitled album, 1878

PLATE 95. *Victoria Regia,* ca. 1878

Victoria Regia 3737

PLATE 96. *Casa Grande, Pre-Historic Ruins Arizona*, 1880

PLATE 100. *C. P. ferry boat* Solano *in slip at Pt. Costa waiting for train.*, ca. 1876

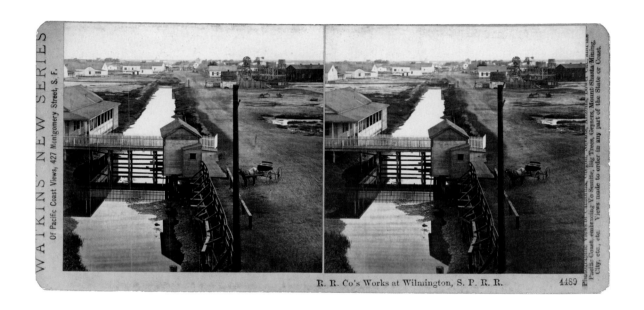

PLATE 101. *R. R. Co's Works at Wilmington, S. P. R. R.*, ca. 1880

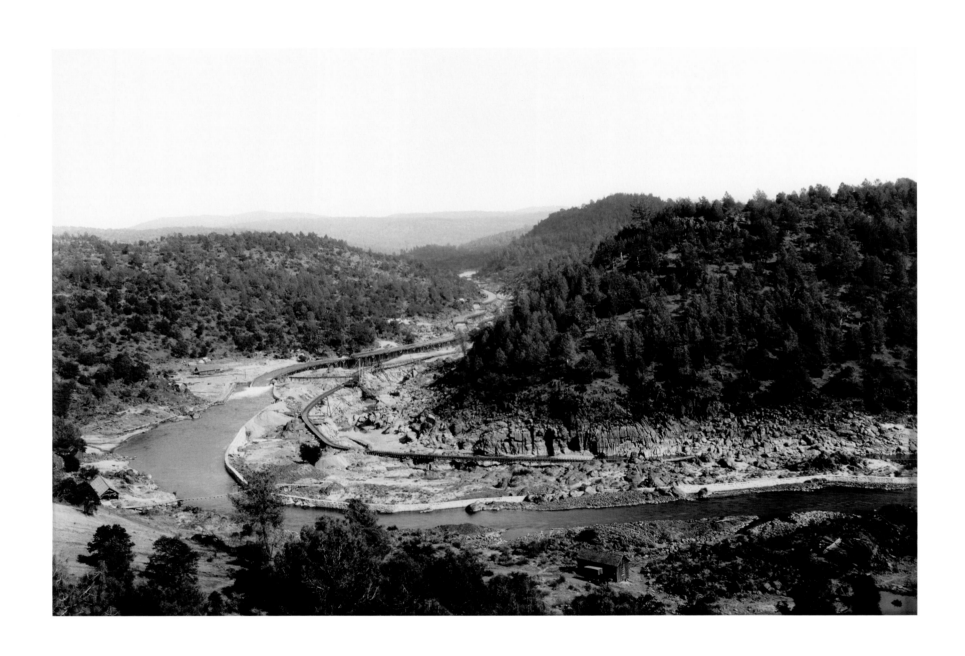

PLATES 102–103. *Golden Feather Mining Claim, No. 2 and No. 3*, 1891

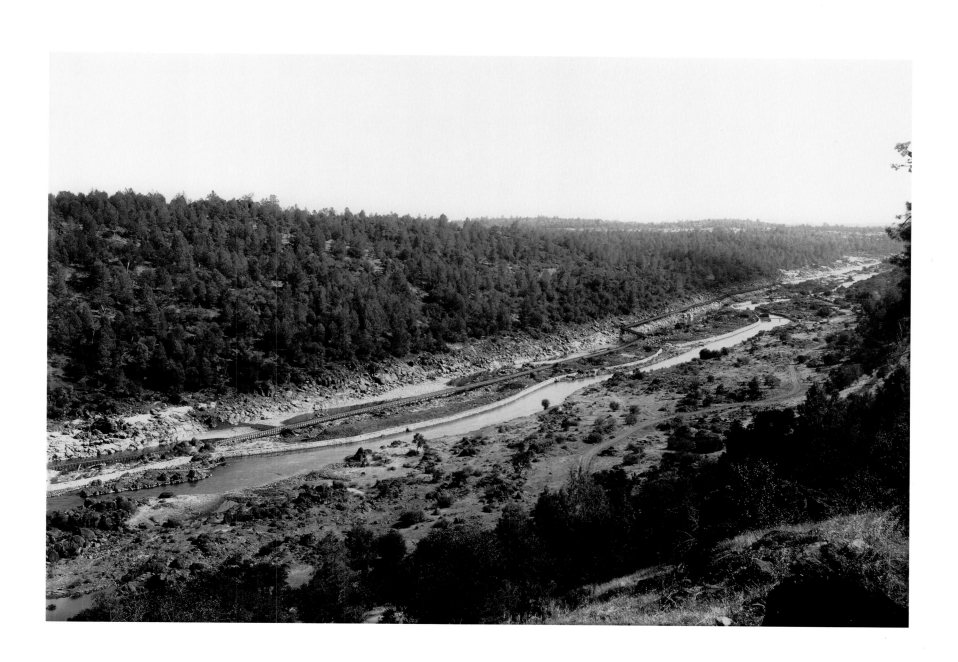

PLATE 104. *Golden Gate Mining Claim, No. 6*, 1891

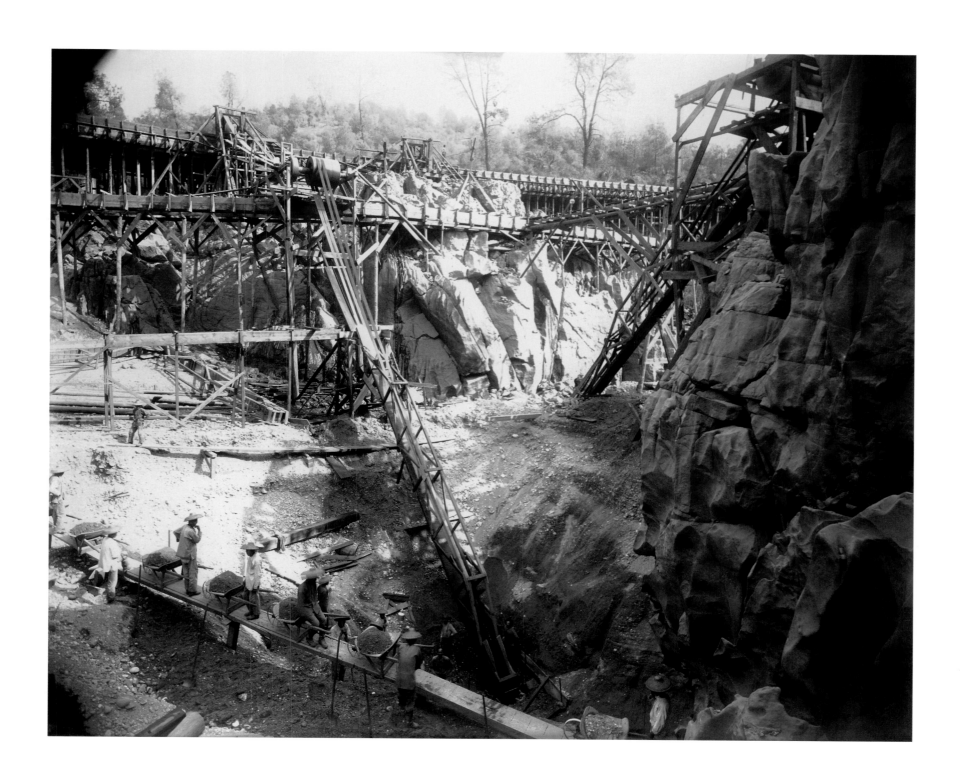

PLATE 105. *Golden Feather Mining Claim, No. 9*, 1891

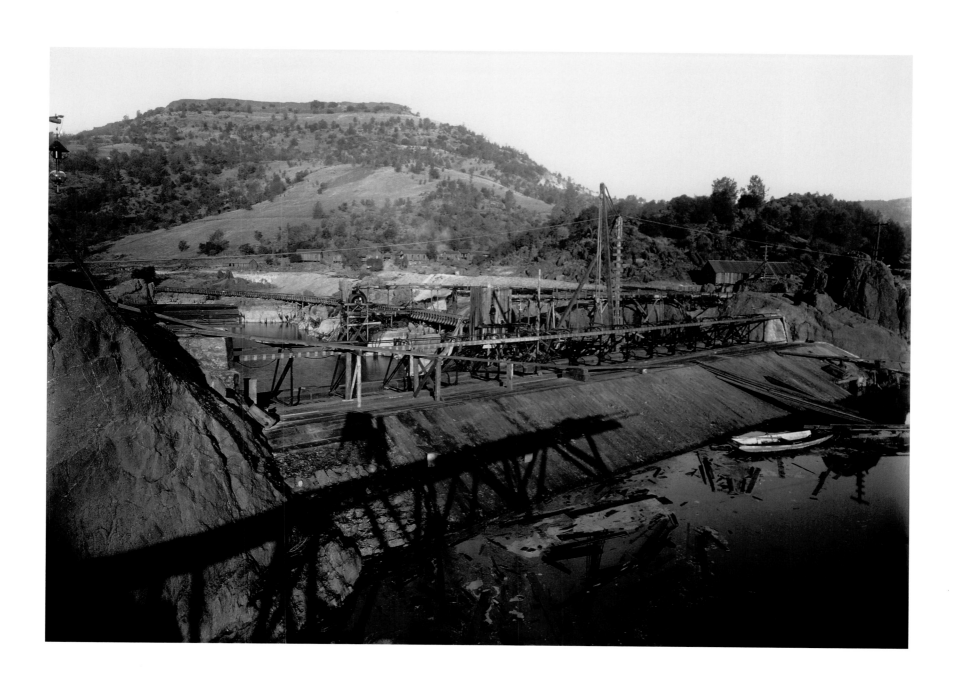

NOTES ON THE PLATES

Peter E. Palmquist

SAN FRANCISCO AND VICINITY

When twenty-one-year-old Carleton E. Watkins arrived in San Francisco in 1851, the frontier city was recovering from a recent devastating fire. Fifty-five years later, the city would once again tumble and burn to the ground, taking with it forty years of Watkins's creative life. Between these bookend conflagrations, young Watkins had become a man, chosen a lifelong profession with all of its ups and downs, married and raised children, and grown old.

San Francisco became Watkins's adopted home, just as his goal to photograph the Pacific Coast "from Alaska to Mexico" became his obsession. Amateur historian Charles B. Turrill (1854–1927) tells us that one of Watkins's earliest San Francisco photographs was called *Over the Plaza*, an overview of Portsmouth Plaza taken in 1857 from a studio window on the southwest corner of Clay and Kearny Streets in the very heart of the city. If so, this is but the first of a long line of images that document flourishing urbanization in what was the largest city on the West Coast.

Often photographing in an environment of visual clutter, Watkins ranged the city and took full advantage of its hilly topography to compose his pictures. The boat-building establishment of Martin Vice, for example, was situated at North Point, where San Francisco Bay meets the Golden Gate, at the foot of Telegraph Hill (pl. 1). Named for the ship-signaling device at its summit, Telegraph Hill was the site Watkins chose to photograph the city developing to the west, in the direction of the Frémonts' home, along unfinished Greenwich Street (pl. 9). A similar maritime

"early warning" station, the Jobson Observatory, was located three hundred sixty feet above sea level on adjacent Russian Hill (pl. 2). From the middle of this urban sprawl, north of California Street, Watkins constructed his multipart stereo panorama (pls. 3–8); visible in its compass is the Nob Hill property upon which railroad magnates Leland Stanford, Mark Hopkins, Charles Crocker, and Collis P. Huntington would raise their grand residences after 1873.

Over the years Watkins triangulated the geography of the expanding municipality: he surveyed the cow pastures at the base of Twin Peaks, three miles away (pl. 10); the remote Lone Mountain from the grounds of the Protestant Orphan Asylum, across the intervening Roman Catholic cemetery (pl. 11); and the Cliff House (pl. 13), a dramatically situated tourist hotel completed in 1864. Although Watkins was not noted as a photojournalist, his marvelous *Wreck of the Viscata* (pl. 12) remains a classic of its kind. The *Viscata* was a twelve hundred-ton British grain bark that got caught in a sudden gust of wind inside the Golden Gate and went aground at Baker Beach on 7 March 1868. Watkins made his picture two days later, as efforts to unload the two hundred tons of wheat the vessel carried drew large numbers of the curious. A closer examination of this photograph reveals Watkins's horse, wagon, and darktent near the center of the image and his stereoscopic camera on the beach near the ship.

Watkins also moved freely in what we now call "the greater Bay Area," a region roughly bounded by Vallejo, San Jose, Oakland, and the Pacific Ocean. The other images in this section show human development integrated with the distinctive landscape

of the region, such as A. D. Starr's flour mill at the port of South Vallejo (pl. 14), the route of the San Francisco and San Jose Railroad line through Palo Alto (pl. 15), and, at the end of the line, Sherman Day's New Almaden quicksilver works, which smelted mercury—a metallic element indispensable to the hard-rock gold-mining operations in the Sierras, which sustained the Bay Area's growth (pls. 16–18).

YOSEMITE

In 1861 Watkins produced at least thirty mammoth negatives and one hundred stereographs of the Yosemite Valley and the Mariposa Grove of Big Trees, and forever after his name has been linked with these subjects. To photograph in the still-remote region, everything had to be carried with him over the twenty-hour stage route from San Francisco: mammoth camera (about thirty inches on a side and at least three feet in length when extended), stereoscopic camera, tripod(s), spare lenses, darktent, glass plates (stereo as well as mammoth size), chemicals, and processing trays, plus sufficient camping supplies for a sojourn of several weeks in the valley. The summer sun warped and shrank camera parts and plate holders, and the black darktent was rendered almost unbearable by the midday sun. Yet Watkins persevered, and from this first campaign brought back several of his most memorable images, including dome-top portraits of the Grizzly Giant (pl. 19)—a fire would ravage much of the grove in August 1864—and delicately translucent views he printed as albumen-on-glass stereographs, such as *"Inverted in the tide stand the grey rocks"*

(pl. 22). After 1863, Watkins discontinued producing stereos with this fragile and comparatively expensive material, offering them only on the more durable card mounts.

In response to new patronage, an expanding tourist market, further exploration of the valley, and competition from photographers Charles L. Weed, Eadweard Muybridge, George Fiske, and others, Watkins made trips back to this area in 1865–66, 1872, 1878, 1881, and possibly 1875. He spent the 1865 and 1866 seasons in close association with the California State Geological Survey in Yosemite. His earlier Yosemite photographs had caught the eye of William Henry Brewer and survey leader Josiah Dwight Whitney. Because there was no money to hire Watkins as the official photographer, he was paid for utility tasks, such as copying maps. Thanks to the sponsorship of Whitney and Brewer, he also sold photographs to members of the scientific community, including their teacher Asa Gray, professor of botany at Harvard. In the summer of 1866 Watkins was making negatives in at least four different formats, including a special set of negatives for Whitney's proposed *Yosemite Book*, and his expansive mammoth-plate panorama centered on Yosemite Falls (pls. 30–32). Although the Yosemite photographs were widely praised, Watkins's attempts to market his work through his San Francisco gallery remained a failure.

The Yosemite works Watkins produced in the late 1870s, published as part of the "New Series," demonstrate the refinement of his vision, as well as mounting settlement in the park. *The Half-Dome from Glacier Point* (pl. 39) reveals a tourist lookout on the right, while *Agassiz Rock and the Yosemite Falls, from Union Point* (pl. 41) discloses the roads and buildings that now occupied the valley floor below.

Plates 42–49
MENDOCINO

Watkins's Mendocino Coast series of 1863 blends the industrial with the surrounding natural landscape. Probably commissioned by lumberman Jerome B. Ford, Watkins traveled by boat to Mendocino, a coastal town north of San Francisco, and documented the mills and surrounding resources to create an inventory of commercial progress that would quicken the pulse of even the most reluctant investor. The prints illustrated here were Ford's own; Watkins's 1864 Daily Pocket Remembrancer notes his and other Mendocino residents' orders for these images. The Mendocino series demonstrates that by this date Watkins's technique was virtually flawless; he had completely overcome the streaked and uneven collodion coatings that had marred earlier assignments.

There are at least fifty-six different mammoth images in the Mendocino series and a large number of stereographs. Most of the lumber mills photographed were located near the mouths of the Albion, Noyo, and Big Rivers (pl. 45). Watkins's activity in the area can be dated by his photographs of the Page Lumber Mill at Big River: the facility burned down on 17 October 1863, allowing Watkins both "before" and "after" views. The Mendocino series also shows what soon became the photographer's characteristic entrepreneurial approach to commissions; he portrayed not only the requisite mills but also, for individual direct sales, the residences of the Freunds (pl. 47), Townsends, and others associated with the operations. *The Church, Mendocino* (pl. 48) is one of a number of views showing the town's emerging fabric, while images of the jagged Mendocino coastline also caught Watkins's eye (pls. 42–43). He even journeyed inland to record the Civil War military site near what is now Fort Bragg and made two images showing a nearby Native American community (pl. 46).

Plates 50–72
COLUMBIA RIVER

In 1867 Watkins went to Oregon to photograph the Columbia and Willamette river valleys. One of the principal goals of the expedition was to obtain photographs of the geology of Oregon, particularly the chain of volcanic mountains that cap the coast range. A second client was the Oregon Steam Navigation Company, which held a steamboat and portage railway monopoly along the route Watkins traveled. The photographer arrived in Portland in mid-July, but unseasonable storms delayed his making a panorama of the city from the summit of Robinson Hill (pls. 52–54). (The plates reveal the effects of a recent fire, as well as the rain-swollen banks of the Willamette River.) Watkins then traveled up the Willamette to Oswego, where he documented the site of the Oregon Iron Company (pls. 51, 55–56, 58), the first operation on the West Coast to manufacture pig iron in a blast furnace. On this side trip he also constructed a panorama of Oregon City (pls. 63–65), whose industry grew up around the portage past Willamette Falls. From there Watkins returned to Portland before setting out to trace the course of the OSNC line up the Columbia.

Most modern critics consider Watkins's 1867 Columbia River photographs among his finest work. His encyclopedic treatment of the region immortalized a sternwheeler under construction (pl. 59), Joseph Bailey's toll bridge at Eagle Creek (pl. 61), his brother-in-law John Stevenson's boat landing at Cape Horn (pl. 69), the company's warehouses and locomotives (pls. 57 and 60), as well as the seven hundred fifty-foot-high basaltic Castle Rock (pl. 66) and more picturesque subjects such as Multnomah Falls in the Columbia Gorge (pls. 67–68). The consistently high technical and aesthetic quality of the photographs distinguishes the series as a high-water mark in Watkins's career. At least

sixty mammoth negatives and more than one hundred stereoscopic negatives were obtained on his Oregon sojourn.

Plates 73–89
PACIFIC COAST AND MINING

One could argue that all of Watkins's outdoor photographs were eventually destined to become part of his "Pacific Coast Views," even those produced on commission. In the eight years following his Oregon trip, Watkins made hundreds of negatives and mass-produced images in various sizes, from mammoth size down to stereo halves for tourist albums. Beginning in 1865, he began to refer to his rented rooms at 425 Montgomery Street as the "Yo Semite Gallery." As his reputation grew, so did his desire to exert greater control over his professional situation. He especially wanted his own gallery, a place easily reached by the public and one with adequate display space for his "Pacific Coast Views." An interim location at 429 Montgomery served this purpose from 1869 to 1871. On borrowed money he then opened his long-awaited Yosemite Art Gallery as both a sales office and public picture gallery: "The walls are adorned with one hundred and twenty-five of those superb views of Pacific Coast scenery (in size 18 x 22 inches) which have given Watkins a reputation world-wide. . .views of almost everything curious, grand or instructive," stated the 1872 *Buyer's Manual and Business Guide*. The main exhibition room measured twenty-eight by forty-five feet and included viewers for examining his thousands of accumulated stereographs.

The images constituting the "Pacific Coast Views" are varied, reflecting assignments from specific clients but also documenting sites of significance for the Far West generally. Watkins's images of the murre rookeries on the Farallon Islands, some thirty miles west of

San Francisco, documented the appearance of a new industry. The Farallons were fast becoming the "egg basket" of the city, and Watkins used his mammoth camera and stereoscopic instrument to show the birds, their nests, and typical egg-gathering techniques. He recorded the rugged and stunningly abstract geology as well (for Whitney) and other native species, such as seals (pls. 73–77).

In the fall of 1871 Watkins was hired by the North Bloomfield gravel mines in Nevada County to photograph their hydraulic gold-mining operations, the largest in the state. The owners of the company were hoping to attract English capitalists to support their venture, which involved damming rivers (pls. 83, 84), conveying water under pressure through pipes (pl. 85) to "monitor" hoses, which essentially washed away the mountainsides (pl. 86); gold ore then settled out for collection in sluices downstream (pl. 87). The *Mining and Scientific Press* for 7 November 1871 notes that "the pictures, which were taken by C. E. Watkins, are really masterpieces of the photographic art, and present the most perfect and lifelike representation of hydraulic mining which we have ever seen depicted on paper. The mines are shown from several different points, and distant views are given of the line of the company's ditches, their dams, reservoirs, etc. . . .The accurate distinctness with which they are shown, in connection with the topography of the country, timber, etc., is really remarkable, and affords another instance of the value of the photographic art in aiding the engineer to describe the progress and condition of his work." The destructive results of this kind of mining led to the first environmental court case in the United States (in 1882), when farmers in the Sacramento Valley successfully sued North Bloomfield for the flooding that resulted from its mud washing downstream.

The Utah trip was made in the dead of

winter, 1873–74, when Watkins and his friend the landscape painter William Keith decided to collaborate on views seen along the route of the Central Pacific Railroad. Crossing the Sierra in midwinter was an adventure in hardship; the travelers reported temperatures as low as twenty-six degrees below zero. After making a panorama of Salt Lake City (pls. 80–82), Watkins advanced past Promontory, where the Central Pacific had met the Union Pacific line in 1869, to photograph the desolate track-side sights of Echo Canyon (pl. 79) and Weber Canyon (pl. 78). Another physically difficult assignment was undertaken in 1870, when Watkins accompanied geologist Clarence King in an ascent of 14,000-foot-high Mount Shasta. On September 11 the little band of scientists began the ascent, each burdened with the "traps" of their profession. King later described the task as "the most dangerous kind of climbing I have ever seen." Wet-plate photography at 14,000 feet was tricky; slippery and unstable surroundings made all movement hazardous. Pitching his darktent on the only level spot, a small frozen pond of blue ice, Watkins was forced to cover the ice in order to prevent light from filtering into his tent from underneath and fogging his plates.

Plates 90–105
NEW SERIES

Following his bankruptcy and loss of most of his "Old Series" negatives in 1875–76, Watkins spent long periods on assignments out of San Francisco, adding to his stock of New Series negatives. He eventually traveled to Arizona, Idaho, Montana (as far east as Yellowstone), Oregon, Washington, and British Columbia. Watkins spent most of the summer of 1878 in Yosemite; he was also courting Frances ("Frankie") Sneade, the twenty-two-year-old assistant he would marry on his fiftieth birthday.

Many of Watkins's new Yosemite negatives were taken in cabinet (four-by-six-inch) or boudoir (five-by-eight-inch) formats. Watkins sometimes masked these deep-space images into oval, round, or dome-top prints (pl. 94). Agricultural commissions in Sonoma, the San Gabriel Valley, and Kern County resulted in many of his most memorable images. *Arbutus Menziesii Pursh* (pl. 90) and *Late George Cling Peaches* (pl. 93) document the thriving new industry made possible by irrigation farming in areas serviced by new rail lines. His mammoth-plate work during this period seems more confrontational in style, as we note in his study of the Anasazi site *Casa Grande, Pre-Historic Ruins Arizona* (pl. 96). This and many other images were made in 1880 when Watkins traveled to Southern California and Arizona along the route of the Southern Pacific.

In 1890 Watkins was in Montana, photographing underground in the copper mines of Butte and Anaconda. He was already suffering from diminished eyesight and was plagued by arthritis: "Yesterday I was taken with one of my vertigo fits. . . . I hope it will not be a bad attack, if it should the Lord save us," he wrote to his wife. One of his last commercial projects involved documenting the new dams and waterways of the Golden Gate and Golden Feather mines in Butte County, California, in November 1891. These two companies were formed in the 1880s (again, with English backing) to extract gold from the gravel in the bed of the Feather River, a short distance upstream from the town of Oroville. To work the gravel, the entire river had to be diverted. In the Golden Gate claim the entire river flow was carried in a wooden flume 3,900 feet in length.

The Golden Feather claim diverted the river from its normal bed through a 6,000-foot canal along the right bank (pls. 102–103). Pumps kept the water level down in the riverbed as gravel was removed by Chinese laborers (pl. 104). Even though Watkins had already begun to work with an eight-by-ten-inch camera and dry-plate negatives, it seems fitting that for these final images he reverted to his trademark technique: mammoth camera and wet-plate negatives. One of these views stands out from the rest as a remarkable symbol of the intrepid Watkins at his best: in the foreground, silhouetted by the bright sun behind his back, is the shadow of the photographer himself in a rare self-portrait with his giant camera (pl. 105).

SELECTED REFERENCES

Peter E. Palmquist

Books

Alinder, James, ed. *Carleton E. Watkins: Photographer of the Columbia River and Oregon.* Carmel, Calif.: The Friends of Photography in association with the Weston Gallery, 1979.

Andrews, Ralph W. *Picture Gallery Pioneers, 1850 to 1875.* Seattle, Wash.: Superior Publishing Company, 1964.

Bentley, William R. *Bentley's Hand-Book of the Pacific Coast. . . .*Oakland: Pacific Press, 1884.

Carleton E. Watkins, Photographs 1861–1874. San Francisco: Fraenkel Gallery in association with Bedford Arts Publishers, 1989.

Carleton Watkins: Photographs from The J. Paul Getty Museum. Los Angeles: J. Paul Getty Museum, 1997.

Current, Karen, and William Current. *Photography and the Old West.* New York: Harry N. Abrams, 1978.

Earle, Edward W. *Points of View: The Stereograph in America—A Cultural History.* Rochester: Visual Studies Workshop, 1979.

Fels, Thomas Weston. *Carleton Watkins, Photographer: Yosemite and Mariposa Views from the Collection of the Park-McCullough House, North Bennington, Vermont.* Williamstown, Mass: Sterling and Francine Clark Art Institute, 1983.

Johnson, Joe William. *The Early Pacific Coast Photographs of Carleton E. Watkins.* Berkeley: University of California, Water Resources Center, 1960.

Naef, Weston J. et al. *Era of Exploration: The Rise of Landscape Photography in the American West, 1860–1885.* Buffalo, N.Y.: Albright-Knox Art Gallery; New York: Metropolitan Museum of Art, 1975.

Palmquist, Peter E. *Carleton E. Watkins: Photographer of the American West.* Albuquerque: University of New Mexico Press, 1983.

Sandra Phillips et al. *Crossing the Frontier: Photographs of the Developing West, 1849 to Present.* San Francisco: San Francisco Museum of Modern Art and Chronicle Books, 1997.

Pioneers of Landscape Photography: Gustave Le Gray/Carleton E. Watkins. Malibu, Calif.: J. Paul Getty Museum, 1993.

Rule, Amy, ed. *Carleton Watkins: Selected Texts and Bibliography.* Oxford, England.: Clio Press, 1993.

Sexton, Nanette Margaret. *Carleton E. Watkins, Pioneer California Photographer (1829–1916): A Study in the Evolution of Photographic Style during the First Decade of Wet Plate Photography.* Ph.D. diss., Harvard University, 1982.

Terry, Richard. *Carleton E. Watkins: A Listing of the Photographs in the Collection of the California State Library.* Sacramento: California State Library Foundation, 1984.

Truettner, William H., ed. *The West as America: Reinterpreting Images of the Frontier, 1820–1920.* Washington, D.C., and London: National Museum of American Art and Smithsonian Institution Press, 1991.

Watkins to Weston: 101 Years of California Photography 1849–1950. Santa Barbara, Calif.: Santa Barbara Museum of Art, 1992.

Whitney, Josiah Dwight. *The Yosemite Book: A Description of the Yosemite Valley and the Adjacent Region of the Sierra Nevada, and of the Big Trees of California.* New York: Julius Bien, 1868.

Articles

Anderson, Ralph H. "Carleton E. Watkins: Pioneer Photographer of the Pacific Coast." *Yosemite Nature Notes,* vol. 32, no. 4 (April 1953): 33–37.

"Carleton E. Watkins: Pioneer Photographer." Special issue of *California History,* vol. 57, no. 3 (fall 1978).

Coplans, John. "C. E. Watkins at Yosemite." *Art in America,* vol. 66 (November/December 1978): 100–8.

Loeffler, Jane C. "Landscape as Legend: Carleton E. Watkins in Kern County, California." *Landscape Journal,* vol. 11, no. 1 (spring 1992): 1–21.

McIntosh, Clarence F. "The Carleton E. Watkins Photographs of the Golden Gate and Golden Feather Mining Claims." *The Diggin's,* vol. 8, no. 1 (spring 1964): 3–21.

Palmquist, Peter E. "Discovering Yosemite." *Timeline* (May/June 1997): 40–54.

———. "Carleton E. Watkins: A Checklist of Surviving Photographically Illustrated Books and Albums." *The Photographic Collector,* vol. 2, no. 1 (spring 1981): 4–12.

———. "Carleton E. Watkins at Work (A Pictorial Inventory of Equipment and Landscape Techniques Used by Watkins in the American West 1854–1900)." *History of Photography* [London], vol. 6, no. 4 (October 1982): 291–325.

———. "Carleton E. Watkins: Master of the 'Grand View.'" *The Argonaut,* vol. 6, no. 2 (winter 1995–96): 1–48.

————. "Carleton E. Watkins's Oldest Surviving Landscape Photograph." *History of Photography* [London], vol. 5, no. 3 (July 1981): 223–24.

————. "Carleton E. Watkins—What Price Success?" *The American West*, vol. 17, no. 4 (July/August 1980): 14–29, 66–67.

————. "'It is Hot as H—': Carleton E. Watkins' Photographic Excursion Through Sounthern Arizona, 1880." *Journal of Arizona History* (winter 1987): 353–72.

————. [Serialized Watkins biography]: Parts 1 and 2—"Oneonta New York, 1829–1851" and "California!, 1851–1854," *The Photographic Historian*, vol. 8, no. 4 (winter 1987–88): 7–26. Part 3—"Shadowcatching in El Dorado, 1849–1856," *The Daguerreian Annual* 1990 (Eureka, Calif.: Daguerreian Society, 1990): 165–86. Part 4—"From Babies to Landscapes, 1856–1858," *The Daguerreian Annual* 1991 (Eureka, Calif.: Daguerreian Society, 1991): 225–46.

————. "Taber Reprints of Watkins's Mammoth Plates." *The Photographic Collector*, vol. 3, no. 2 (summer 1982): 12–20.

————. "Views to Order." *Portfolio Magazine* (March/April 1983): 84–91.

————. "Watkins's E-Series: The Columbia River Gorge and Yellowstone Stereographs." *Stereo World*, vol. 10, no. 1 (March/April 1983): 4–14.

————. "Watkins's New Series Stereographs." *The Photographic Collector*: Part I—vol. 3, no. 4 (winter 1982–83): 16–18; Part II—vol. 4, no. 6 (spring 1983): 28–39; and Part III—vol. 4 [sic], no. 2 (summer 1983): 18–27.

Turrill, Charles B. "An Early California Photographer: C. E. Watkins." *News Notes of California Libraries*, vol. 13, no. 1 (January 1918): 29–37.

Other Resources

The Bancroft Library, University of California, Berkeley, is the single largest holder of Watkins's photographs and related materials. Manuscript collections for Watkins include copies of his correspondence ca. 1880–91; his Daily Pocket Remembrancer, 1864; and interviews with his daughter, Julia. Watkins's court deposition for *United States v. Charles Fossat* (1858), *United States v. D. & V. Peralta* (1861), and *Lux v. Haggin* (1881) are also located here. Other useful collections exist for the California State Geological Survey, correspondence between Josiah Dwight Whitney and William Henry Brewer, and the papers of Joe William Johnson and George Davidson.

CHRONOLOGY

1829 Carleton Eugene Watkins is born in Oneonta, New York, on November 11, the eldest of eight children of carpenter and innkeeper John Watkins and his wife, Julia. As a young man he is an avid hunter and fisherman and active in a local glee club and Presbyterian church choir.

1851–52 Arrives in San Francisco, then proceeds to Sacramento, where he is employed by childhood friend Collis P. Huntington (1821–1900) to deliver supplies to the gold mines.

1852 Visits family in New York but remains only briefly before returning to California.

1852 Listed in Sacramento city directory as a carpenter, dwelling with George W. Murray, bookseller and stationer. Relocates to San Francisco, where he becomes a clerk in Murray's new bookstore on Montgomery Street, one block from Robert H. Vance's First Premium Daguerrean Gallery at the corner of Sacramento and Commercial Streets.

1854–56 Begins photography career by chance, probably in the studio of Robert Vance (1825–1876), by filling in for a photographer who had left his post without warning. By March 1856 newspaper advertisements indicate that Watkins is employed by James May Ford (1827–ca. 1877) in San Jose, taking portraits by both the daguerreotype and ambrotype processes. By November the San Jose gallery is taken over by a new owner; Watkins operates as a freelance photographer in the San Jose and San Francisco areas and probably begins outdoor work.

1857 Experiments with wet-collodion process for making glass-plate negatives; produces salted-paper photographs and continues to be interested in outdoor work.

1858 Commissioned to document the site of the Guadalupe quicksilver mine for use as courtroom evidence (*United States v. Fossat*). The finished image is composed of two large salt prints joined to form a panorama of the site. In court testimony on August 27 he states his profession as "photographicist" and says that he personally selected the standpoint for his camera, and that the image(s) represented an "accurate" view. Produces large-format (imperial-size) pictures of San Francisco and undertakes earliest stereoscopic work as well.

1859–60 Commissioned to document the Mariposa estate of John C. Frémont (1813–1890); employs both imperial and stereographic formats. The Mariposa images form the largest surviving body of Watkins's work before 1861 (at least fifty-two of the large-size negatives). These images are shown to potential European investors and Napoleon III. Shares studio with Ford located at 425 Montgomery Street. Begins association with the California State Geological Survey. Produces stereographs of the Third San Francisco Mechanics' Institute Industrial Exhibition and a series on San Francisco fire departments. Establishes important social contacts in the Black Point home of Frémont's wife, Jessie Benton Frémont (1824–1902), among them Thomas Starr King (1824–1864), the popular pastor of the First Unitarian Church of San Francisco.

1861 On February 22 photographs crowds of people in San Francisco at a mass meeting in support of the Union; King is keynote orator. Accepts commission to photograph the San Antonio Rancho for the Northern District Court (*United States v. D. & V. Peralta*); gives sworn testimony on May 8 and 10. Arranges to have a local cabinetmaker construct a camera capable of handling negatives as large as eighteen by twenty-two inches (mammoth size) and fits it with a Grubb Aplanatic Landscape lens for wide-angle work. In July travels to Yosemite, where he makes at least thirty mammoth photographs and one hundred stereographs of Yosemite Valley and the Mariposa Grove. Finishes prints on albumenized paper; signs and titles many of these on the mounts.

1862 William H. Brewer (1828–1910) of the California State Geological Survey views the Yosemite photographs on January 31 and calls them "the finest I have seen." Enthusiastic comments received from King and Ralph Waldo Emerson, who was to visit the valley nine years later. By December Watkins's giant Yosemite prints are placed on display at the prestigious Goupil's Gallery in New York City. Mariposa mining views are exhibited in London. Watkins photographs members of the California State Geological Survey with the "Carleton Iron" meteorite fragment and records Fourth of July celebrations in San Francisco.

1863 Uses studio at 649 Clay Street, San Francisco, possibly with photographer George Howard Johnson (born ca. 1823). Photographs King's church and makes a panorama of San Francisco from five mammoth-plate negatives. Yosemite photographs are praised in both the *North Pacific Review* and *Atlantic Monthly*. Photographs New Almaden quicksilver mine in the spring and Mendocino Coast lumber mills in the fall. Also, at about this time, undertakes a series of views of the Spring Valley Water Works (principal source of San Francisco's water supply) in San Mateo County. Publishes the album *Yo-Semite Valley: Photographic Views of the Falls and Valley.*

1864 Watkins's Yosemite photographs play influential role in persuading United States Congress to pass legislation to preserve Yosemite Valley; bill signed by Abraham Lincoln. Relocates gallery to 415 Montgomery Street. Loses prestigious landscape award to Charles Leander Weed (1824–1903) at Mechanics' Institute Industrial Exhibition. Actively photographs San Francisco, including new panoramic overviews and documentation of the ironclad vessel *Comanche*. Notations in Watkins's 1864 Daily Pocket Remembrancer suggest that his gross income for the year was nearly $3,000.

Figure 12. Watkins with his mammoth camera, dark-tent, and crew, ca. 1880. Collection of Peter E. Palmquist

1865 Yosemite commissioner Frederick Law Olmsted (1822–1903) consults Watkins on the best means for preservation and use of Yosemite as a public trust. Watkins joins the California State Geological Survey in Yosemite; by July he is on his way to the valley with "2000 lbs. of baggage" and enough glass for one hundred mammoth negatives. Photographs Schuyler Colfax (1823–1885) party in Yosemite. Begins ongoing series of images of trees and other botanical specimens for Professor Asa Gray (1810–1888) of Harvard University. *Report of Progress for 1860–1864* (volume 1 of the *Geological Survey of California*), by Josiah Dwight Whitney

(1819–1896), is published with woodcut illustrations based on Watkins's 1861 Yosemite images. Mount Watkins, in Yosemite, is named in honor of the photographer. Wins award for "Mountain Views" at the San Francisco Mechanics' Institute Industrial Exhibition. Relocates gallery to 425 Montgomery Street, referring to it as the "Yo Semite Gallery." Visited by Utah photographer Charles Roscoe Savage (1832–1909), who is greatly impressed by Watkins's water-bath techniques for handling collodion-plate negatives in Yosemite, "a climate so dry and difficult to work in."

1866 Extensive reviews of Watkins's Yosemite work are published in the photographic press. Continues his work with the California State Geological Survey, making negatives in four sizes: 18 by 22 inches, $9\frac{1}{2}$ by 13 inches (for albums), $6\frac{1}{2}$ by $8\frac{1}{2}$ inches (for Whitney's forthcoming *Yosemite Book*), and stereo (two prints mounted side by side on a $3\frac{1}{2}$-by-7-inch card). Sends six of his new mammoth Yosemite images to Edward L. Wilson (1838–1903), editor of the *Philadelphia Photographer*. Watkins's 1861 Yosemite images are pirated by D. Appleton & Company, New York, and sold in a reduced size ($6\frac{1}{2}$ by $8\frac{1}{2}$ inches) under the title *Album of the Yosemite Valley, California*. Experiences persistent economic problems because his expenses exceed income from sales.

1867 Despite continuing economic troubles, makes a four-month trip to Oregon and the Columbia River for the Oregon Steam Navigation Company; takes at least sixty mammoth-size negatives as well as a number of stereographs. Returns overland to California, on the way photographing Mounts Lassen and Shasta. Copyrights his photographs for the first time to prevent pirating of his work. Wins bronze medal for landscape photographs at the Paris International

Exposition and gains a worldwide reputation through reviews in the foreign press; the landscape painter Albert Bierstadt buys a set of Watkins's Yosemite views. His photographs are praised at a meeting of the California Academy of Sciences.

1868 Exhibits fifty mammoth views of Oregon at Shanahan's Art Gallery, Portland. Whitney's *Yosemite Book* is published in an edition of two hundred fifty copies; includes twenty-four photographs by Watkins. Painter William Keith (1839–1911) designs special logo commemorating Watkins's award at the Paris International Exposition, reproduced on the verso of Watkins's stereographs of this period. Mounts major exhibit of Pacific Coast photography at San Francisco Mechanics' Institute Industrial Exhibition; wins top award. Photographs Lime Point project on San Francisco Bay for U.S. Topographic Engineers. Records the wreck of the ship *Viscata* near San Francisco. Poses for his likeness in cameo, carved by sculptor Pietro Mezzara (1820–1883).

Figure 13. Cameo of Carleton Watkins carved by Pietro Mezzara, ca. 1868–69. Courtesy of the Yosemite Museum, National Park Service

1869 Moves Yosemite Gallery to 429 Montgomery Street and greatly expands his inventory of landscape views—under the topical heading "Pacific Coast Views"—by photographing geysers, the Farallon Islands, hydraulic mining, and urban development in San Francisco and adjacent towns. Undertakes an ambitious program of stereograph production, including a series on the Central Pacific Railroad for the *Illustrated San Francisco News*. Obtains the Central Pacific Railroad negatives

of Alfred A. Hart (1816–1908) and publishes them as his own. Begins production of *Yosemite Gallery* albums. Exhibits again at the San Francisco Mechanics' Industrial Exhibition, where his photographs are praised for "clearness, strength, and softness of tone."

1870 Begins extensive use of an enclosed traveling wagon for field work. Travels to Mount Shasta with geologist Clarence King (1842–1901); ascends to the 14,162-foot-high summit and photographs Whitney Glacier. Exhibits at the Cleveland Exposition.

1871 Becomes charter member of the San Francisco Art Association. On borrowed money, opens lavish new Yosemite Art Gallery at 22–26 Montgomery Street; it includes portrait-taking facility, stereo viewers, and wall display space for one hundred twenty-five mammoth photographs. Travels frequently to expand his inventory of images from all points along the Pacific coast. Makes first photographic excursion to the North Bloomfield gravel mines and documents the facilities of the Pacific Mail Steamship Company in San Francisco Bay. Wins silver medal for photography at the San Francisco Mechanics' Institute Industrial Exhibition.

1872 Invited to join the Bohemian Club. Becomes increasingly involved in San Francisco art circles; photographs the estates of many of the city's wealthiest families. Revisits Yosemite and establishes a separate exhibit and sales outlet for his photographs at the Woodward Gardens in San Francisco.

1873 Travels with Keith along the Central Pacific Railroad as far as Salt Lake City, then on to Weber Canyon and Echo Canyon on the Union Pacific line. For the first time, employs two special railroad flatcars to carry his photographic wagon, horses, etc., to distant sites. Accepts a commission to photograph the

Carson & Tahoe Fluming Company's operations in Nevada, east of Lake Tahoe. Begins series of images for the *California Horticulturalist and Floral Magazine*. Publishes the Modoc War negatives of Louis Heller (1839–1928). Receives Medal of Progress award at the Vienna Exposition. Travels to New York to learn the Albertype process from Edward Bierstadt (1824–1906); uses the new process to reproduce two sketches by Albert Bierstadt (1830–1902). Photographs paintings by Keith and Virgil Williams (1830–1886) for record and portfolio uses. Landscape painter Thomas Hill (1829–1908) uses Watkins's photographs as a source of inspiration for his paintings.

1874 Local business depression hampers gallery sales; price of stereographs drops precipitately throughout the industry due to mass production by eastern publishers. Undertakes commission to photograph the Milton Latham estate at Thurlow Lodge, south of San Francisco; produces some seventy-three large negatives, and sixty-three of the finished mammoth prints are mounted in two presentation albums imprinted *Views of Thurlow Lodge, Mollie Latham, Photographs by Watkins* (now in the collection of the Canadian Centre for Architecture, Montreal). Watkins's printer breaks eight mammoth-plate negatives from the 1873 Utah trip.

1875 Begins extensive series on Nevada's Comstock mining region—in at least two trips—including images inside the stamping mills. Returns to Yosemite. Joins Photographic Art Society of the Pacific Coast. Continuing economic slump leads to loss of the Yosemite Art Gallery and most "Old Series" negatives to businessman John Jay Cook (1837–1904), who had lent money to Watkins. Cook becomes owner of the gallery in association with photographer Isaiah West Taber (1830–1912).

1876 Although greatly embittered by the loss of his Yosemite Art Gallery, Watkins begins to replace his lost negatives by revisiting his favorite locations; calls these images his "New Series of Pacific Coast Views." Continues Comstock series, including panoramas of Virginia City, Nevada. Returns to the North Bloomfield gravel mines to record industrial progress and photographs Centennial celebrations in San Francisco. Exhibits at the Centennial Exposition in Philadelphia and also wins award at the Chilean Exposition. Travels by rail (again using his special two-car arrangement) to Southern California, where he begins a series on mission architecture and documents the elaborate Tehachapi Loop and other features of the Southern Pacific Railroad for Collis Huntington.

1878 Spends most of the summer in Yosemite; makes forced-perspective images in smaller formats with wide-angle lens. New work, displaying a renewed and deeply personal involvement with the landscape, appears to be a catharsis. Becomes romantically involved with Frances ("Frankie") Sneade (1856–1945), a studio assistant.

1879 Opens a new gallery at 427 Montgomery Street with William H. Lawrence as financial partner. Undertakes Mount Lola and Round Top commissions for George Davidson (1825–1911) of the United States Coast and Geodetic Survey. On his fiftieth birthday marries the twenty-two-year-old Sneade.

Figure 14. Frances Henrietta Sneade shortly before her marriage to Carleton Watkins in 1879. Collection of The Bancroft Library, University of California, Berkeley

1880 Embarks on major journey southward along the route of the Southern Pacific Railroad and makes numerous photographs of Southern California agriculture, fledgling oil industry, etc. Travels as far as Tombstone, Arizona, where he photographs mining and railroad development, as well as the prehistoric Casa Grande ruins. Returns to San Francisco by traveling wagon as he completes his mission series and makes views all along the Southern California coast from San Diego northward.

1881 In January photographs Kern County agricultural estates for court case *Charles Lux v. James B. Haggin*; testifies on 31 July 1882. Daughter, Julia, born April 18. Visits Yosemite (probably for the last time) and completes a series showing the work of the Yolo Base Line project for Davidson and the United States Coast and Geodetic Survey.

1882 In the fall travels north by rail to Portland, Oregon, the Washington Territory, and Victoria, British Columbia, where he photographs Port Blakely and the Puget Sound area and makes overviews of Victoria and surrounding sites.

1883 In January photographs the Hotel Del Monte and numerous coastal sites in the Monterey/Carmel region being developed by the Central and Southern Pacific Railroad. Exhibits at the Illinois State Fair on behalf of the California Immigration Commission. Travels to Oregon to photograph the Cascade Locks on the Columbia River. Son, Collis, born October 4.

1884 *Bentley's Handbook* and *Ben Truman's Illustrated Guide* are published with photographic illustrations by Watkins. Returns to Oregon, then travels eastward into Idaho and Montana, where he also photographs Yellowstone. Commences use of eight-by-ten-inch dry-plate negatives for field work.

1885 Begins advertising his line of landscape photographs "from Mexico to Alaska" in *Overland Monthly* and similar popular journals. Exhibits at the New Orleans Exposition.

1887–88 Completes commission on El Verano, a Sonoma County ranch. Undertakes and completes massive series on Kern County agriculture, producing an estimated one thousand negatives.

1889 Exhibits Kern County photographs at the San Francisco Mechanics' Institute Industrial Exhibition.

1890 Photographs Montana copper mines in Butte and Anaconda, using electric light and flashpowder underground. Eyesight failing and health weakening; suffers from vertigo. Details hardships in a series of letters to his wife. Photographs St. Ignatius College, San Francisco.

1891 Photographs Golden Gate and Golden Feather mines, Butte County, California, in mammoth-size wet plates—the last commercial enterprise completed. Relocates studio to 425 Montgomery Street.

1892–93 Suffers greatly from arthritis and diminished eyesight; also experiences increasingly desperate economic privation.

1894 Obtains commission from Phoebe Hearst (1842–1919) to photograph her Hacienda del Pozo de Verona, near Livermore, California. After spending nearly a year on site, he is unable to complete the project. Relocates studio to 417 Montgomery Street.

1895–96 Unable to pay rent, Watkins lives with his family in an abandoned railroad car for eighteen months. As an act of kindness for past favors, Huntington deeds Capay Ranch in Yolo County to Watkins. Rents photographic rooms at 1249 Market Street.

1897–1900 Almost totally blind, Watkins is assisted in his photographic printing by his son and Charles Beebe Turrill (1854–1927), a photographer and amateur historian.

1903–4 Desperately poor, Watkins accepts financial aid from Turrill. Exhibits at the Lewis and Clark Exposition on behalf of the state of California but fails to receive financial compensation for his photographs.

1905 California State Library purchases examples of Watkins's historic photographs at Turrill's encouragement.

Figure 15. Watkins (middle) after the San Francisco earthquake, 1906. Collection of The Bancroft Library, University of California, Berkeley

1906 Loses everything in the April 18 San Francisco earthquake and fire. Retires to Capay Ranch.

1909 Watkins is declared incompetent and placed in the custody of his daughter.

1910 Committed to the Napa State Hospital for the Insane. His wife begins to refer to herself as a "widow."

1916 Dies June 23 and is buried in an unmarked grave on the hospital grounds.

ACKNOWLEDGMENTS

An endeavor of this complexity and scale could never have been accomplished without the talents, dedication, and good will of many individuals. I would foremost like to thank my collaborator on the exhibition, Maria Morris Hambourg, curator in charge of the Department of Photographs at the Metropolitan Museum of Art, for her trust, wisdom, fine eye, and open mind as we developed the ideas that went into this project, and Sandra S. Phillips, curator of photography at the San Francisco Museum of Modern Art, whose inspiration and largess made it possible in the first place.

Maria Hambourg joins me in thanking Peter Palmquist for advice, the use of his exceptionally rich files on Watkins, and for answering innumerable questions; Jeffrey Fraenkel, for guidance in locating the photographs, for his enthusiasm, and for reading drafts of our essays; Peter Blank, librarian, Art and Architecture Library, Stanford University, for the time, generosity, and support he lent us; Jack von Euw, curator of the Pictorial Collection at the Bancroft Library, University of California, Berkeley, for research access to the collections and personal ministrations on our behalf; Laura T. Harris, librarian in the Department of Photographs, Metropolitan Museum of Art, for her imaginative and efficacious historical and bibliographical research; and Laura Muir, curatorial assistant, Department of Photographs, Metropolitan Museum of Art, for administrative assistance and dependable good humor.

I would personally like to thank the doctoral students who assisted with research for my essay and helped stimulate its writing: Isabel Breskin, University of California, Berkeley; Christine Holt-Lewis, Boston University; and Jason Weems and Alison Matthews, both of Stanford University. I am also indebted to Jonathan Crary, Barnard College, and Mary Warner Marien, Syracuse University, for their feedback and participation on our NEH planning advisory committee, and to Sarah Greenough, curator of photographs, National Gallery of Art, Washington, D.C., for her support of the exhibition. For their discussions, responses, and access to collections, I thank Jülide Aker, Harvard University; Verna Curtis, Library of Congress; Lisa Decessare, Gray Herbarium, Harvard University; William Deverell, California Institute of Technology; Leah Dickerman, Stanford University; Tom Fels, North Bennington, Vermont; Peter Galassi, The Museum of Modern Art, New York; David Harris, Montréal, Quebec; Anne Havinga, Museum of Fine Arts, Boston; David Joselit, University of California, Irvine; Mead Kibbey, Sacramento, California; Weston Naef, The J. Paul Getty Museum; Catherine Scallen, Case Western Reserve University; John Szarkowski; Steve Thomas, California Museum of Photography, Riverside; and Emily Wolf, San Francisco Historical Society. Genoa Shepley proved an especially astute reader of the text and provided much appreciated moral support.

Of course, the presentation would not have been possible without the cooperation of the many individuals and institutions who lent works to it: Allison Kemmerer and Jock Reynolds, Addison Gallery of American Art; Georgia Barnhill, American Antiquarian Society; Barbara McCandless and John Rohrbach, Amon Carter Museum; David Travis, The Art Institute of Chicago; Jack von Euw, The Bancroft Library, University of California, Berkeley; Gordon L. Bennett; Gary Kurutz, California State Library; Louise Désy, Centre Canadien d'Architecture/ Canadian Centre for Architecture, Montréal; Thomas Hinson, The Cleveland Museum of Art; James Crain; Jeffrey Fraenkel, Fraenkel Gallery, San Francisco; Weston Naef and Anne Lyden, The J. Paul Getty Museum; Pierre Apraxine and Maria Umali, Gilman Paper Company Collection; Mark Leno; Maria Morris Hambourg, Metropolitan Museum of Art, New York; Catherine Mills; Peter Galassi and Susan Kismaric, The Museum of Modern Art, New York; Sarah Greenough, National Gallery of Art, Washington, D.C.; Susan Seyl, Oregon Historical Society; Merrily and Tony Page; Peter Palmquist; Kathy and Ron Perisho; Jane and Larry Reed; Bill McMorris, The Society of California Pioneers; Roberto Trujillo, Department of Special Collections, Cecil H. Green Library, Stanford University Libraries; Howard Stein; Leonard Vernon and the late Marjorie Vernon; Leonard A. Walle; Margaret Weston, Weston Gallery, Inc., Carmel, California; Michael and Jane Wilson; Daniel Wolf; Barbara Beroza, Yosemite Museum, National Park Service; and several anonymous collectors

who made works available to us. Thanks also to Peter C. Bunnell, Princeton University, and Weston Naef for lending period stereo viewers to the installation. A special debt of gratitude is owed to Robert Skotheim, David Zeiberg, and particularly Jennifer Watts, curator of photographs at the Huntington Library in San Marino, California, who offered special dispensation in allowing that institution's rare Watkins materials to be included here.

This catalogue reflects the creativity of a gifted and professional team: Jody Hanson, whose elegant design is everywhere apparent; Janet Wilson, whose editing saved the authors from themselves on several occasions; and Robert J. Hennessey, whose subtle translations of Watkins's prints into ink are indeed a marvel. At SFMOMA, Kara Kirk, publications and graphic design director, Alexandra Chappell, publications coordinator, and Keiko Hayashi, graphic design manager, devoted lavish amounts of time to the project and made sure the trains left the station on time.

For their usual proficiency in carrying out the myriad aspects of exhibition planning and installation, I would also like to thank my colleagues at SFMOMA: Theresa Andrews, photographs conservator; Kerry Dixon, curatorial associate; Lori Fogarty, senior deputy director; Adrienne Gagnon, curatorial associate; Barbara Levine, exhibitions director; Ariadne Rosas, administrative assistant in the photography department; Kent Roberts, installation manager; Thom Sempere, graphic study manager; J. William Shank, chief conservator; Rico Solinas, installation technician; Jill Sterrett, conservator; Sarah Tappen, assistant registrar; and Greg Wilson, framer extraordinaire.

Finally, the crew of Perimetre Design—Stephen Jaycox, Curtis Christophersen, and Anthony Amidei—developed the marvelous computer interface that has allowed us to aptly show Watkins's stereo views in the galleries. They likewise have my thanks and admiration.

Douglas R. Nickel

CATALOGUE OF THE EXHIBITION

Unless otherwise indicated, all works are albumen prints from wet-collodion negatives. Where possible, Watkins's original titles have been retained. His inconsistencies in spelling and punctuation often reflect a lack of standardization in geographic place names at the time.

1.
View from Russian Hill, 1859. 12¼ x 16¼ in. (31.1 x 41.3 cm). Collection of The Bancroft Library, University of California, Berkeley.

2.
Bridal Veil from the Coulterville Trail, 1861. Albumen on glass stereograph. 3⁵⁄₁₆ x 6¾ in. (8.4 x 17.1 cm). Courtesy of the Yosemite Museum, National Park Service. Plate 24

3.
Cathedral Rock, Yosemite, 1861. 16 x 21 in. (40.6 x 53.3 cm). Fraenkel Gallery, San Francisco. Plate 20

4.
Cathedral Rocks, Yosemite, 1861. 15³⁄₈ x 20⁵⁄₈ in. (39.05 x 52.4 cm). Collection of Leonard A. Walle.

5.
Cathedral Spires, 1861. Albumen on glass stereograph. 3⁵⁄₁₆ x 6¾ in. (8.4 x 17.1 cm). Courtesy of the Yosemite Museum, National Park Service.

6.
Grizzly Giant, Mariposa Grove, 33 ft. Diam., 1861. Albumen print from wet-collodion-on-glass negative. 20½ x 15³⁄₈ in. (52.1 x 39.7 cm). Collection of The J. Paul Getty Museum, Los Angeles. Plate 19

7.
"Inverted in the tide stand the grey rocks.," 1861. Albumen on glass stereograph. 3⁵⁄₁₆ x 6¾ in. (8.4 x 17.1 cm). Courtesy of the Yosemite Museum, National Park Service. Plate 22

8.
Mt. Broderick, Nevada Fall, 700 ft., Yosemite, 1861. 16 x 21 in. (40.6 x 53.3 cm). Collection of the San Francisco Museum of Modern Art. Purchased through a gift of Judy and John Webb, Sande Schlumberger, Pat and Bill Wilson, Susan and Robert Green, the Miriam and Peter Haas Fund, Members Accessions Fund, and Mr. and Mrs. Max Herzstein and Myrtle Lowenstern in honor of Mr. and Mrs. Stanley Herzstein's Fiftieth Wedding Anniversary, 95.98. Plate 23

9.
Nevada Fall, 700 Ft., Yosemite, 1861. 16 x 21 in. (40.6 x 53.3 cm). Fraenkel Gallery, San Francisco.

10.
North Dome. from the South Fork, 1861. Albumen on glass stereograph. 3⁵⁄₁₆ x 6¾ in. (8.4 x 17.1 cm). Courtesy of the Yosemite Museum, National Park Service.

11.
Over the Vernal Fall, 1861. Albumen on glass stereograph. 3⁵⁄₁₆ x 6¾ in. (8.4 x 17.1 cm). Courtesy of the Yosemite Museum, National Park Service. Plate 28

12.
Piwac, Vernal Falls, 300 feet, Yosemite, 1861. 15¹¹⁄₁₆ x 20⁹⁄₁₆ in. (39.8 x 52.2 cm). Collection of the National Gallery of Art, Washington, Gift (Partial and Promised) of Mary and David Robinson 1995.35.23.

13.
Pompompasos, 1861. 15¾ x 20⁵⁄₈ in. (40 x 52.9 cm). Collection of Stanford University Libraries, Cecil H. Green Library, Department of Special Collections.

14.
Under the Upper Fall., 1861. Albumen on glass stereograph. 3⁵⁄₁₆ x 6¾ in. (9 x 17.1 cm). Courtesy of the Yosemite Museum, National Park Service.

15.
View from the South Fork., 1861. Albumen on glass stereograph. 3⁵⁄₁₆ x 6¾ in. (8.4 x 17.1 cm). Courtesy of the Yosemite Museum, National Park Service.

16.
Yosemite Falls (River View), 1861. 15⁵⁄₈ x 20⁷⁄₈ in. (39.7 x 53 cm). Private collection, Montecito, California. Plate 27

17.
Albion River, Mendocino Co., Cal., 1863. 15⁵⁄₈ x 20½ in. (39.7 x 52.1 cm). Collection of The Bancroft Library, University of California, Berkeley. Plate 45 (not in exhibition)

18.
Albion River, Mendocino Co., Cal., 1863. 15⁵⁄₈ x 20½ in. (39.7 x 52.1 cm). Collection of Stanford University Libraries, Cecil H. Green Library, Department of Special Collections.

19.
At Mendocino, Mendocino County, California., 1863. Albumen stereograph. 3½ x 7 in. (8.9 x 17.8 cm). Collection of Peter E. Palmquist.

20.
The Church, Mendocino, 1863. 15³⁄₈ x 20⁹⁄₁₆ in. (39.1 x 52.2 cm). Collection of The Bancroft Library, University of California, Berkeley. Plate 48

21.
City of Mendocino, Mendocino Co., Cal., 1863. 15½ x 20½ in. (39.4 x 52.1 cm). Collection of Merrily and Tony Page: Page Imageworks.

22.
Coast View, Mendocino County, 1863. 21 x 15 in. (53.3 x 38.1 cm). Private collection, Montecito, California. Plate 43

23.
Coast View Number One, 1863. 15⁵⁄₈ x 20½ in. (39.7 x 52.1 cm). Collection of The Bancroft Library, University of California, Berkeley. Plate 42 (not in exhibition)

24.
Hacienda, View East, New Almaden mines, California, 1863. 15¾ x 20⅝ in. (40 x 52.5 cm) Collection Centre Canadien d'Architecture/ Canadian Centre for Architecture, Montréal. Plate 18

25.
(Indian) Sweat House, Mendocino Co., Cal., 1863. 15¾ x 20⅝ in. (40 x 52.4 cm). Gilman Paper Company Collection. Plate 46

26.
Kents Landing, Mendocino Co., Cal., 1863. 15⅝ x 20½ in. (39.7 x 52.1 cm). Collection of Stanford University Libraries, Cecil H. Green Library, Department of Special Collections. Plate 49

27.
Mendocino River, From the Rancherie, Mendocino County, California, 1863. 15¹¹⁄₁₆ x 20¹¹⁄₁₆ in. (39.8 x 52.5 cm). Collection of the Art Institute of Chicago, Gift of the Auxiliary Board, 1981.649. Plate 44

28.
The Mill #2, 1863. 15⁵⁄₁₆ x 19¹⁵⁄₁₆ in. (38.9 x 50.6 cm). Collection of The Bancroft Library, University of California, Berkeley.

29.
Residence of Mr. Freund, 1863. Albumen stereograph. 3½ x 7 in. (8.9 x 17.8 cm). Collection of Peter E. Palmquist. Plate 47

30.
Smelting Works, New Almaden., 1863. Albumen stereograph. 3½ x 7 in. (8.9 x 17.8 cm). Collection of Kathy and Ron Perisho. Plate 17

31.
The Town on the Hill, New Almaden, 1863. 15⅝ x 20⁹⁄₁₆ in. (39.7 x 52.2 cm). Collection of the Metropolitan Museum of Art; Purchase, The Horace W. Goldsmith Foundation Gift, 1989. Plate 16

32.
Russian Hill Observatory, ca. 1865. Albumen silver print stereograph. 3 x 6 in. (7.6 x 15.2 cm). Collection of Daniel Wolf. Plate 2

33.
Yosemite Falls, Yosemite Valley, ca. 1865. 15¾ x 10⁹⁄₁₆ in. (40 x 52.2 cm). Michael and Jane Wilson Collection.

34.
Yosemite from Mariposa Trail (Yosemite Valley No. 1), ca. 1865. 20⅝ x 16⅜ in. (52.4 x 41.6 cm). Michael and Jane Wilson Collection. Plate 29

35.
Yosemite Valley from "Best General View," ca. 1865. 15½ x 20½ in. (39.4 x 52.1 cm). Gilman Paper Company Collection. Plate 38

36.
El Capitan 3600 ft., 1865–66. Albumen stereograph. 3⁵⁄₁₆ x 6¾ in. (8.4 x 17.1 cm). Courtesy of the Yosemite Museum, National Park Service. Plate 37

37.
Foot Bridge below the Nevada Fall, 1865–66. Albumen stereograph. 3¼ x 6¾ in. (8.3 x 17.1 cm). Courtesy of the Yosemite Museum, National Park Service.

38.
Grizzly Giant, 33 feet diameter, Looking Up, 1865–66. Albumen stereograph. 3¼ x 6¾ in. (8.3 x 17.1 cm). Courtesy of the Yosemite Museum, National Park Service.

39.
Mirror View, Yosemite Valley, Mariposa County, Cal., 1865–66. Albumen stereograph. 3⁵⁄₁₆ x 6¹³⁄₁₆ in. (8.4 x 9.7 cm). Courtesy of the Yosemite Museum, National Park Service.

40.
Mirror View, Yosemite Valley, Mariposa County, Cal., 1865–66. Albumen stereograph. 3⅜ x 6¹⁵⁄₁₆ in. (8.6 x 17.6 cm). Courtesy of the Yosemite Museum, National Park Service. Plate 36

41.
The Ponderosa, Yosemite, 1865–66. 20⅝ x 15¾ in. (52.4 x 40 cm). Collection of Stanford University Libraries, Cecil H. Green Library, Department of Special Collections.

42.
Tutocanula El Capitan, 1865–66. 20⅝ x 15¾ in. (52.4 x 40 cm). Collection of Stanford University Libraries, Cecil H. Green Library, Department of Special Collections.

43.
View from the Sentinel Dome, Yosemite, 1865–66. Albumen silver prints from glass negatives. 3 prints: 15⅞ x 20½ in. (40.3 x 52.1 cm) each. Collection of the Metropolitan Museum of Art; Purchase, Joseph Pulitzer Bequest, 1989. Plates 30–32

44.
View up the Valley, 1865–66. 15¾ x 21 in. (40 x 53.3 cm). Collection of Stanford University Libraries, Cecil H. Green Library, Department of Special Collections.

45.
Bridal Veil, Yosemite, ca. 1865–66. 15½ x 20⅝ in. (39.4 x 52.4 cm). Collection of The Cleveland Museum of Art, Andrew R. and Martha Holden Jennings Fund 1992.12. Plate 25

46.
The Domes, Yosemite, ca. 1865–66. 16 x 20⅝ in. (40.6 x 52.4 cm). Collection of Howard Stein.

47.
El Capitan at the Foot of the Mariposa Trail, ca. 1865–66. 15⅝ x 20¾ in. (39.7 x 52.7 cm) Private collection, Montecito, California.

48.
Lower Cathedral Rock, ca. 1865–66. 20⅝ x 15⅞ in. (52.4 x 40.3 cm). Anonymous lender. Plate 21

49.
Lower Yosemite Fall, ca. 1865–66. 30 x 26 in. (76.2 x 66 cm). Collection of Mark Leno.

50.
River View up the Valley, ca. 1865–66. 15½ x 20½ in. (39.4 x 52.1 cm). Fraenkel Gallery, San Francisco. Plate 26

51.
Alcatraz, from North Point, ca. 1866. 15⅝ x 20½ in. (39.7 x 52.1 cm). Collection of The J. Paul Getty Museum, Los Angeles. Plate 1

52.
Lone Mountain, from the Orphan Asylum, 1866–69. 15⅝ x 20½ in. (39.7 x 52.1 cm). Collection of Stanford University Libraries, Cecil H. Green Library, Department of Special Collections. Plate 11

53.
San Francisco from Twin Peaks, Looking Northeast, 1866–69. 14½ x 21⅛ in. (36.8 x 53.7 cm). Collection of the California State Library. Plate 10

54.
Cape Horn, Columbia River, 1867. 15⅝ x 20½ in. (39.7 x 52.1 cm). Private collection, Montecito, California. Plate 69

55.
Cape Horn, Columbia River (Sheer Cliffs), 1867. Albumen print from wet-collodion-on-glass negative. 15⅝ x 20½ in. (39.7 x 52.1 cm). Collection of Howard Stein.

56.
Cape Horn near Celilo, 1867. 15¾ x 20⅝ in. (40 x 52.4 cm). Gilman Paper Company Collection. Plate 71

57.
Castle Rock, Columbia River, 1867. 15⅝ x 20½ in. (39.7 x 52.1 cm). Collection of Stanford University Libraries, Cecil H. Green Library, Department of Special Collections.

58.
Castle Rock, Columbia River, 1867. 21⅝ x 27 in. (54.9 x 68.6 cm). Collection of the San Francisco Museum of Modern Art. Madeleine H. Russell Fund of the Columbia Foundation, and purchase through a gift of Judy C. Webb and the Evelyn and Walter Haas, Jr., Fund, 98.558. Plate 66

59.
City of Portland and the Willamette River, 1867. 2 prints: 15⅝ x 20½ in. (39.7 x 52.1 cm) each. Left and center images of panorama formed with cat. no. 60. Collection of Stanford University Libraries, Cecil H. Green Library, Department of Special Collections. Plates 52–53

60.
City of Portland and the Willamette River, 1867. 16⅞ x 21⅜ in. (42.9 x 54.3 cm). Right image of panorama formed with cat. no. 59. Collection of the Oregon Historical Society, neg. # OrHi 21588. Plate 54

61.
Dalles City from Rockland, Columbia River, 1867. 15⅝ x 20½ in. (39.7 x 52.1 cm). Collection of Stanford University Libraries, Cecil H. Green Library, Department of Special Collections.

62.
Dalles City from the East, Columbia River, 1867. 15½ x 20⅜ in. (39.4 x 51.8 cm). Collection of Jane Levy Reed.

63.
Eagle Creek, Columbia River, 1867. 15⅝ x 20½ in. (39.7 x 52.1 cm). Collection of Marjorie and Leonard Vernon. Plate 61, cover

64.
Flour and Woolen Mills, Oregon City, 1867. 15⅝ x 20½ in. (39.7 x 52.1 cm). Private collection, Montecito, California. Plate 59

65.
The Garrison, Columbia River, 1867. 15¾ x 20⅝ in. (40 x 52.4 cm). Courtesy of Weston Gallery, Inc., Carmel, California. Plate 50

66.
Indian Camp at the Head of the Dalles, Columbia River, 1867. Albumen stereograph 3⁵⁄₁₆ x 6¾ in. (8.4 x 17.1 cm). Collection of the Oregon Historical Society, neg. # OrHi 57510, loc. # 232SO13.

67.
Islands in the Columbia, Upper Cascades, 1867. 15⅝ x 20½ in. (39.7 x 52.1 cm). Collection of Stanford University Libraries, Cecil H. Green Library, Department of Special Collections.

68.
Islands in the Columbia, Upper Cascades, 1867. 15¾ x 20⅝ in. (40 x 52.4 cm). Private collection, Montecito, California.

69.
Islands in the Columbia, Upper Cascades, 1867. 15⅞ x 20¹¹⁄₁₆ in. (40.3 x 52.5 cm). Fraenkel Gallery, San Francisco, and Weston Gallery, Inc., Carmel, California.

70.
The Middle Block House, Columbia River, 1867. 15⅝ x 20½ in. (39.7 x 52.1 cm). Collection of Stanford University Libraries, Cecil H. Green Library, Department of Special Collections.

71.
Mt. Hood and the Dalles, Columbia River, 1867. 22⅛ x 28¼ in. (56.2 x 71.8 cm). Collection of the San Francisco Museum of Modern Art. Madeleine H. Russell Fund of the Columbia Foundation, 98.560. Plate 72

72.
Mt. Hood from near Government Island, 1867. 15⅝ x 20½ in. (39.7 x 52.1 cm). Collection of Stanford University Libraries, Cecil H. Green Library, Department of Special Collections. Figure 3

73.
Multnomah Falls, Cascades, Columbia River, 1867. 20½ x 15⅝ in. (52.1 x 39.7 cm). Fraenkel Gallery, San Francisco. Plate 68

74.
Multnomah Falls, Columbia River, 1867. 3¼ x 6¾ in. (8.3 x 17.1 cm). Collection of James Crain. Plate 67

75.
Multnomah Falls, Oregon, 1867. 20½ x 15¼ in. (52.1 x 38.7 cm). Gilman Paper Company Collection.

76.
Oregon Iron Company at Oswego, 1867. 15⅝ x 20½ in. (39.7 x 52.1 cm). Collection of The J. Paul Getty Museum, Los Angeles. Plate 58

77.
Oregon Steam Navigation Company Works, Columbia River, 1867. 15⅝ x 20½ in. (39.7 x 52.1 cm). Collection of Marjorie and Leonard Vernon.

78.
Oregon Steam Navigation Company Works, Dalles City, Columbia River, 1867. 15⅝ x 20½ in. (39.7 x 52.1 cm). Collection of Stanford University Libraries, Cecil H. Green Library, Department of Special Collections.

79.
O.S.N. Co's Warehouse, Celilo, Columbia River., 1867. Albumen stereograph. 3⁵⁄₁₆ x 6¾ in. (8.4 x 17.1 cm). Collection of the Oregon Historical Society, neg. # OrHi 38763, loc. # 232SO17. Plate 57

80.
Oswego Iron Works, Willamette River, 1867. 2 prints: 15⅝ x 20½ in. (39.7 x 52.1 cm) each. Collection of Stanford University Libraries, Cecil H. Green Library, Department of Special Collections. Plates 55–56

81.
Oswego Iron Works. Willamette River, 1867. 15⅝ x 20½ in. (39.7 x 52.1 cm). Collection of Stanford University Libraries, Cecil H. Green Library, Department of Special Collections. Plate 51

82.
Panorama of Oregon City and Willamette Falls, 1867. 3 prints: 15¾ x 20⅝ in. (40 x 52.4 cm) each. Collection Centre Canadien d'Architecture/Canadian Centre for Architecture, Montréal. Plates 63–65

83.
The Passage of the Dalles, Columbia River, 1867. Albumen print from wet-collodion-on-glass negative. 15⅝ x 20⅝ in. (39.7 x 52.4 cm). Collection of Howard Stein.

84.
The Rapids, Indian Block House, Cascades, 1867. 15⅝ x 20½ in. (39.7 x 52.1 cm). Collection of Stanford University Libraries, Cecil H. Green Library, Department of Special Collections.

85.
Rooster Rock, Columbia River, 1867. 15⅝ x 20½ in. (39.7 x 52.1 cm). Collection of Stanford University Libraries, Cecil H. Green Library, Department of Special Collections.

86.
The Tooth Bridge, O.R.R. Cascades, Columbia River, 1867. Albumen stereograph. 3½ x 7 in. (8.9 x 17.8 cm). Collection of Peter E. Palmquist. Plate 70

87.
Upper Cascades, Columbia River, 1867. 15⅝ x 20½ in. (39.7 x 52.1 cm). Collection of Stanford University Libraries, Cecil H. Green Library, Department of Special Collections. Plate 60

88.
View on the Columbia, Cascades, 1867. Albumen silver print from glass negative. 15⅝ x 20½ in. (39.7 x 52.1 cm). Collection of the Metropolitan Museum of Art; Warner Communications Inc. Purchase Fund and Horace Brisbane Dick Fund, 1979.

89.
View on the Columbia, O.R.R. Cascades, Columbia River, 1867. Albumen stereograph 3⁵⁄₁₆ x 6¾ in. (8.4 x 17.1 cm). Collection of the Oregon Historical Society, neg. # CN017020, loc. # 231S113.

90.
View on the Columbia River, from Celilo, 1867. Albumen stereograph. 3⁵⁄₁₆ x 6¾ in. (8.4 x 17.1 cm). Collection of the Oregon Historical Society, neg. # OrHi 11860, loc. # 232SO21.

91.
Willamette Falls, Oregon City, 1867. 15⅝ x 20½ in. (39.7 x 52.1 cm). Private collection, Montecito, California.

92.
The Cliff House from the Beach, San Francisco, after 1867. Albumen print from wet-collodion-on-glass negative. 15¾ x 20⅝ in. (40 x 52.4 cm). Collection of The J. Paul Getty Museum, Los Angeles. Plate 13

93.
The Wreck of the Viscata, 1868. Albumen silver print. 15¾ x 20⁹⁄₁₆ in. (40 x 52.4 cm). Amon Carter Museum, Fort Worth, Texas. Plate 12

94.
College Buildings, Santa Clara, California, ca. 1868. 15¾ x 20⅝ in. (40 x 52.4 cm). Collection Centre Canadien d'Architecture/Canadian Centre for Architecture, Montréal.

95.
The Golden Gate from Telegraph Hill, ca. 1868. 15⅝ x 20½ in. (39.7 x 52.1 cm). Collection of Stanford University Libraries, Cecil H. Green Library, Department of Special Collections. Plate 9

96.
Oak Tree, ca. 1868. 15⅝ x 20½ in. (39.1 x 52.1 cm). Gilman Paper Company Collection.

97.
Untitled, ca. 1868. Albumen stereograph. 3½ x 7 in. (8.9 x 17.8 cm). Collection of The Society of California Pioneers.

98.
Strait of Carquennes, from South Vallejo, 1868–69. 15⅝ x 20⅝ in. (39.7 x 52.4 cm). Gilman Paper Company Collection. Plate 14

99.
Devil's Canyon, Geysers, Looking Down, 1868–70. Albumen silver print from glass negative. 15¹¹⁄₁₆ x 20⅝ in. (39.8 x 52.4 cm). Collection of the Metropolitan Museum of Art; Purchase, Director's Discretionary Fund, 1989.

100.
Devil's Canon, Geysers, Looking Up, ca. 1868–70. Albumen print from wet-collodion-on-glass negative. 15⅝ x 20½ in. (39.7 x 52.1 cm). Collection of Howard Stein.

101.
Arch at the West End, Farallone Islands, Pacific Ocean., 1869. Albumen stereograph. 3½ x 7 in. (8.9 x 17.8 cm). Collection of Peter E. Palmquist.

102.
Arch at the West End Farallons, 1869.
15⅝ x 20½ in. (39.7 x 52.1 cm). Collection of
Stanford University Libraries, Cecil H. Green
Library, Department of Special Collections.
Plate 76

103.
*On the Sugar Loaf Islands, Farallone Islands,
Pacific Ocean.*, 1869. Albumen stereograph.
3½ x 7 in. (8.9 x 17.8 cm). Collection of Peter
E. Palmquist. Plate 75

104.
Sea Aquarium, Farallone Islands, Pacific Ocean,
1869. Albumen stereograph. 3½ x 7 in.
(8.9 x 17.8 cm). Collection of The Society
of California Pioneers.

105.
Seal Rocks, From the Point, 1869. 15⅝ x 20½ in.
(39.7 x 52.1 cm). Collection of Stanford
University Libraries, Cecil H. Green Library,
Department of Special Collections.

106.
*Sugar Loaf Islands and Fisherman's Bay,
Farallons*, 1869. 15⅝ x 20½ in. (39.7 x 52.1 cm)
Collection of Stanford University Libraries,
Cecil H. Green Library, Department of
Special Collections. Plate 77

107.
Sugar Loaf Islands, Farallons, 1869. 15⅝ x
20⅛ in. (39.7 x 51.1 cm). Gilman Paper
Company Collection. Plate 73

108.
Sugar Loaf Islands, Farallons, 1869. 15¾ x
20⅝ in. (40 x 52.4 cm). Gilman Paper
Company Collection. Plate 74

109.
View from Sugar Loaf Islands, Farallons, 1869.
15⅝ x 20½ in. (39.7 x 52.1 cm). Collection of
Stanford University Libraries, Cecil H. Green
Library, Department of Special Collections.

110.
*Big Canon (Bowman) Dam, distant view. North
Bloomfield Mining Company*, ca. 1869–72.
Albumen stereograph. 3½ x 7 in. (8.9 x 17.8
cm). Collection of Kathy and Ron Perisho.

111.
*Malakoff Diggings. North Bloomfield Gravel
Mining Company*, ca. 1869–72. 16¼ x 21⁹⁄₁₆ in.
(41.3 x 54.8 cm). Collection of the Addison
Gallery of American Art, Phillips Academy,
Andover, Massachusetts. Plate 87

112.
*Malakoff Diggins, North Bloomfield, Nevada
Co., Cal.*, ca. 1869–72. 15⅝ x 20½ in. (39.7 x
52.1 cm). Collection of Stanford University
Libraries, Cecil H. Green Library,
Department of Special Collections. Plate 85

113.
*Malakoff. North Bloomfield Gravel Mining
Company*, ca. 1869–72. 15⅝ x 21⁷⁄₁₆ in. (39.7 x
54.5 cm). Collection of the Addison Gallery of
American Art, Phillips Academy, Andover,
Massachusetts (gift of Stephen C. Sherrill
[PA 1971]). Plate 88

114.
*North Bloomfield Gravel Mines, Nevada Co.,
Cal.*, ca. 1869–72. Albumen stereograph. 3½ x
7 in. (8.9 x 17.8 cm). Collection of The Society
of California Pioneers. Plate 86

115.
*Union Diggings, Columbia Hill, North
Bloomfield Gravel Mining Co.*, ca. 1869–72.
Albumen stereograph. 3½ x 6⅞ in. (8.9 x 17.5
cm). Collection of the California State Library.

116.
*Union Diggins, Columbia Hill, Nevada Co.,
Cal.*, ca. 1869–72. 15⅝ x 20½ in. (39.7 x 52.1
cm). Collection of Stanford University
Libraries, Cecil H. Green Library,
Department of Special Collections.

117.
Mount Shasta from the North, 1870. 15¾ x
20⅝ in. (40 x 52.4 cm). Gilman Paper
Company Collection.

118.
Twin Redwoods, Palo Alto, 1870. 20⁹⁄₁₆ x
15⁹⁄₁₆ in. (52.2 x 39.5 cm). Collection of the
National Gallery of Art, Washington, Gift
(Partial and Promised) of Mary and David
Robinson 1995.35.27. Plate 15

119.
Dam and Lake, Nevada County, Near View,
ca. 1871. 16¼ x 21⅝ in. (41.3 x 54.9 cm).
Collection of The J. Paul Getty Museum,
Los Angeles. Plate 84

120.
Dams and Lake, Nevada County, Distant View,
ca. 1871. 15⁵⁄₁₆ x 21⅜ in. (40.5 x 54.3 cm).
Collection of The J. Paul Getty Museum,
Los Angeles. Plate 83

121.
Mirror View of El Capitan, ca. 1872. 20¾ x
15¾ in. (52.7 x 40 cm). Collection of Stanford
University Libraries, Cecil H. Green Library,
Department of Special Collections. Plate 34

122.
Washington Column, 2052 ft., Yosemite,
ca. 1872. 20¼ x 15⅜ in. (51.4 x 39 cm).
Collection of Catherine Mills. Plate 35

123.
Arbutus Menziesii Pursh, ca. 1872–78. 14⅜ x
21⅜ in. (36.5 x 54.3 cm). Collection of The
Museum of Modern Art, New York, Purchase.
Plate 90

124.
Buckeye Tree, California, ca. 1872–78. Albumen
silver print. 15⅜ x 20⁷⁄₁₆ in. (39.1 x 51.9 cm).
Collection Centre Canadien d'Architecture/
Canadian Centre for Architecture, Montréal.
Plate 91

125.
Hanging [Profile] Rock, Echo Canyon, Utah,
1873–74. 21½ x 16¼ in. (54.6 x 41.3 cm).
Private collection, New York (Courtesy Jill
Quasha). Plate 79

126.
Panorama of Salt Lake City, Utah, 1873–74.
3 prints: 16⅜ x 21½ in. (41.6 x 54.6 cm); 16⅜ x
21½ in. (41.6 x 54.6 cm); and 16⅜ x 19¹¹⁄₁₆ in.
(41.6 x 50 cm). Collection Centre Canadien
d'Architecture/Canadian Centre for
Architecture, Montréal. Plates 80–82

127.
View in Weber Cañon, Utah, 1873–74.
15¾ x 20⅝ in. (40 x 52.4 cm). Anonymous
lender. Plate 78

128.
Panorama from California and Powell Streets, San Francisco, 1874. Albumen stereograph. $3^{7}/_{16}$ x $6^{15}/_{16}$ in. (8.7 x 17.6 cm). Collection of The Bancroft Library, University of California, Berkeley. Plate 4

129.
View from California and Powell Streets, San Francisco, 1874. Albumen stereograph. $3^{7}/_{16}$ x $6^{15}/_{16}$ in. (8.7 x 17.6 cm). Collection of The Bancroft Library, University of California, Berkeley. Plate 3

130.
View from California and Powell Streets, San Francisco, 1874. Albumen stereograph. $3^{7}/_{16}$ x $6^{15}/_{16}$ in. (8.7 x 17.6 cm). Collection of The Bancroft Library, University of California, Berkeley. Plate 5

131.
View from California and Powell Streets, San Francisco, 1874. Albumen stereograph. $3^{7}/_{16}$ x $6^{7}/_{8}$ in. (8.7 x 17.5 cm). Collection of the American Antiquarian Society. Plate 6

132.
View from California and Powell Streets, San Francisco, 1874. Albumen stereograph. $3^{7}/_{16}$ x $6^{15}/_{16}$ in. (8.7 x 17.6 cm). Collection of The Bancroft Library, University of California, Berkeley. Plate 7

133.
View from California and Powell Streets, San Francisco, 1874. Albumen stereograph. $3^{7}/_{16}$ x $6^{15}/_{16}$ in. (8.7 x 17.6 cm). Collection of The Bancroft Library, University of California, Berkeley. Plate 8

134.
At the Yacht Race, S.F., July 5, 1876, 1876. Albumen stereograph. $3^{1}/_{2}$ x 7 in. (8.9 x 17.8 cm). Collection of The Society of California Pioneers.

135.
The Cliff House and Environs, S.F., ca. 1876. Albumen stereograph. $3^{1}/_{2}$ x 7 in. (8.9 x 17.8 cm). Collection of The Society of California Pioneers.

136.
C. P. ferry boat Solano *in slip at Pt. Costa waiting for train.,* ca. 1876. Albumen stereograph. $3^{1}/_{2}$ x 7 in. (8.9 x 17.8 cm). Collection of The Society of California Pioneers. Plate 100

137.
Mt. Diablo, from Pt. Costa, ca. 1876. Albumen stereograph. $3^{1}/_{2}$ x 7 in. (8.9 x 17.8 cm). Collection of The Society of California Pioneers.

138.
Untitled album of seventy-three albumen silver prints from glass negatives, 1878. Closed: $9^{7}/_{8}$ x $10^{3}/_{8}$ x $1^{1}/_{8}$ in. (25.1 x 26.4 x 2.9 cm). Image diameter: 5 in. (2.7 cm). Gilman Paper Company Collection. Plate 94

139.
Casa Nevada and Cottage, Yosemite, ca. 1878. Albumen stereograph. $3^{9}/_{16}$ x 7 in. (9 x 17.8 cm). Courtesy of the Yosemite Museum, National Park Service.

140.
Mirror View of the Upper Yo Semite Fall, ca. 1878. Albumen stereograph. $3^{9}/_{16}$ x 7 in. (9 x 17.8 cm). Courtesy of the Yosemite Museum, National Park Service.

141.
Pohono; the Bridal Veil, 900 ft. Yo Semite, ca. 1878. Albumen stereograph. $3^{9}/_{16}$ x 7 in. (9 x 17.8 cm). Courtesy of the Yosemite Museum, National Park Service.

142.
Tutocanula; El Capitan, 3600 ft., Yo Semite., ca. 1878. Albumen stereograph. $3^{9}/_{16}$ x 7 in. (9 x 17.8 cm). Courtesy of the Yosemite Museum, National Park Service.

143.
Upper Yo Semite Fall, 1600 ft. from Eagle Point Trail, ca. 1878. Albumen stereograph. $3^{9}/_{16}$ x 7 in. (9 x 17.8 cm). Courtesy of the Yosemite Museum, National Park Service.

144.
Victoria Regia, ca. 1878. Albumen stereograph. $3^{1}/_{2}$ x 7 in. (8.9 x 17.8 cm). Collection of The Society of California Pioneers. Plate 95

145.
View from the Bottom of the Ladders, Yo Semite, ca. 1878. Albumen stereograph. $3^{9}/_{16}$ x 7 in. (9 x 17.8 cm). Courtesy of the Yosemite Museum, National Park Service.

146.
The Yo Semite Falls, 2634 ft., ca. 1878. Albumen stereograph. $3^{9}/_{16}$ x 7 in. (9 x 17.8 cm). Courtesy of the Yosemite Museum, National Park Service.

147.
Agassiz Rock and the Yosemite Falls, from Union Point, 1878–81. $21^{1}/_{4}$ x $15^{1}/_{4}$ in. (54 x 38.7 cm). Collection of Gordon L. Bennett. Plate 41

148.
Yosemite Falls, View from the Bottom, 1878–81. 21 x 15 in. (38.1 x 53.3 cm). Collection of Gordon L. Bennett. Plate 40

149.
Agassiz Rock, Union Point. Yo Semite, ca. 1878–81. Albumen stereograph. $3^{9}/_{16}$ x 7 in. (9 x 17.8 cm). Courtesy of the Yosemite Museum, National Park Service.

150.
The Half-Dome from Glacier Point, ca. 1878–81. $15^{1}/_{4}$ x $21^{1}/_{4}$ in. (38.7 x 54 cm). Collection of Gordon L. Bennett. Plate 39

151.
Mirror Lake (View of Mt. Watkins), ca. 1878–81. $21^{1}/_{4}$ x $15^{1}/_{4}$ in. (54 x 38.7 cm). Collection of Gordon L. Bennett. Plate 33

152.
Yosemite Valley, from Big Oak Flat Road, ca. 1878–81. 15 x 21 in. (38.1 x 53.3 cm). Collection of Gordon L. Bennett.

153.
Mt. Lola; Looking NW Showing Effect of Wind on Trees, 1879. $22^{1}/_{8}$ x $28^{1}/_{8}$ in. (56.2 x 71.4 cm). Collection of the Oregon Historical Society, neg. # OrHi 65560.

154.
Round Top from Western Part of Ridge, 1879. $22^{1}/_{8}$ x $28^{1}/_{8}$ in. (56.2 x 71.4 cm). Collection of the Oregon Historical Society, neg. # OrHi 65561. Plate 89

155.
Cactus, (Cereus Giganteus.) Arizona., 1880.
Albumen stereograph. 3$\frac{1}{2}$ x 6$\frac{7}{8}$ in. (8.9 x
17.5 cm). Collection of the California State
Library. Plate 97

156.
Cactus, (Cereus Giganteus.) Arizona., 1880.
Albumen stereograph. 3$\frac{1}{2}$ x 6$\frac{7}{8}$ in. (8.9 x
17.5 cm). Collection of the California State
Library. Plate 98

157.
Casa Grande, Pre-Historic Ruins Arizona,
1880. 15$\frac{1}{4}$ x 21$\frac{1}{4}$ in. (38.6 x 54 cm). Courtesy
of The Huntington Library, Art Collections,
and Botanical Gardens. Plate 96

158.
La Joli, Pacific Coast, near San Diego, 1880.
Albumen stereograph. 3$\frac{1}{2}$ x 7 in. (8.9 x 17.8
cm). Collection of The Society of California
Pioneers.

159.
La Joli, Pacific Coast, near San Diego, 1880.
Albumen stereograph. 3$\frac{1}{2}$ x 7 in. (8.9 x 17.8
cm). Collection of The Society of California
Pioneers.

160.
R. R. Co's Works at Wilmington, S. P. R. R.,
1880. Albumen stereograph. 3$\frac{1}{2}$ x 6$\frac{7}{8}$ in.
(8.9 x 17.5 cm). Collection of the California
State Library. Plate 101

161.
Yucca Draconis, Paper Tree, Mojave Desert.,
1880. Albumen stereograph. 3$\frac{1}{2}$ x 6$\frac{7}{8}$ in.
(8.9 x 17.5 cm). Collection of the California
State Library. Plate 99

162.
The Cliff House, ca. 1880. 15 x 21 in. (38.1 x
53.3 cm). Michael and Jane Wilson Collection.

163.
The Cliff House, ca. 1880. 14 x 20$\frac{1}{2}$ in. (35.6 x
52.1 cm). Michael and Jane Wilson Collection.

164.
Fig Tree, Tejon Ranch, Kern County, Cal.,
ca. 1880. 14$\frac{1}{2}$ x 21$\frac{1}{8}$ in. (36.8 x 53.7 cm).
Courtesy of The Huntington Library,
Art Collections, and Botanical Gardens.

165.
Larch Grove, Tallac House, Lake Tahoe,
ca. 1880. 14$\frac{1}{8}$ x 21$\frac{1}{16}$ in. (35.9 x 53.5 cm).
Courtesy of The Huntington Library, Art
Collections, and Botanical Gardens.

166.
*"The Needles," View East, Cascades, Col. River,
Or.*, 1883. Albumen stereograph. 3$\frac{1}{2}$ x 6$\frac{7}{8}$ in.
(8.9 x 17.5 cm). Collection of the California
State Library.

167.
Baldwin and Wilder Dairy, Santa Cruz,
ca. 1883. 15 x 21 in. (38.1 x 53.3 cm). Michael
and Jane Wilson Collection.

168.
Late George Cling Peaches, ca. 1887–88.
14$\frac{3}{8}$ x 21 in. (36.5 x 53.3 cm). Courtesy of
The Huntington Library, Art Collections,
and Botanical Gardens. Plate 93

169.
*Orange Cling Peach, Waul Orchard, Kern
County, California*, ca. 1887–88. 14$\frac{1}{8}$ x 21$\frac{1}{16}$ in.
(35.9 x 53.5 cm). Courtesy of The Huntington
Library, Art Collections, and Botanical
Gardens. Plate 92

170.
Golden Feather Mining Claim, No. 2 and No. 3,
1891. 2 prints: 15$\frac{3}{4}$ x 21$\frac{7}{16}$ in. (40 x 54.5 cm)
and 15$\frac{1}{4}$ x 21$\frac{7}{16}$ in. (38.7 x 54.5 cm).
Collection of The Bancroft Library, University
of California, Berkeley. Plates 102–103

171.
Golden Feather Mining Claim, No. 7, 1891.
15 x 21$\frac{7}{16}$ in. (38.1 x 54.5 cm). Collection
of The Bancroft Library, University of
California, Berkeley.

172.
Golden Feather Mining Claim, No. 9, 1891.
15$\frac{7}{16}$ x 21$\frac{1}{2}$ in. (39.2 x 54.6 cm). Collection
of The Bancroft Library, University of
California, Berkeley. Plate 105

173.
Golden Gate Mining Claim, No. 6, 1891.
17$\frac{9}{16}$ x 21$\frac{1}{2}$ in. (44.6 x 54.6 cm). Collection
of The Bancroft Library, University of
California, Berkeley. Plate 104